Creative Techniques in Stage and Theatrical Photography

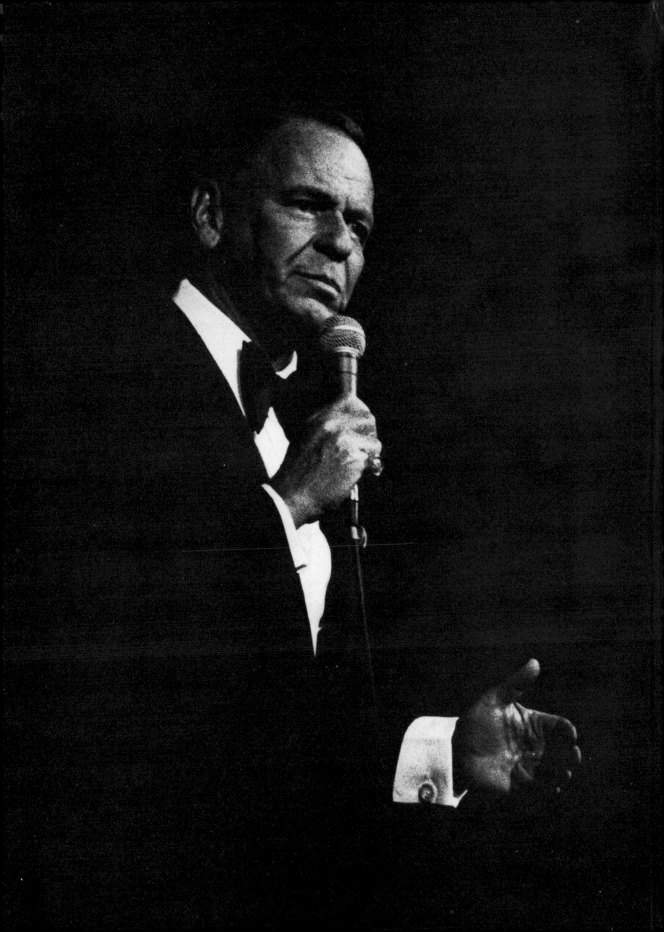

Creative Techniques in Stage and Theatrical Photography

Paddy Cutts and Rosemary Curr

B. T. Batsford, London

This book is dedicated to the memory of our late fathers, George Cutts and David Curr.

First published 1983

© Paddy Cutts and Rosemary Curr

ISBN 0 7134 0667 4

Printed in Great Britain
for the publishers,
B T Batsford Ltd,
4 Fitzhardinge Street.
London, W1H 0AH

Frontispiece *Frank Sinatra in concert, Royal Festival Hall, London 1978 This picture really captures the spirit of the live performance, showing mood, expression and drama. This shot was very difficult to get and the full story behind it can be found in Chapter 1. Olympus OM1 motor drive, 300mm lens, Recording film rated at 2000 ASA.* (Photograph, courtesy Matthew Taylor.)

Contents

Acknowledgement

The authors wish to extend their thanks for their kind co-operation to the following:
Paul Alger; Asahi Pentax; Avolites Production Co. Ltd; Mel Bush; C.B.S.; Chichester Festival Theatre; Colorama Photographic; Colour Centre; Donald Cooper; Zoë Dominic; Epic Records; Fairdene School, Chipstead, Surrey; Glyndebourne Festival Opera; Harvey Goldsmith Entertainments; Sue Hyman Associates; Image Photographic; P. & P. F. James; Kennedy Street Enterprises; Nesta McDonald; James Mann; M.C.P.; Modern Publicity (Alan Edwards); Nikon U.K. Ltd; Opera North; Sadlers Wells Ballet; Chris Stewart; Stoll Productions Ltd; Genista Streeten; Matthew Taylor; Peter Thompson; W.E.A.; Welsh National Opera.
All the photographs in this book were taken by Paddy Cutts, except: Matthew Taylor: frontispiece, 5, 10, 12, 21, 25, 47, 51, 66, 69, 85; Anthony Crickmay: 7, 56; Paul Alger: 93, 94, 95, 96; Chris Stewart: 38a and b, 54, 60, 65, 81, 87, 88, 89a and b, 90a and b; Asahi Pentax 13, 17; Nikon U.K. Ltd 14, 19. The diagram of the frame plan and poster sizes on p. 156 was designed by George Hoare.

1 *Don Giovanni*, (Thomas Allen), Glyndebourne, 1982
Although this would appear to be a close up, it was in fact photographed from the centre of the dress circle whilst the actual piece occurred far upstage. The predominent lighting state was red, with the smoke coming up from behind the stage areas; conditions could have easily given an inflated light meter reading, resulting in detail in the smoke effects, but producing a silhouette of the artiste – by taking a reading from the foreground stage shadow areas this was avoided. Despite the difficulties encountered in this sort of scene, the resulting picture is remarkably clear as it was taken at just that right moment – two seconds later Don Giovanni was engulfed by the smoke, depicting his descent into Hell! Nikon F2, motor drive, 200mm lens, HP5 rates at 1600 ASA

Introduction

Stage and theatrical photography requires skills from the photographer that are quite different from any other form of photography. One is photographing the action and situations as presented, rather than asking the artists to present themselves to the best advantage, to obtain a good photograph which is flattering and at the same time true to the characters being portrayed. The venue and situations will often demand the utmost of the photographer's technical skills, and dealing with the performers themselves will often necessitate tact and diplomacy; at the same time one should have total regard for the other photographers who are around at the same time and who are experiencing the same difficulties. Difficult lighting conditions, the fact that some artistes do not really wish to be photographed, technicalities going wrong – for example rather too much smoke in an operatic damnation scene – all tax the photographer's skill both technically and psychologically in achieving the desired effect and obtaining a good picture into the bargain. Added to this are the inevitable time restrictions one always meets with at photo calls and the like. The equipment that is necessary is often highly specialised if the most professional results are to be achieved. Artistes hate being kept waiting whilst lighting is adjusted, light meters read and cameras loaded, and they will often be pleasantly surprised, if the correct equipment is used, at how relatively brief and painless a photographic session can be.

Stage and theatrical photography offers some of the most artistic opportunities of all photographic situations and, regard-

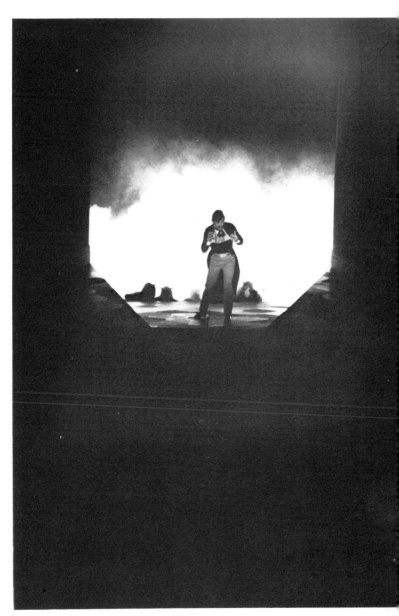

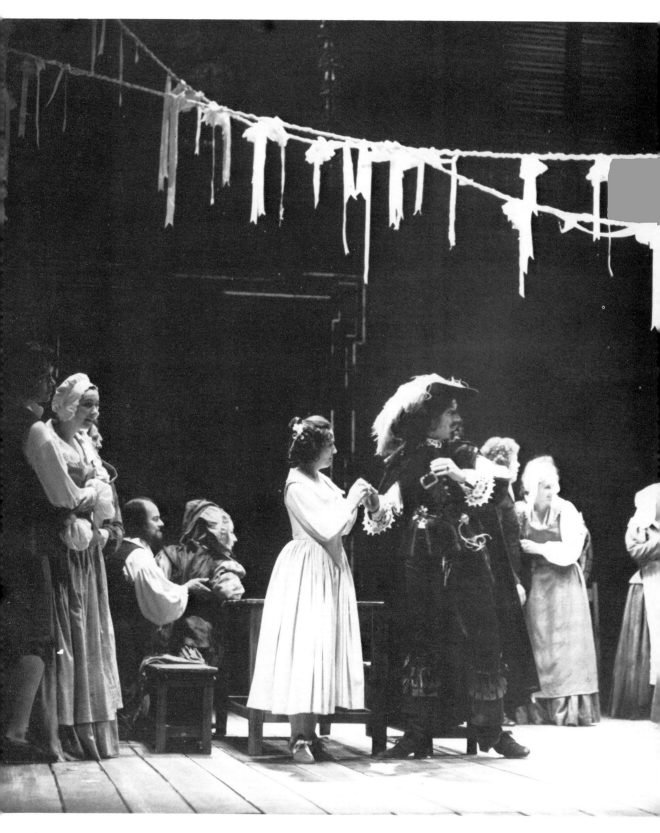

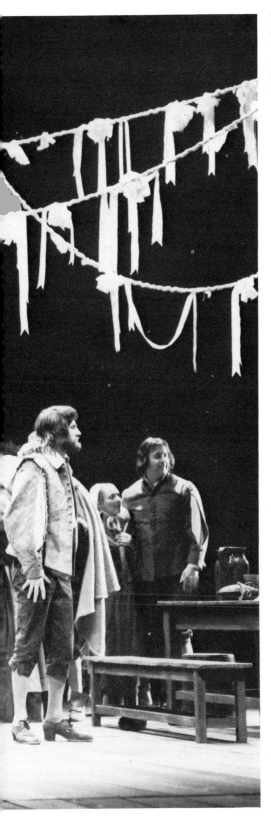

less of whether the resulting pictures are for the amateur's family album or destined for a glossy magazine, the aim is to capture one single moment of a live performance for ever. It has also to be a good and true representation of the performers, sets, costumes and lighting, combined to make an excellent advertisement at all times, as well as an exact record. This may seem difficult, but the purpose of this book is to explore the various techniques that can be employed.

The very nature of the stage and theatre can be immensely varied, and each aspect requires very different skills. An interest on the part of the photographer in the subject matter is obviously important since a good photograph may require considerable energy and imagination and a disinterested photographer is likely to produce boring, unimaginative pictures. For this reason many photographers will tend to specialise in just one field of this vast subject. Ballet buffs may not like rock concerts, and not everyone who likes opera will also have a great interest in musicals. However, whatever the subject, it is still performed for an audience, and the photographer must also aim to reflect the atmosphere in the auditorium at the moment the photograph is taken. It is this feeling of capturing a single, never-to-be-repeated moment of time in a photograph that makes these pictures so very different from those that are posed and therefore able to be reconstructed when necessary.

2 *Don Giovanni*, (Welsh National Opera), Mold, North Wales, 1982
Operatic photography can often involve very busy scenarios, with many characters on stage, frequently all doing different things; it is very easy for such scenes to look very confused when photographed. It is useful to try and find a theme, as illustrated in this shot where the attention is focused on one spot where all the artistes looking towards it, thus giving a unity to the picture. This photograph was taken at a dress rehearsal where the lighting levels were true of the final production and thus somewhat low. The picture was taken from the stalls area and, as the stage was not set too high from the surrounding areas, there is very little distortion. Pentax 6 × 7, 55mm lens, HP5 rated at 1200 ASA

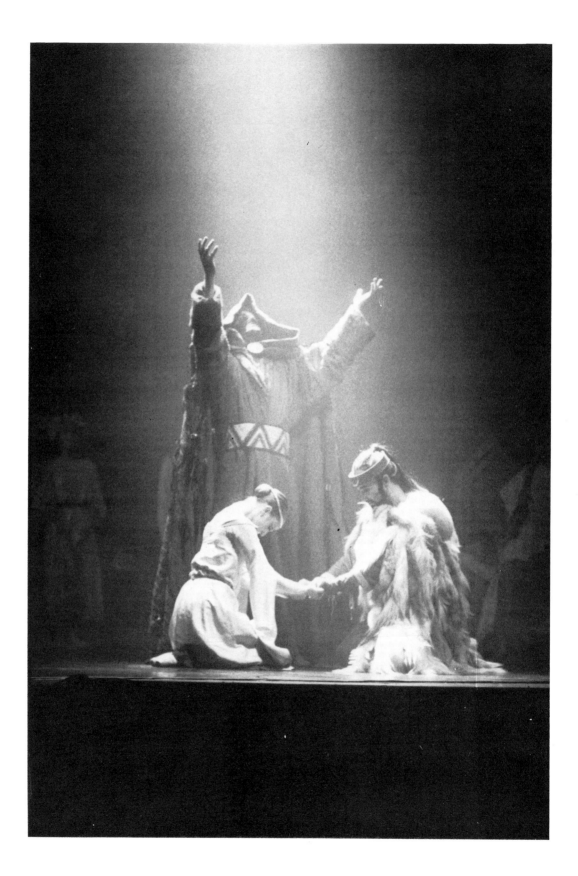

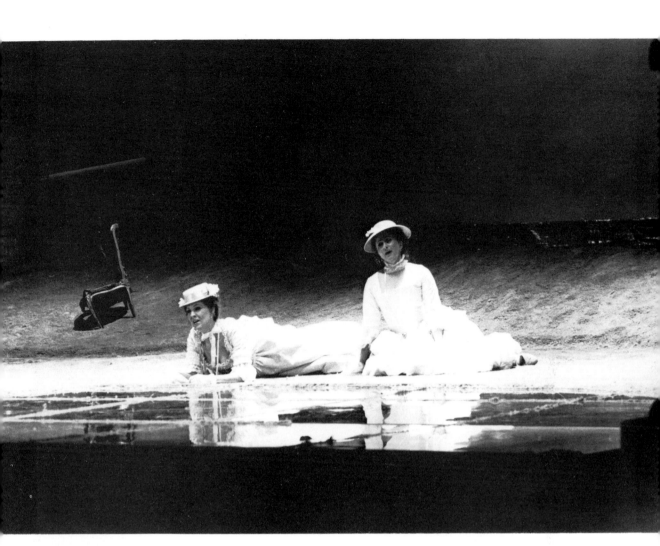

3 LEFT : *The Swan of Tuonela*, (Sadlers Wells Royal Ballet), London, 1982

Although a picture of a ballet, this picture gives over a really dramatic effect, and equally well could have been a play or an opera as there are no obviously balletic poses. It is an excellent picture, showing great depth and illustrating well the lighting effects, giving a good atmospheric record of the production. Nikon F2, motor drive, 200mm lens, HP5 rated at 1600 ASA

4 ABOVE : *Cosi Fan Tutte*, (Opera North), Leeds, 1982
Some of the stage effects, although interesting and effective to the audience, can give the photographer quite a headache. For this production, the set designer produced a 'mirrored' floor to give the effect of water as many of the scenes in this particular opera were supposed to take place on the sea shore. Coupled with this,

the two girls are dressed in white which is always a difficult colour to capture photographically, especially when up-rated film has to be used. The darker areas were used to take the meter reading from, and the final result had to be printed-in at the darkroom stage in order to give detail in the white dresses as well as detail in the reflections. This picture was therefore not easy to take, but the results are very worthwhile as they have captured a typical scene from the production. Nikon F2, motor drive, 105mm lens, HP5 rated at 1200 ASA

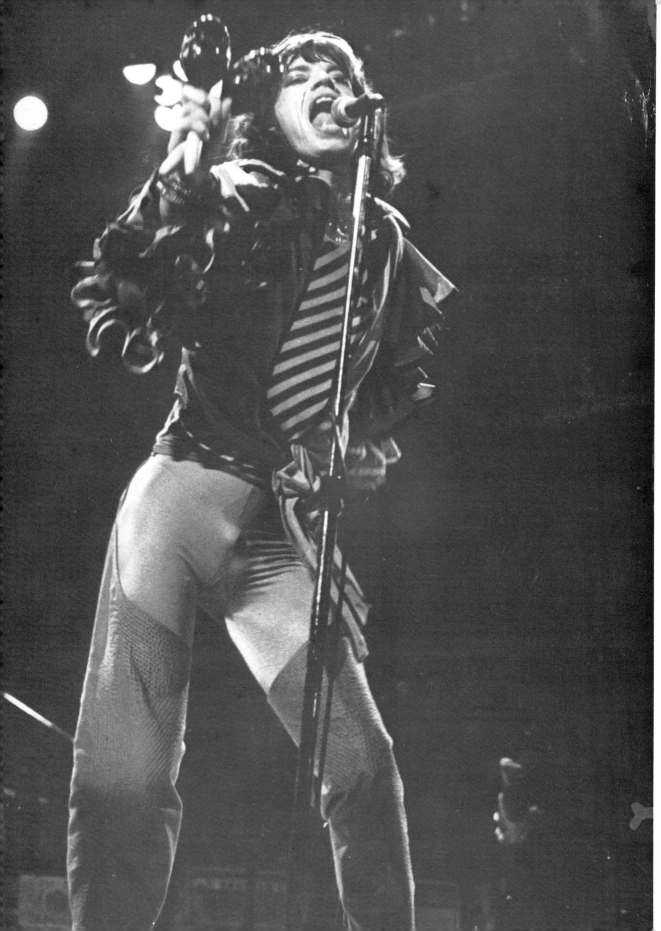

5 LEFT : Mick Jagger of the Rolling Stones, Earls Court, London, 1976
An action-packed moment that would be very difficult to re-create and was only possible by considerable foresight and anticipation on the part of the photographer. Such pictures are not easy to get as there are so many factors to take into consideration. Not only is this picture beautifully framed, but it is also well exposed and sharp, giving a very pleasing and highly usable print, which is extremely typical of this well-known artiste. The angle of view gives an interesting effect to the shot, as the picture was taken very close to the stage with the use of a wide angle lens. Olympus OM1, motor drive, 28mm lens, Tri-X rated at 1600 ASA

6 RIGHT : Neil Young, Wembley, 1982
A picture truly evocative of a particular performance need not be of great action to give real interest. Extreme close-ups, showing no distracting background detail and using the dramatic effect of the stage lighting, can produce a very theatrical study. Although there is no action in this particular picture, its value lies in the concentrated and thoughtful expression depicted and which the photographer had anticipated. Nikon F2, motor drive, 200mm lens, HP5 rated at 1600 ASA

1 Gaining Access

The subject of access may seem simple to the uninitiated; you buy a ticket, find your seat, and start shooting. However, it is not as obvious as it seems.

For a start, with very few exceptions (which will be mentioned later) nearly all theatre, opera and ballet productions will very clearly state that 'the taking of photographs in the auditorium during performances is strictly forbidden.' This is usually displayed in the foyer and the auditorium, and also printed in the programme. It may even be found that hand bags are searched to make sure that photographic equipment is not smuggled in, but this is likely only in very extreme circumstances (hand bags are more usually searched for bombs, and the like). When the show *Oh! Calcutta!* first opened in London (and indeed throughout its entire West End run) cameras were absolutely forbidden in the auditorium at all times (the production photographer had done his work and there photographing ended). The theatres concerned had the fairly unusual facility, attached to the cloakroom, of a free 'camera park'. Cameras were lodged there at the start of the performance, a cloakroom ticket obtained, cameras guarded at all times and collected at the end of the performance. Since a great many tourists came to see the show this 'camera park' was an absolute necessity and, once they realised their cameras were going to be safe, patrons readily agreed to leave them with the attendant. Failure to leave the cameras there, and photographs being subsequently taken as a result of 'smuggling', ended with the offending cameras being confiscated by the theatre management and the films being exposed immediately.

As a great many tourists came to see the show, not only the illicit photographs were lost, but also quite a few holiday snaps as well! But, happily, this did not happen too often and when it did it was more often than not due to a language problem between a foreign visitor and the theatre manager, which further complicated the issue.

To the amateur this may sound daunting, and indeed it is, for there is little place in the professional theatre for amateur photography. The reasons for this are two-fold. Firstly, it is most distracting for both the performers and the audience to have lights flashing and cameras clicking during a performance – it is common politeness to stay as quiet as possible and, indeed, afficionados will quietly choke rather than utter so much as a cough during a performance! Secondly, an amateur may well take unflattering pictures of the artistes that should not be published.

The most usual way to photograph theatrical performances (and by this we include theatre, musicals, opera and ballet) is at a photo call or a dress rehearsal. Usually, photo calls cover the theatre and dress rehearsals provide the opportunity within the area of ballet and opera for photography. These are all by invitation only, so the method of access is to get oneself on the mailing lists. It is normally the production's publicity company or press representative who will organise these events and allow press coverage, and a telephone call to the Public relations officer of the production company or theatre will usually reveal the person to contact.

In the case of opera, ballet, repertory

companies and other subsidised theatres, the publicity is usually handled in-house. It will usually be necessary to prove that you are a bona fide member of the press, or that you have good reason for wanting to take photographs, before you are allowed entrance. The reason that amateurs are rarely allowed such access is simply that they will most probably be unused to such situations and could be distracting and a nuisance, both to the performers and to the professional photographers who have to earn their livelihood through this type of work. As these events are normally arranged especially for the press, so that maximum coverage will be given to the production within the media, the P.R.O.s will not wish to have anyone causing difficulties for the press photographers.

Access to popular music and rock concerts is either through the promoter or the record company. There is ample scope at most concerts for the amateur to take pictures from the auditorium, albeit that there are often several rows of heads to overcome before seeing the stage. This is one of the few instances which affords an amateur photographer his chance as, with the weird lighting effects and excessive

7 *La Bouree Fantasque* (London Festival Ballet) This picture has caught the action at exactly the right moment – eight ballerinas all in mid-air. Although they were obviously moving at the time, not one of them shows any trace of blur. This could well be used for front-of-house purposes, as it is an exciting picture and certainly would promote the production extremely well. (*Photograph, courtesy of Anthony Crickmay*)

sound, his flash and camera noise is hardly going to be a distraction. However, it must be remembered that flash would rarely be used when extremely close to the stage, such as in the 'photo pit'.

A limited number of passes are available to members of the press for a special press enclosure. Owing to the very strict security procedures, these passes are rarely given out until a few hours prior to the commencement of the show. When there are several performances at the same venue, either the design of the passes or their colour will be changed from day to day to avoid the possibility of forgery, and lessen the chance of their being passed over to someone not qualified for access. Passes are therefore usually collected at the stage door on the night of the perfor-

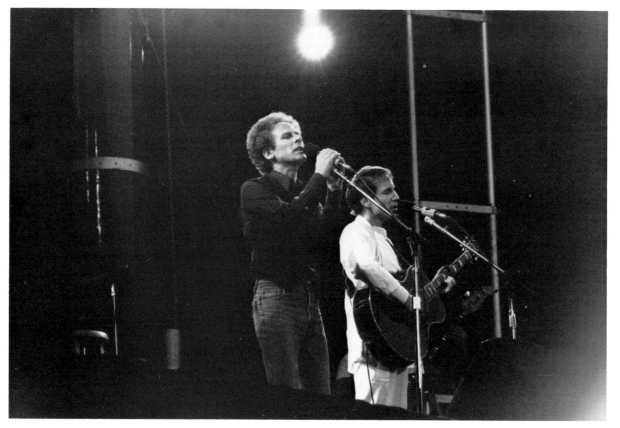

mance and this in itself can lead to problems, as quite often the passes fail to arrive! This can often necessitate a touch of the 'cloak and dagger' approach in order to gain admission, and a good vantage point without the all-important passes and without running into the security men.

On one occasion, two photographers were promised passes, to be collected at the stage door, but these failed to arrive. Tickets were therefore purchased very cheaply after the performance had begun, from a ticket tout. One of these was exchanged for a pass and the two photographers managed to bluff their way to the stage area. By this time the last of the numbers which the press were allowed to photograph was nearly over, but usable pictures were still obtained. Working as a team can help, especially if one of the photographers is female, as security men will often get quite forceful with male photographers whilst rarely getting physically so with a woman. Thus, the man distracts the 'bouncers' whilst the

lady takes as many motor-driven shots as possible before being ejected! These pictures were actually taken from the side of the stage, as opposed to the press area below, and were only possible as a result of the fast, observant actions of the photographers.

Another example of 'devious' access is in the case of a performer who will not allow any photographic press coverage, affording access facilities only to reporters. This was the case at the Frank Sinatra concerts, where photographers were not allowed to take pictures, presumably because 'old blue eyes' is not as young as he used to be and his press agent did not want any unflattering shots of the ageing crooner to appear in the press. A British national daily tabloid wanted some live pictures of the concert, and a photographer called Matthew Taylor was approached as it was felt that he would be able to gain access and provide the photographs that were required. A contact of his managed to come up with a suitable ticket, a seat in the centre and only three rows from

the stage, thus affording a good viewpoint without being so close as to make his presence obvious. At such short notice the ticket was acquired on the black market, at a cost of £150. The minimum of equipment was to be used, as it had to be subtly smuggled in under his jacket, and an Olympus OM1 with motor drive and a 300mm lens was therefore selected; the films used were up-rated (US: 'pushed'; *see* Chapter 3) 400ASA, Recording film and Ektachrome 160.

During the interval between the support artistes and Sinatra himself, while the audience were seated and the lights turned right down, the camera was swiftly removed from its hiding place and brought into action. The noise from the motor drive caused a certain amount of nuisance to the people seated nearby, but this did not give the game away – it was Sinatra himself who spotted the photographer and at the end of the number looked straight at him, saying '. and the press, who have been so good to me on this tour', thus letting his press agent know that there was a photographer in the audience, and where he was seated. As the photographer was leaving at the end of the concert, he was stopped by Sinatra's press agent and eight large 'aides', who insisted that the films should be handed over to them. Despite his protestations about 'freedom of the press', the production of his National Union of Journalists' (UK) press card and other such salient points, it became obvious that he was unlikely to leave the hall without suffering serious damage to his person unless the films were handed over. Accordingly, he produced five rolls of film from his pocket but, unknown to them, most of them were unexposed. The majority of the exposed films were in his other pocket and, as they didn't search him, remained undiscovered. At the end of the day it was only the colour films that had been lost, and the black and white were safely delivered back to Fleet Street where they appeared, not only in one paper, but in several as they were the only 'live' pictures of Sinatra taken on that tour.

There is perhaps a moral to this tale, which is simply that these pictures were very much a 'one off'; two years later

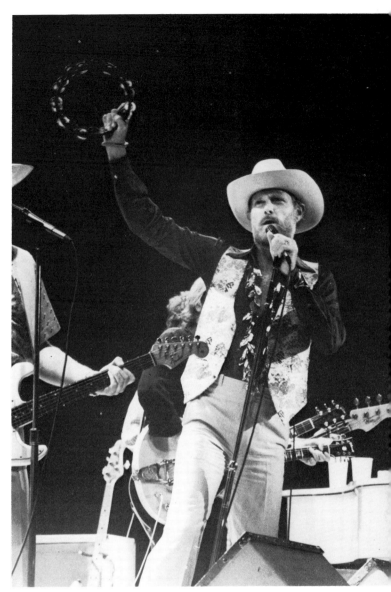

8 ABOVE: The Beach Boys, Wembley, 1979
Their first tour for many years, this picture illustrates the feeling of happiness that they are back on the road again. It always adds to a picture if a sudden, spontaneous action has been captured, as it is not an effect that can be easily manufactured. The shot was taken from the photo-pit. Nikkormat FT2, 200mm lens, HP5 rated at 1600 ASA

9 OPPOSITE: Simon and Garfunkle, Wembley, 1982
A picture typifying the performance of these two well-known artistes. As their stage show is rather reserved in comparison to most rock and pop concerts, and as they do not tend to move about the stage much, the photographers job is made very much easier. This shot was taken from the same level as the stage, thus giving an undistorted viewpoint. Nikon F2, motor drive, 135mm lens, HP5 rated at 1600 ASA

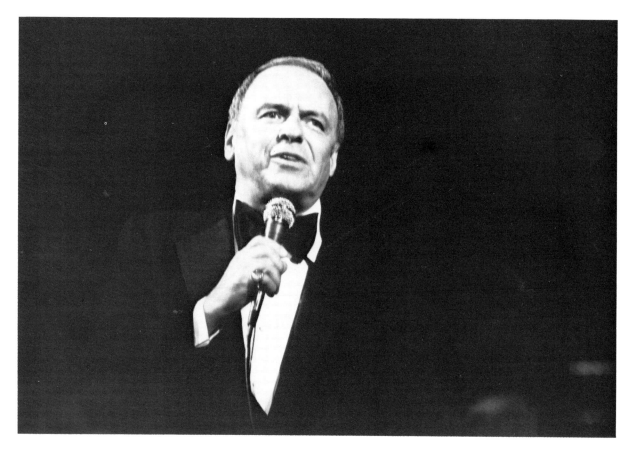

10 Frank Sinatra, Royal Festival Hall, London, 1978
The fact that this series of pictures (see also illustration on the
Frontispiece) were possible at all reflects the dedication of the
photographer who managed to overcome what seemed to be
insurmountable difficulties. The resulting pictures were syndicated
throughout the UK, as they were the only pictures taken on the all-
important first night; the full story behind these shots can be found
in Chapter 1. Olympus OM1, motor drive, 300mm lens, Recording
film rated at 2000 ASA

when Sinatra had another series of con-
certs in London, Matthew was again ap-
proached to take pictures – this time,
however, he was recognised as soon as he
entered the auditorium and, despite
trying several doors to gain access, he was
finally, and forcibly, thrown out of the
stage door and onto the street!

Often, if it has not been possible to get
an official pass, access can be obtained
through the 'who you know, not what you
know' method, and being more than a
passing acquaintance of the venue man-
ager can help. However, when access is
gained in this manner it is 'unofficial' and
the photographer must keep a low profile
and try not to be too obvious; one such
photographer was allowed access to a
concert because he knew the theatre man-
ager and, as the concert had started, he
was told to go down to the press area
which, in this instance, happened to be the
orchestra pit. He jumped over the par-
tition separating this area from the audi-
ence but, as it was dark and he couldn't see
what he was doing, he inadvertently
landed on another photographer's
cameras, smashing one of them in the
process. When the access has been affor-
ded as a personal favour, this is possibly
not one of the best ways of ensuring future
popularity!

So, although the amateur photog-
rapher's opportunities of taking photo-
graphs are rather limited, there is not
much that will stop the professional if
gaining access for photographic purposes
is his intent. It should be remembered,
however, that in the United States any
attempt to gain illegal entry or take illicit
photographs will be severely dealt with.

2 Equipment: Cameras, Lenses and Accessories

The items of equipment needed to take successful pictures within the often difficult lighting conditions of the theatre are usually specialised. Flash is rarely used since it destroys the essence of theatrical photography which is to capture the atmosphere of a performance, together with telling the story pictorially and making a true record of the show. Unless you are close to the subject being photographed flash doesn't light it to any great effect, and only succeeds in blasting out the atmospheric lighting that may have been carefully planned for a production. It can be exceedingly distracting and annoying to the artistes, not to mention the possibility of leaving them with 'hot spots' in their eyes which can take some time to readjust and could be potentially dangerous, especially if something tricky has to be done in the action of the play immediately afterwards. Other photographers can also be distracted by flash and if they were to take a picture at the same time their light readings would be thrown which could well result in a ruined photo for them. The action, drama and excitement can be recorded without flash, even in very subdued lighting, by the use of fast camera lenses, built-in meters and fast or uprated films.

There are many different cameras available, ranging from the very simplest 'instamatic' type to the most sophisticated 35mm and 120mm roll film 'system' cameras. So, how does a photographer choose the right equipment for the job or, indeed, how does an amateur get the best results with often the minimum of equipment? A camera is but a tool to serve a purpose, and most cameras have limi-

11 *Arms and the Man* (Richard Briers), Lyric Theatre, London, 1982
It would be rare to use flash when photographing a photo call. Although the use of flash will allow the photographer a greater freedom of choice for films, there are many drawbacks. The flash will give a harsh light and, unless a reflector is used to 'bounce' the light, there will be unpleasant harsh shadows; it is possible to 'bounce' the light from a suitable ceiling, but the ceilings are so high in most theatres that they would serve no useful purpose. Using direct flash will illuminate the foreground subject area, but will also serve to darken the background detail which, in the theatre, is often an integral part of the picture. These will all tend to make the finished picture give a false impression of the production, by destroying all-important stage effects and lighting. Pentax 6 × 7, standard lens (105mm), Tri-X rated normal (400 ASA) direct flash

tations within their format or design. To make a motoring analogy, an 850cc Mini could hardly be expected to win a Grand Prix race, but a Formula I Ferrari or Brabham would not be the most suitable choice for collecting the children from school or for doing the weekend shopping. What is important is to recognise the advantages and limitations of the various camera types, and to learn how to make the most of each format and exploit its full potential.

CAMERAS

As will be explained fully in later chapters, there are basically three ways in which it is possible to photograph professional performances, and the equipment used is reflected in these situations.

The noise from the shutter, automatic wind-on or motor drive on a camera is not of any particular significance at photo calls and live rock concerts, but can be most distracting for the performers and artistes during dress rehearsals. Therefore, in the first two situations the professional will arm himself with all that modern technology can offer, but at full dress rehearsals it may be necessary to use much quieter cameras, such as the Leica rangefinder. Much of this is dependent upon the whims of the production team, who may or may not allow the use of motor drives. The photographer is expected to be as unobtrusive as possible, though no one will deny that he is a small, but very important, part of the whole production in the making. Whilst every courtesy and help is extended to the production photographer he too must extend the same courtesy to the actors and the director.

With the quality of modern lenses and films, it is rare to find plate cameras used, i.e. 5 × 4in. and 10 × 8in. They are far too bulky and awkward for most theatrical situations and, even for the great enlargement needs of front-of-house pictures displayed outside the theatre, the equipment used is either 35mm or 120mm. Within these formats there are many camera systems available, but the professional will usually opt for those systems that offer a range of lenses that are 'fast', i.e. that have wide apertures, along with reliable centre-weighted metering sy-

stems, and that can take either a motor drive or an automatic wind-on. These, in the 35mm system, will usually be Nikon or Canon, and with the 120mm system, either Hasselblad or Pentax 6 × 7, although the latter does not offer the facility for motor drive attachments. For the purposes of this book we will illustrate Nikon, Hasselblad and Pentax 6 × 7 for professional assignments.

The Instamatic 110 Format Camera

This is often the first camera purchased, and is thus for most people their introduction to the exciting world of photography. It is an excellent camera with which to take 'snapshot' type pictures as it is quick and easy to use, but with any specialist work it is of very little use. One of the main drawbacks is that with few exceptions it is a viewfinder camera and there is no facility for altering the focal length (see Glossary of Technical Terms) of the lens; most of these cameras are fitted with a standard or semi-wide angle lens, and take no interchangeable lenses or accessories. This means that unless you are very close to, or actually on, the stage there will be so much foreground detail that is superfluous to the subject that it will render most pictures next to useless.

Another problem is that the film available only comes in the one speed, which is a medium speed, and is usually only available as colour negative or transparency that must be developed as per the recommended ASA rating. As is explained in the chapter on films and processing techniques, it is impossible to capture the atmosphere of the theatre on such films unless up-rated, or when the use of flash is employed. These films are always daylight-balanced, whereas theatre lighting is 'tungsten', which means that any resulting pictures will show a marked orange hue (see colour plate 5), and within this format it is difficult to make effective a colour correction. It is of the utmost importance to be able to control the speed with which the shutter is fired in order to capture the action happening on stage, and this can rarely be achieved with an instamatic; most have a fixed shutter speed of $\frac{1}{80}$ to $\frac{1}{100}$ second. As the cameras are extremely light in weight, it is very

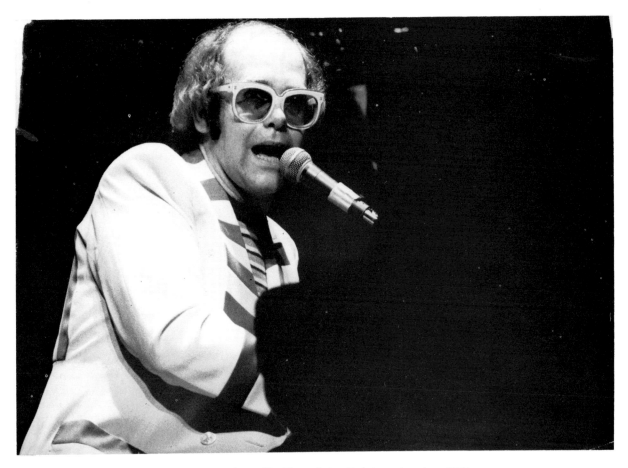

easy to move them when depressing the shutter release, and this can mean getting both 'camera shake' as well as 'subject blur' (*see* Glossary of Technical Terms).

Within the professional theatre, therefore, there is no real place for this format; however, it can still be used to produce reasonably acceptable 'snapshot album' pictures of very small amateur productions. These will necessitate the use of flash to capture successfully any action when using a medium speed film; as flash is daylight balanced, it will be suitable for use with the daylight film used. This usually means that the instamatic photographer is limited to school plays, and local amateur operatic and theatre productions. Even within these fields, the organisers may not want flash being used during performances, which means that the only possibility is to arrange to take shots during a dress rehearsal. When using an instamatic it will be necessary to go as close to the stage as possible unless

12 Elton John, Rainbow, London, 1977
A motor-drive or automatic wind-on unit is all but essential if this sort of expression is to be captured successfully. The fleeting change of mood happens so quickly that it would be sheer luck if this picture had been produced without a motor-drive. By the time the photographer had realised a good shot, it would have been over before he had had time to click the shutter. The motor drive will allow for consecutive pictures to be taken, at up to five frames a second, whilst a wind-on will simply wind the next frame on so that, in both cases the photographer does not have to take his eye away from the viewfinder. Olympus OM1, 300mm lens, Tri-X rated at 1600 ASA

you want the illuminated backs of the heads of the people in front of you. Although the use of flash will lessen the dramatic effect of the natural stage lighting, it should be possible to produce an image of reasonable definition.

It was mentioned earlier that there were exceptions within this system and there are, at the time of going to press, two single lens reflex (SLR) 110 cameras: the Pentax 110 SLR has a range of lenses and filters, whilst the Minolta 110 Zoom SLR features a fixed zoom lens of 25–67mm

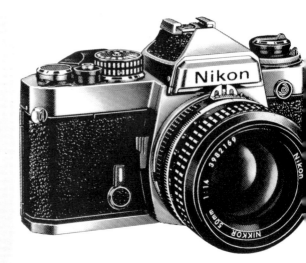

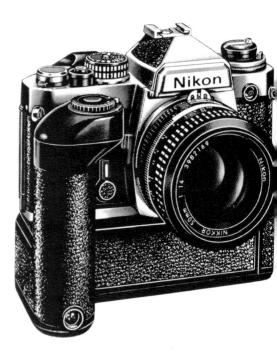

13 The Asahi Pentax 110 SLR camera, illustrated here with a range of accessories including interchangeable lenses and automatic flash gun. This is certainly the most sophisticated camera currently available for the 110 format, but it still has many of the problems inherent with this format and so is not really suitable for theatrical photography (*Photograph, courtesy of Asahi Pentax.*)

14 The Nikon FE is a middle-of-the range 35mm SLR that will accept many of the features that the more sophisticated Nikon cameras offer, such as interchangeable lenses, motor drives etc. The top illustration shows the basic camera and standard lens, whilst the lower one shows it fitted with the motor drive attachment. (*Photograph, courtesy of Nikon UK Ltd.*)

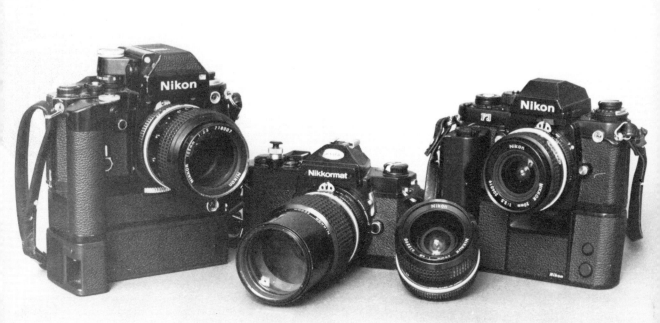

15 Nikon is often selected by professionals as it is one of the most versatile camera systems. Illustrated here are a selection of Nikon cameras some of which can now only be bought second-hand, but still widely used by professional photographers, and are most suitable for theatrical work

(From left to right): **NIKON F2 FTN**, one of the classic cameras and, although superseded by the F3 model three years ago, is still one of the most popular cameras with professionals as it is so very sturdy and reliable. It is shown fitted with a motor drive attachment and 105mm lens. **NIKKORMAT FT2**, the last of the manual Nikkormat range and replaced by the electronic Nikkormat EL. The Nikkormat, with the exception of the EL which had its own special automatic wind on, does not accept a motor drive or similar attachment. The camera body illustrated here shows a 'soft release' fitted to the shutter: this effectively makes the shutter easier and quicker to fire and is most useful with a

camera that does not have a motor-drive. The lens fitted is the 200mm. **NIKON F3**, the top of the market camera from Nikon, which features very sophisticated electronics, making it probably one of the most advanced 35mm cameras currently available. It is illustrated here fitted with the motor-drive attachment which, it should be noted, is considerably smaller than the counterpart for the F2 model. The lens fitted is a 20mm wide angle and in front of it is a 24mm lens.

The Nikon F2 and the Nikkormat are both no longer in production, but can be bought second hand quite easily. These models both have a mechanical metering coupling, whereas the F3 has an electronic coupling. Whilst the newer lenses have both couplings built into them, thus making them interchangeable for any cameras in the Nikon range, the older lenses have only the mechanical coupling and require modification if they are to be used in conjunction with the new camera bodies.

(about equivalent to 50–135mm on a 35mm system). Although certainly more versatile, most of the problems inherent in the 110 format still hold true for these cameras.

The 35mm Format Camera

This is the next film size up, and within this format there is a tremendous range of camera models and systems available. Cameras of 35mm format can be divided into two main categories, the rangefinder and the single lens reflex (SLR), both of which are most useful for taking pictures in the theatre; indeed, this format is probably the one most often selected for professional purposes.

Rangefinder cameras are probably best epitomised by the famous Leica, one of the pioneers of this format and still widely used today. The main advantage of a rangefinder over an SLR is its extremely quiet shutter, which is most useful when working at ballet and opera dress rehearsals. The noise from an SLR is caused by the mirror locking up and down when the shutter is fired. The rangefinder system does not have these mirrors because, as the name implies, the viewing takes place through a separate finder, and not through the lens. Another advantage, especially for press work, is that they are extremely light to carry. A disadvantage is that you are not actually seeing exactly what you are taking as the rangefinder is slightly above and to one side of the taking lens. This is known as 'parallax error' and is usually compensated for within the rangefinder with a marked area showing what you are actually taking. Parallax is rarely a problem unless close-up (i.e. at 8ft or less) photography is used, and thus will be apparent when portraits are being taken. Although the range of accessories for rangefinders is fairly extensive, including an array of different lenses, it is the SLR that offers the greatest range of 'optional extras', and is a true 'system' camera.

In many aspects of professional 35mm SLR photography, Nikon will be the choice. Their reliability and versatility are recognised worldwide and, for the photographer on location abroad, it is not difficult to hire additional lenses for this system in most countries. They probably offer the finest selection of lenses in any system, with several of their lenses being available with the same focal length, but with various maximum apertures. These 'fast' lenses are invariably more expensive than their slower counterparts, but the investment is worthwhile to the photographer whose livelihood depends on this type of work. There are many different bodies to choose from, from the compact Nikon EM to the very sophisticated Nikon F3. There are also many of the older models available, such as the Nikkormat and Nikon F2 which, although no longer in production, can be bought secondhand. All the lenses available are interchangeable with any of the Nikon/Nikkormat range, but the motor drives and wind-ons are specific for each camera body.

A range of through the lens (TTL) light meters are available, some of which give a manual 'match the needle' metering, whilse the F3 has a meter which can be used in several modes, from manual to fully automatic. The newer models give the metering read out by way of light emitting diodes (LEDs) which means that even in low lighting conditions the metering reading can be clearly seen. In older models, such as the F2 Photomic, the meter reading is illuminated only by the light available in the situation, which can cause problems with the low light levels encountered in the auditorium. This can be overcome by the use of a Nikon illuminator, a small device that screws into the eyepiece of the camera and contains a small neon light that shines into the metering read out so that the 'match the needle' can be seen.

Motor drives and wind-ons are available in many forms, from the basic wind-on of the Nikkormat EL to the motor drives of the Nikon F series, which offer both single and continuous modes and can also take a bulk-film chamber, allowing up to 250 exposures to be taken without changing the film.

The two 35mm cameras mentioned, Leica and Nikon, are both very expensive to purchase, but the investment is worthwhile if really first-rate results are required. The cheaper ranges of camera are, obviously, not built to such a high standard, are usually much less robust, offer a

much more limited range of accessories and will generally give a noticeably inferior performance than their more expensive counterparts.

The 120mm Format Camera

This format is used within the theatre, but rarely so for press purposes as it is much heavier and bulkier to use than 35mm. The film comes in either 120 (giving eight, ten or twelve exposures per roll depending on the camera format used) or 220 (giving double the amount). This is in itself a drawback for high-speed press photography, as it gives fewer exposures per roll than the longest length of 35mm usually used (36 exposures). Some 120 SLR format cameras, such as Hasselblad, have interchangeable film backs or 'magazines'; it would be usual to have several of these, each preloaded with film and ready for use. With other types, such as the Pentax 6 × 7cm, this is not possible (in fact the Pentax 6 × 7cm is very much like a larger form of its 35mm counterpart) and

16 *Don Giovanni*, (Welsh National Opera), Mold, Wales, 1982

The larger format will give a much better definition, especially if the resulting shot is to be enlarged to a great degree, such as for front-of-house purposes. This picture, although shot on up-rated film in very low lighting levels, shows a very acceptable quality and definition as it was enlarged from the whole negative area. The 6 × 6cm and 6 × 7cm camera are considerably heavier than the 35mm systems, but the difference in quality of the resulting prints can be quite remarkable. Pentax 6 × 7, 105mm standard lens, HP5 rated at 1600 ASA

if much film is to be expended necessitates the use of two or more pre-loaded camera bodies. Many of these cameras will, as with 35mm, accept a motor drive. The Hasselblad is typical of this but again, for some types of performance it is of great

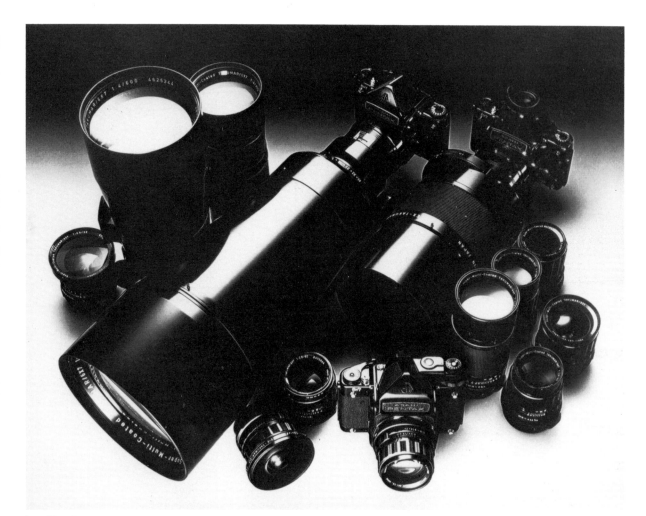

17 The Pentax 6 × 7 system, showing some of the range of lenses and accessories that are available for this camera. The camera body at the back left is fitted with the standard viewfinder, the back right with the waist level finder, and the body in the foreground with the TTL metering system. Although these cameras have one big disadvantage in that they cannot be fitted with a motor-drive attachment, they are still extremely useful within the theatre as they produce the 'ideal format' image that gives a substantially larger working area on the negative than in the 6 × 6cm format. They are also very easy to use as their design is basically that of an overgrown 35mm camera.

importance to avoid a lot of noise being generated, and it must be realised that leaf shutters can be loud anyway, and coupled with a motor drive will often have a very audible 'ker-klunk-whurr-chunk'!

The main advantage of the Pentax 6 × 7cm is its so-called 'ideal format'. Most 120 cameras take a 6 × 6cm ($2\frac{1}{4} \times 2\frac{1}{4}$in.) square image and, as a square

picture is rarely used, means that the resulting pictures will have to be cropped. However, because of the greatly increased quality of the larger negatives produced from these cameras, their main use is for front-of-house photography. The front-of-house pictures are sometimes enlarged to such a great degree of magnification that when 35mm is used the grain will be unacceptably apparent, but with this larger format, although the grain will be noticeable, the final result will be of a much more acceptable quality.

The twin lens reflex (TLR) camera was, and still is, popular with the press. It is not, however, suitable for the theatre. Many of these cameras have a fixed lens, which gives little adaptability for theatrical photography. They also have, as with the rangefinder cameras, the inherent problem of parallax error as the taking lens is

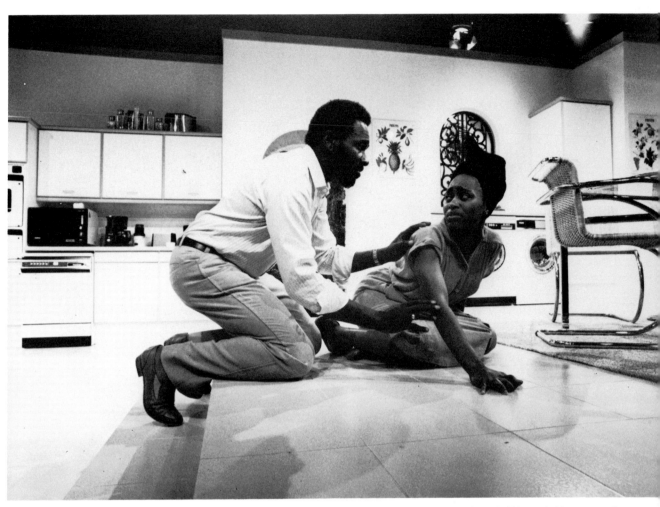

set below the viewing lens. There is usually a device that indicates where the 'cut-off' will occur, and this is seen in the viewfinder. All the twin-lens cameras offer a square format and, as previously explained, this can also be a drawback.

Special Purpose Cameras

There are many special purpose cameras available, but most of these are rarely used in the theatre. The following three examples, however, are occasionally employed for a specific purpose and are worth mentioning here.

The first of these is the Hasselblad 'Super-Wide', which is a fixed-lens camera version of the usual Hasselblad. The lens is an extremely wide angle, but one that has been optically corrected to give none of the distortion that is usually associated with wide angle lenses. It is

18 *Meetings*, (Rudolph Walker and Angela Wynter), Hampstead Theatre, London, 1982
The distortion apparent with wide angle lenses can be overcome by the use of a fixed-lens, wide angle camera such as the Hasselblad Super-wide. This picture, from a smaller 'fringe-theatre' production, required that as much of the set should be included in the shot as possible, whilst still showing the characters obviously in the foreground. By shooting on a conventional wide angle lens, the picture has been given an unnatural viewpoint, and the far walls of the kitchen appear to be 'falling away'. The use of a perspective-corrected lens would have counteracted this effect, whilst still giving a similar angle of view. Nikon F2, 24mm lens, HP5 rated at 1200 ASA

frequently used as an alternative to the plate-camera system, where distortion can be corrected by the movements of the front and back plates. Although most often used in the realms of architectural or interior photography, it could be useful when taking overall pictures of the entire stage.

The Polaroid, or instant picture

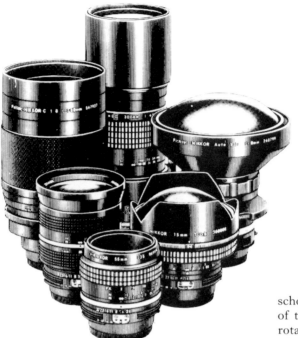

19 A selection of lenses from the Nikkor range, specially made to suit the Nikon camera system. The extreme focal length lenses would be of little use in the theatre, except for distorted special effect, such lenses as the 500mm Catadioptric (*far left*) could serve a purpose when taking pictures from far back in an auditorium, but would not be generally useful; the extreme wideangle 'fish-eye' lenses (*centre and centre-left*) would only produce a most distorted image and so also would not be generally used; and the 55mm Macro (*front left*), although it could be used as an alternative to the 50mm standard lens, is really designed for extreme close-up work. The other lenses illustrated are far more typical of those more suited to this type of work.

camera, has an occasional use, mostly for the production photographer shooting the pictures for front-of-house requirements. A Polaroid, either used as a separate camera or as a 'Polaroid back' fitted on to existing equipment, can give an instant photographic assessment of composition, lighting and exposure before the final pictures are taken.

The other specialist camera which may be of use is the 'panorama' camera best known to most people from the official school picture. There are two main types of these cameras, one in which the lens rotates across the camera and the other, where the camera rotates as the film advances. They could provide a distortion-free image when, for example, a need exists for a picture of an entire cast lined up on stage.

However, any camera or system is only as good as the optical quality of the lenses that are used in conjunction with it, and the choice of lenses is extremely varied.

LENSES

With the exception of most 110 instamatic cameras and some 35mm cameras, most modern cameras have a wide selection of lenses to fit them.

Lenses are composed of a series of glass elements which are either convex or concave. Depending on their arrangement, these will give a variety of focal lengths. If a lens is not capable of producing a good image then it is worthless. All lenses will have a certain amount of faults, which are technically termed 'aberrations', and it is usually fair to say that the more expensive a lens, the fewer the aberrations and therefore the better the quality.

Many of the camera manufacturers also produce lenses and in the more expensive bracket of camera, such as Nikon and Pentax, it is much better to purchase their own lenses as they are specially made to

best suit their camera systems. In the case of the 6 × 6cm format Hasselblad and the 35mm Contax systems, although the lenses are specially designed to suit the cameras, they are not manufactured by the camera makers, but by the well-respected company of Zeiss, who are renowned throughout the world for the excellence of their optics. Many independent companies make lenses, especially zoom lenses, but these are often best left for use with the middle to lower price range of cameras.

Lenses are available in various focal lengths from extreme wide angles to very long telephotos that need so many elements within that they are almost like telescopes! To make them shorter and lighter, many now use a series of mirrors to increase the magnification – these are commonly called 'mirror' lenses but are technically known as 'Catadioptric'.

The 'standard' lens for any format is that lens which gives an angle of view that is most like the normal viewpoint: 50mm for 35mm camera; and 80mm for 120mm. Lenses are considered 'wide angle' if the amount of millimeters is less than the 'standard', and 'telephoto' if it is greater. Except for special effects, the extreme focal length lenses are rarely used in the theatre, the most usual ones used being medium wide angle, standard lenses and short to medium length telephotos.

A chart describing the various lens equivalents for both 35mm and 120mm format can be found, in Appendix II.

There are also lenses that do not have a fixed focal length, but that are capable of being changed throughout a range of focal lengths. Such lenses are known as 'zooms' and, when they were first introduced, were often considered to be (although convenient) of optically inferior quality to their fixed length counterparts. This may be true today of those zoom lenses in the lower price bracket, but many of the more expensive ones have undeniably excellent optics. They can be most useful for general purpose photography but their main drawback within theatrical photography is that they are what is termed 'slow' lenses.

The amount of light that travels through the lens is controlled by an iris diaphragm, which is similar to the iris in the human eye. The diaphragm is capable of opening and closing, and the degree to which this occurs is measured in terms of an f stop. The greater the f stop number, the less the amount of light that is allowed through the lens, and only the slower shutter speeds can be used; as the f stop number decreases, so the more light is allowed to pass and a faster shutter speed can be used: hence the terminology 'fast' and 'slow' lenses.

Using a lens at its maximum aperture is termed as being 'wide open'. When the f stop is increased, and the diaphragm becomes smaller, this is known as 'stopping-down'. The depth of field, which is the amount of depth of image that will be in focus, is dependent upon the aperture. The maximum depth of field will be obtained by stopping-down as much as possible to, say, f22. When shooting at a maximum aperture of, for example, f1.4 on some of the faster lenses, the depth of field will give only a few inches that will be sharp. The choice of f stop, and thus the amount of depth of field desired, is dependent upon the amount of light available, and the shutter speed needed. It is usually possible to shoot at $\frac{1}{125}$ at about f5.6 at most photo calls, when 400 ASA film has been 'pushed' a stop to 800 ASA (see Chapter 3). Unless the lighting is very low, it is better to try to keep from using a totally opened-up lens, unless there is just one figure that has to be focused upon. Where there are two figures, and one is slightly behind the other, if such a wide aperture is selected only one of those figures will be in focus, and this can destroy the finished picture, if unintentional. Details of exposure are more fully explained in Chapter 3.

ACCESSORIES

Of the many accessories available for cameras some are essential and others are only required for a specific function, or to achieve a special effect.

Lens Hoods

These are an absolute must, as they cut down on any 'flare' from the stage lights. The different focal lengths require different hoods, for example if a telephoto

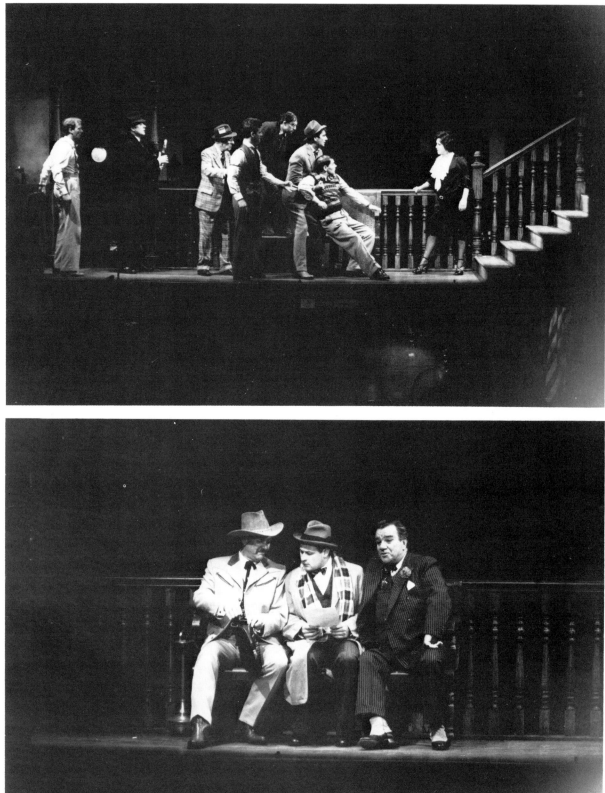

c

20a, b and **c** *Windy City*, Victoria Palace, London, 1982

These three pictures, all from the same production, show the effect of different lenses, in different situations. All three capture the atmosphere of the production and might be used for front-of-house purposes.

a This depicts the action taking place on the top level of a two-level stage set, and was taken from the centre of the dress circle, so that the photographer would be on the same level as the action taking place. The scene uses most of the width of the stage, and this has been captured by using a 200mm lens.

b This was taken from the same place, but with a longer lens, a 300mm. This changes the angle of view, restricting it to the central area around the bench. Both these pictures illustrate the difficult lighting situations encountered in the theatre. The clarity of the shots is quite surprising considering the distance from the subject from which they were taken, but the lenses chosen were of excellent optical quality.

c This shows a grouping similar to that depicted in picture **b**, but it was taken from the front of the stalls area, as this piece of action took place on the lower level of the stage set. At this point, the photographer was approximately 50ft closer to the stage than in picture **b**, and so selected a shorter telephoto lens, a 105mm. Although none of the billed stars appear in the picture, so it would be unlikely to be used for press circulation, it is most indicative of the production, showing a typical scene, and leaves the viewer in no doubt that he is going to see a musical, as the actors are most obviously singing. The three photographs were taken with a Nikon F2, motor drive, 105mm, 200mm and 300mm lenses respectively, and HP5 rated at 1600 ASA

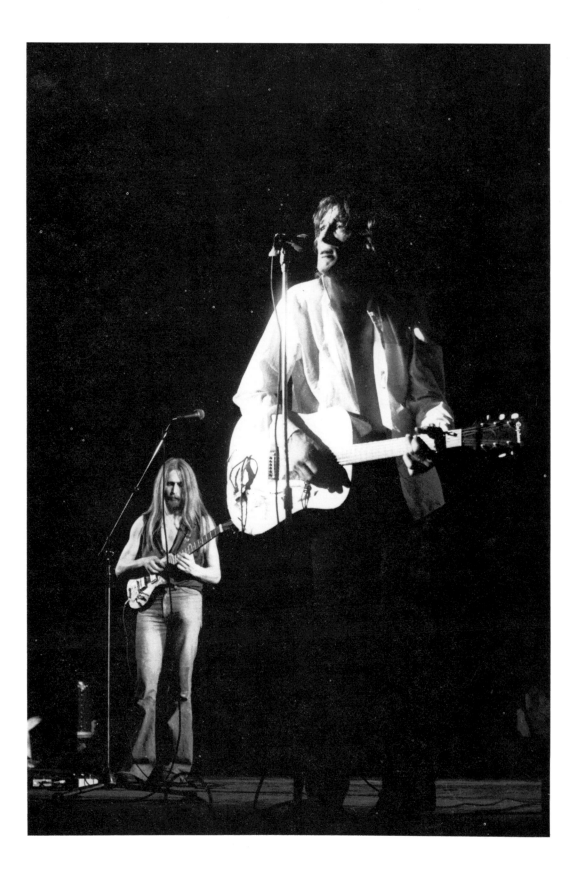

hood were fitted onto a wide angle lens, it would be visible and give 'cut-off' on the picture. Some lenses, mainly the telephotos, have built-in hoods that only have to be pulled out from the lens to become operational.

Tele-Converters

These are tubes, often sold in threes, that will increase the magnification of a lens. The increase in magnification will depend upon how many of the tubes are used at any one time in conjunction with each other. They are quite inexpensive to purchase, but will cause a considerable amount of degradation, loss of depth of field and speed. Therefore, they are not to be recommended for theatrical work.

Tripods

For the serious theatre photographer this is most important, especially if he is involved in front-of-house photography. A sturdy tripod, used in conjunction with a cable release, will stop camera shake, thus allowing pictures to be taken at a slower speed and, often, with a smaller aperture, thus giving a greater depth of field. There are hundreds of different models available, two of the most popular being the Husky and the Gitzo. When choosing a tripod, the most important points to look for are sturdiness and ease of use. A 'pan and tilt' head allows a greater amount of freedom when making final, detailed adjustments to the alignment, and so should be seriously considered when purchasing a tripod.

Exposure Meters

Even with the advanced metering systems available within the TTL cameras, it is always useful to have a reliable separate

21 John Otway and Wild Willy Barrett, Hammersmith Odeon, London, 1977
This picture shows great depth-of-field, unusual in this type of photography. However, by using a wide angle lens and a slower shutter speed, thus allowing for a smaller aperture to be selected, this picture was made possible. The photographer was actually on stage to take this shot, and so was able to be very close to the subject. Olympus OM1, 28mm lens, 1/60th at f11, Tri-X rated at 1600 ASA

meter. Exposure meters basically come in three forms, Selenium, CDS and Spot meters. The first two have been well known for many years and are best represented by the Weston Master (Selenium) and the Gossen Lunasix (CDS). The former, although now discontinued, has been the favourite meter of professional photographers for many years. The Selenium cell is capable of giving accurate readings in very low lighting levels and is thus so very useful in the theatre. The CDS meter is extremely accurate and can give detailed readings of shadow and highlight areas. A more recent development is the Spot meter and this, although more expensive, is probably the most useful meter for the theatre. These meters have a viewfinder so that the photographer can see exactly what the exposure is for any particular close-up area. The angle of the reading is very narrow, and is thus of greater sensitivity than the other types of meter.

Camera Cases

As it is usual to take at least a couple of camera bodies and several lenses along on any assignment, not to mention the films, lens hoods, meters and other accessories, it will be useful, if not essential, to have something in which to carry them. Camera cases come in two basic forms, soft or rigid. Soft cases are light, easy to carry, and cheap to purchase. Rigid cases are heavier, more expensive but have the one overriding advantage that they are built to be strong enough to stand on. This can mean adding anything up to a couple of feet onto the photographer's height which can be useful when the field of vision is blocked (often by other photographers). Rigid cases are also the best means of transporting cameras over long distances, as they are fitted with firm foam inlays which are specially cut out to fit each item of equipment, thus affording the very best protection.

The final selection of equipment, whether for the keen amateur or working professional, will inevitably be decided by need, usage and price. For a suggestion of order of importance of equipment acquisition, look to page 156 in Appendix II.

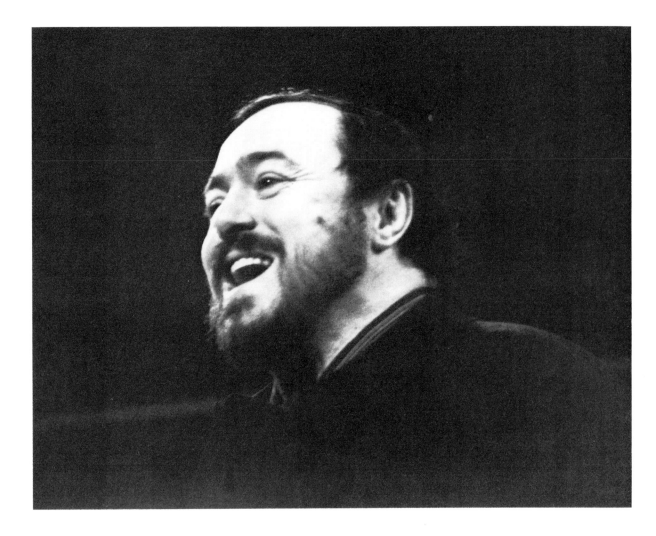

22a, 22b It is very often the quality of the equipment (usually dictated by the budget available!) that will let the amateur down and make his pictures obviously unprofessional, as these two pictures illustrate. Although picture **a** has caught Pavarotti in a pleasing attitude, the print shows a great lack of definition, making it appear almost foggy and blurred. The picture **b** is much brighter and clearer, showing excellent definition and tonality. Picture **a** was taken on a Praktica fitted with a 135mm lens and × 2 tele-converter, whilst picture **b** was taken with a Nikon and 200mm lens. The definition and tonality was so degraded on picture **a** that it had to be printed on a grade 5 paper, whilst picture **b** was printed on grade 2.

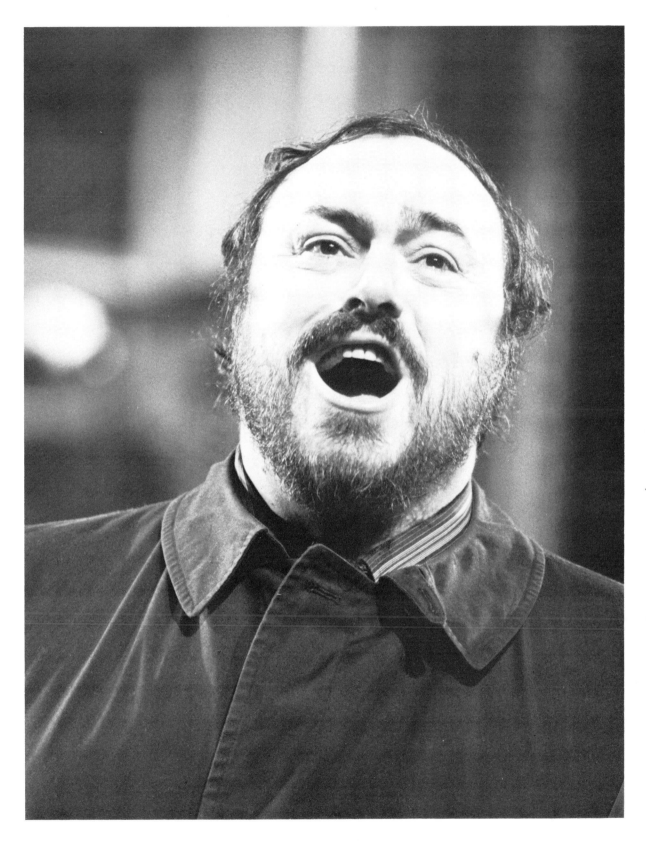

3 Films:
Development, Printing and Retouching

FILMS AND DEVELOPMENT

The nature of theatrical photography and the variable lighting situations that are encountered make the selection of the most suitable films of the utmost importance. Within these different kinds of film stock – black and white negative, colour negative and colour transparency – there will be a variety of film speeds from which to choose.

The speed of a film is governed by how fast it will react to light, and is measured in two standards, the American ASA and the German DIN. Every packet of film will show both the ASA and DIN ratings, and it is the ASA standard that is usually referred to in the UK. The lower the ASA or DIN number, the longer the film will take to react to light and thus register an image; as the ASA or DIN number increases, so does the film's ability to react to light; this is where we get the terms 'slow' and 'fast' in relation to film speed. The usual selection of film speeds available are from the slow, 25 ASA/14 DIN, through medium speed, 100–125 ASA/21–22 DIN, to those that are termed fast, 400 ASA/27 DIN; these are all available as black and white or colour, and can be obtained for all camera formats except the 110 instamatic, for which there is only one speed.

The slower and medium speed films will give excellent quality, with very fine, non-apparent grain, and a wide range of tones. However, these films have little use in the theatre, as they are too slow to record the often very low lighting levels encountered. The only way that they could be used is with flash, and flash is rarely used as it destroys the dramatic impact of the theatrical atmosphere.

Fast films are most often used, but even rated at the suggested 400 ASA they may not be able to record the image sufficiently quickly; if a slower camera shutter speed is selected to compensate for this, the image will show subject blur as the shutter speed is not fast enough to freeze the action. Therefore it will be found that in most theatrical situations it will be necessary to 'push' or 'up-rate' the films, and the faster materials are quite tolerant of this process. This technique can be used on most fast black and white negative and colour transparency materials, but is rarely effective on colour negatives as the image will tend to reticulate (*see* Glossary of Technical Terms) when given a long development time.

Pushing, or up-rating, films is basically a way of under-exposing the negative and compensating for this in the processing by allowing a longer development time and/or an increase in the temperature of the chemicals. This will invariably lead to a marked increase in the 'grain', and also in the image contrast as up-rated films will lack the fine range of tonal values that would be apparent in the slower films. It is important to remember that it is not normally possible to up-rate process-paid colour films and for this reason colour transparency stock that is developed using the E-6 process is most commonly used. If the processing of either black and white or colour is not undertaken by the photographer himself, but is sent to a professional laboratory, all films must be clearly labelled that they have been rated at an ASA speed other than that recommended by the manufacturer.

It can be useful to 'clip-test' up-rated

film to ensure that they have been exposed correctly. This is simply removing a short length of exposed film from the cassette or roll and using this as a 'control', and developing it for the assumed exposure value. It can be viewed when the processing is complete and, if it is found to be either under- or over-exposed, the rest of the film can be saved by increasing or decreasing the development time for the remainder of the film. Clip-testing, unless the exposure is correct, often necessitates the loss of several frames but, unless absolutely certain of the exposure values, it is a worthwhile precaution.

If it is discovered that some terrible fault has befallen a black and white film during exposure, it can be possible to salvage the film by a technique known as 'inspection development'. This is done by using a very low wattage bulb in the safelight, and using a special dark green safelight filter. The film is very quickly viewed, at least 12in. away from the safelight, and returned to the developer before any fogging results. It will take quite a lot of experience in this type of viewing before the results are perfect and, if this experience has not been gained, it is best left to a professional laboratory. This type of developing should not be used as a matter of course, but only as a matter of necessity and as a last resort.

When up-rating films it is advisable, for the best results, to push only one or one and a half stops, i.e. exposing 400 ASA film to 800 ASA (one stop) or 1200 ASA (one and a half stops). It is possible to push the film further than this but the deterioration of image quality will be most noticeable, especially in the size of the grain. What must not be forgotten, however, is that if the photographs are required to be blown up to enormous sizes for front-of-house, or other purposes, e.g. 5 × 8ft, then the grain will appear pea-sized anyway.

The choice of film materials, although to a certain extent the personal preference of the photographer, is governed by the ultimate purpose for which the pictures are to be employed. As most theatrical pictures are used for reproduction, colour negative materials serve little purpose as black and white prints or colour transparencies would be required. Black and

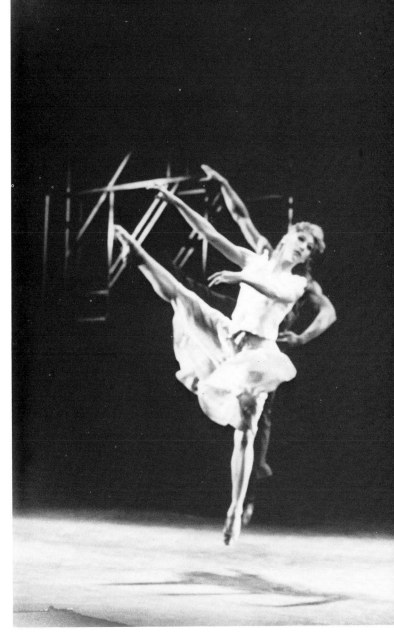

23 An excellent example of how not to take a picture of the ballet! From the point of view of composition, the girl appears to have four arms as she had completely obscured the main torso of the male dancer behind her. Photographically, although attempting to catch a moment where both dancers are in mid-air, the effect is blurred and out-of-focus because too slow a shutter speed was selected. This sort of picture would serve no purpose within the theatre, but well illustrates the sort of problems that the photographer will come up against in this sort of situation. Nikon F2, 105mm lens, 1/60th second, HP5 rated at 800 ASA

24 ABOVE: *Windy City* (Dennis Waterman and 'reporters'), Victoria Palace, London, 1982
This picture shows very good composition, and is a typical shot for front-of-house illustration as it is very indicative of the show as a whole, and features the main star of the production. However, the picture was taken on Recording film rated at 2000 ASA so, although the pose is excellent, it would never stand up to the great amount of enlargement that would be needed for a display photograph. It is interesting to note the loss of tonality, which is very typical of this type of film when up-rated, and also that the grain is so apparent as to give the impression that Dennis Waterman has a rash on the side of his face! Nikon F2, 105mm lens, Recording film rated at 2000 ASA

25 OPPOSITE: Dolly Parton, London
This shot shows the successful use of Recording film. The image of the one artiste almost fills the fame and thus, unlike the previous picture which was a group shot, stands up to quite a degree of enlargement. Even though the grain is obvious, there is still a good definition and fair range of tones. Recording film can be very useful when working in low lighting conditions, but its use should be restricted to head-and-shoulders poses, as it will not successfully capture the range of tones found in larger groups or entire sets. Olympus, 300mm lens, Recording film rated at 2000 ASA

white is probably the most used medium for theatrical photography, as the majority of the resulting pictures are destined for the press, and newspapers rarely reproduce in colour. However, it is now becoming the usual practice to use colour pictures for front-of-house purposes. Not so long ago, it was considered a luxury to use colour pictures because of the expense, but in the last few years it has become more popular as prices have levelled off. Big shows have nearly always had colour photographs because if the show is expensive in the first place then it is worthwhile advertising it expensively as well. Also, there is often a requirement for a souvenir brochure, which is usually a selection of colour pictures combined with some black and white photographs illustrating the show. So, very often, the photographer employed by the company as the 'show photographer' will be asked to shoot in both mediums.

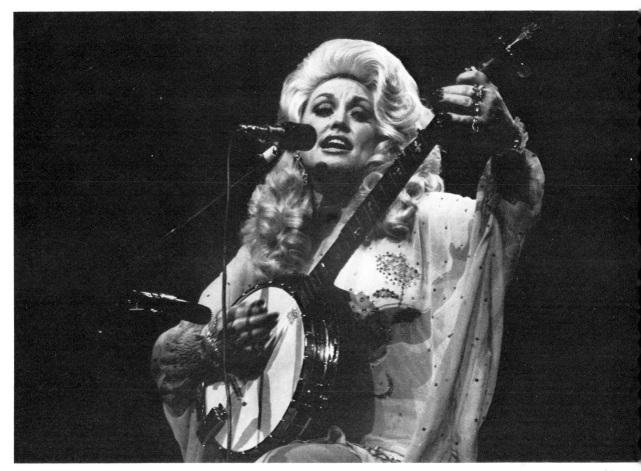

Black and White

There is a tremendous range of black and white films available, from 400 ASA upwards, that are suitable for theatrical work and that will most happily accept pushing or up-rating. Those most commonly used are Kodak Tri-x Pan and Ilford HP5, both of which are easily available from photographic stores and professional suppliers. They are very adaptable films and (although this is not recommended unless absolutely necessary) could be pushed by as much as two stops, thus giving a working film speed of 1600 ASA. A relatively new addition to the 400 ASA film is Ilford XP1, which is an almost grainless film that can be rated as 1600 ASA without tremendous apparent deterioration. Both Tri-x Pan and HP5 are developed in standard chemicals, but XP1 has its own special process. As it has a completely different make-up to normal black and white materials, and bears more resemblance to

'monochrome' colour negative film, if its own special chemicals are not to hand, it is often developed by the normal C-41 process used to develop colour negatives.

There are two special purpose, ultra-fast films that are available (but usually only by special order through a specialist photographic supplier) – both of these are manufactured by Kodak; they are Royal-x Pan which has a recommended rating of 1250 ASA, and 2475 Recording film which is 1000 ASA. For really low lighting situations, these films can save the day as, for example, Recording film could be pushed one and a half stops, giving a working speed of approximately 3000 ASA. The chemicals suitable for the development of these films (HC-110 and DK-50) are available from most professional photographic dealers and can also be used for up-rated 400 ASA films; HP5 and Tri-x Pan can also to developed in the more commonly available D-76 or 'Microdol-x'.

Colour

When using colour materials within the theatre it is important to remember that the lighting in the theatre is tungsten, and to balance any colour film materials used accordingly. Daylight films can be used but they will necessitate the use of a colour correction filter, such as the Kodak Wratten 80B, which will compensate for the tungsten lights. When shooting on colour negative it is possible to make the colour correction at the time of printing. Filters are most usually gelatine sheets which are fitted into a filter holder attached to the end of the lens. The effect of using daylight-balanced film in tungsten lighting situations is that the overall hues will be orange in tone; the opposite occurs when using tungsten-balanced film in daylight conditions, as the general hues will be blue. A colour correction filter of the *opposite* colour is required, so, to balance daylight for tungsten, a blue filter such as the 80B must be used, whilst to convert tungsten to daylight an orange filter, such as the 85, will serve the purpose. The use of a colour correcting filter will cut down on the light reaching the film emulsion by as much as half to one stop so, if a hand-held meter reading is taken, this must be considered when adjusting the final exposure. On a camera fitted with a good TTL metering system this will automatically be compensated for.

Colour materials are extremely sensitive to changes of temperature, and must always be carefully stored. It is usually best to keep all unexposed materials in the refrigerator, removing them a couple of hours before they are to be used to allow them to warm up to room temperature, and they should be processed as soon as possible after exposure. Colour film also has a limited shelf life, and the 'use before' dates printed on the wrapping should be strictly adhered to. When colour materials are incorrectly stored and/or are old stock, the colour balance will be affected, usually giving a green or blue bias overall; if it is realised that there is a fault with the film, it may be possible to salvage it by shooting through a colour filter which will correct the colour balance. There was an occasion when a well-known photographer, who

had been employed by theatre management to take the show photographs in both colour and black and white, had to go to Scotland to photograph the dress rehearsals; late on the previous day he discovered that the colour film stock he was intending to use was out-of-date. He immediately did a colour test and, sure enough, his worst fears were confirmed – the white background to his subject was a delicate shade of green; worse still, at that late stage there was no film available to be purchased. The transparencies were accordingly rushed to a photographic shop and a suitable compensating filter was found; danger was averted and the colour shots were very successful.

There is a more limited range of colour transparency films available suitable for theatrical work than there is for monochrome, mainly because they must be tungsten balanced and this does not, obviously, affect monochrome films. Colour negative materials are rarely used, as colour transparency materials are much more tolerant of 'pushing'. Even for front-of-house needs, the choice of film will still be transparency. The giant enlargements required can be produced either by direct positive printing, such as Kodak's R14 or Ilford's Cibachrome, or by the production of an internegative from which a positive print is made.

The most usual tungsten balanced film used within the theatre is Kodak's Ektachrome 160 Tungsten, which is available for most formats. It is widely available from professional photographic dealers, but may have to be ordered from smaller shops. A new film, only available at time of going to press in 35mm format, is a faster tungsten film which has a recommended rating of 640 ASA, and is manufactured by 3M. As with the faster monochrome films, these colour transparency films can also be pushed by as much as two stops, although the definition will suffer if pushed to extreme. Ordinary daylight-balanced ektachrome could be used at rock concerts without a colour correction filter as the lighting employed in this medium has so many colour effects that the resulting orange hue will not be so noticeable; however, it is still better to use tungsten-balanced film if possible as the

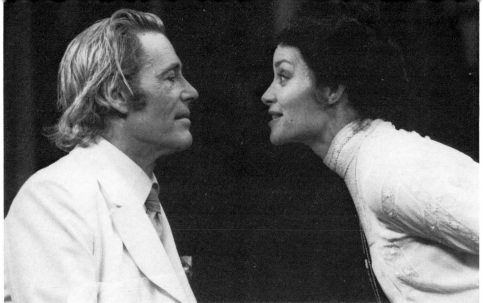

a

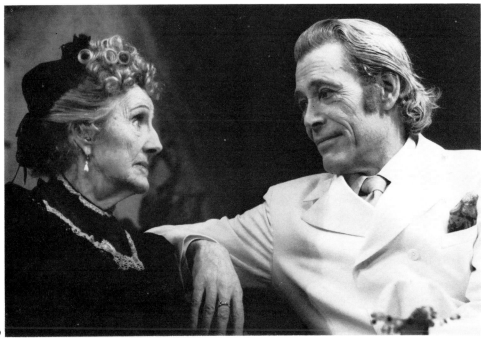

b

26a and **b** *Man and Superman* (**a** Peter O'Toole and Lisa Harrow, and **b** Joyce Carey and Peter O'Toole), Theatre Royal, Haymarket, London, 1982

a This is a good close up shot of two of the star artistes, but there are several photographically incorrect technicalities that are most obvious. The actress's hair had been unavoidably lost in the dark background, and a 'drying mark' is apparent in the bottom left hand corner: as this mark covers such a large area it would be most difficult to retouch to any satisfaction. As a result, although essentially a good composition, this shot would have to be scrapped as the alternative way to remove this mark (i.e. cropping), would spoil the picture.

b This picture is a lot sharper, and again shows a good composition of the two artistes. There was also a drying mark visible on this picture in the bottom left hand corner but, as it was against a black background, it was successfully removed by printing-in whilst exposing the negative in the darkroom printing stage. Both photographs were taken with a Nikon F2, motor drive, 80–200mm zoom lens, and HP5 rated at 1200 ASA

colour will be much more of a true record of the show.

All the colour film materials mentioned are processed with E-6 chemicals, which is the standard process for colour transparency stock.

Although both monochrome and colour transparency materials can be processed at home, it is often best left to a professional laboratory. Unless a very strict quality control is enforced, it is very easy to damage the negatives. With colour materials it is most important to keep the chemicals within plus or minus one degree of the recommended temperature, or the colour balance could be affected. There are many excellent publications that deal with darkroom techniques, and these are listed in the Bibliography.

PRINTING

Ideally, the negative should be perfect for printing, both in composition and exposure, but with theatrical photography this is not always so. Most faults can be corrected in the printing stage by various techniques. However, care must be taken to remove any dust or hairs, etc. from the negatives; special brushes are made to do this job, as re-touching can be difficult otherwise.

When photographing dress rehearsals and/or live performances, there are no lights in the auditorium (other than those illuminating the stage) and, because of the often low light levels, it is not always possible to see exactly what or who you are getting in the frame other than the main, illuminated, subject! It is quite common to find a silhouette of members of the orchestra or parts of their instruments on the negative area; when this happens it is often possible selectively to crop the image during printing, and thus print only those parts of the image that are required, removing any distracting background or foreground detail. But it is obviously better to print the whole negative area if possible, as the quality of the finished print will be so much better. As it is almost impossible to cover photographic assignments within the theatre without up-rating the film (this, as previously explained, leads to considerably increased contrasts and larger, more apparent

grain) the printing stage is not always an easy task. By enlarging only a small area of the negative even less of the more delicate tones will be visible and the grain will be even larger, giving an almost 'reticulated' look (*see* Glossary of Technical Terms). The smaller the original negative size, the more this will become apparent, especially with the 35mm format. Given the right subject, this effect can be quite dramatic.

The problems with printing up-rated films are also manifested in the high and low contrast areas of the negative. To improve definition of the low contrast areas it would be easier to compensate during the exposure of the film, by using built-in flash, but as the latter is rarely allowed in the theatre this now has to be rectified in printing. High contrast areas have the opposite effect and can often necessitate stopping down at least half to one stop, but this would render the low contrast areas totally unprintable. The only way this can be rectified is by 'holding back' ('dodging') certain negative areas and 'printing-in' ('burning') others. Both of these techniques are carried out during the printing stage.

Light areas on the negative, that would appear too dark on the print, are deliberately held back while the paper is exposed – this is done either by using a suitably shaped piece of card or with part of the hand; the card or hand is held directly in the path of the light from the enlarger to the paper, so that the area which needs holding back receives less light than the rest of the image area; conversely, dark areas on the negative which would give a 'burned out' effect on

27 Gary Numan, Hammersmith Odeon, London, 1980
This is a typical example of what occurs when a fragment of a 35mm negative that has been shot on up-rated film is selectively enlarged! It shows very little by the way of tonal gradation, and appears very grainy. However, this has made a very effective picture most indicative of the artiste in question, as he tends to wear white make-up on stage and so the lack of detail in the skin tones is inconsequential. All in all, this has made a most graphic photograph that well illustrates the performance. Nikkormat FT2, 105mm lens, HP5 rated at 1600 ASA

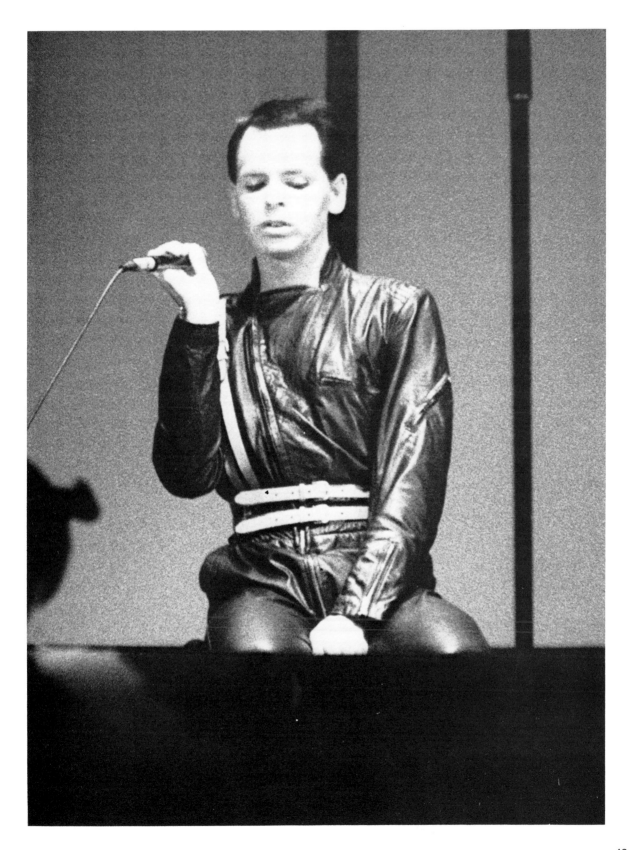

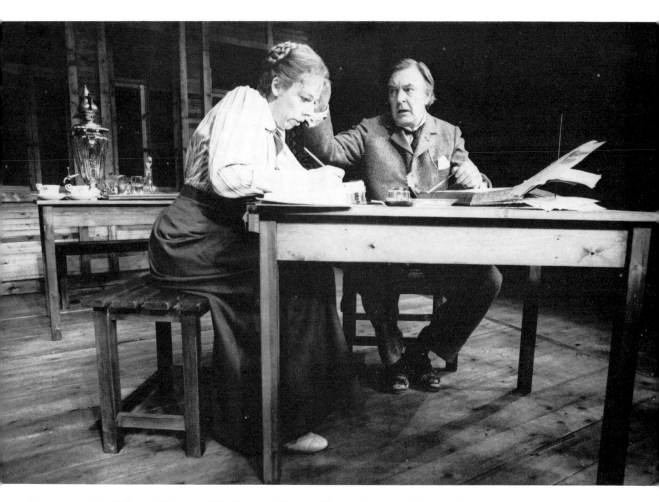

28 ABOVE: *Uncle Vanya* (Frances de la Tour and Donald Sinden), London, 1982

This shows rather well the bleakness and stark reality that is so typical of Chekov's plays, and the low viewpoint that the photographer has taken has added to the dimension of the picture. A great deal of printing-in at the darkroom stage was needed to produce a print showing definition in the actress's sleeve as a straight print showed this area to be blown out. Nikon F2, motor drive, 24mm lens, HP5 rated at 1200 ASA

29 OPPOSITE: *Cosi Fan Tutte*, (Opera North), Leeds, 1982
Costumes are rarely designed for the benefit of the photographers, so having both dark and light clothes in the same scene can play havoc with the exposure! Although an exposure was taken to be mid-way between the light and dark costumes in the foreground, giving reasonable definition of both, the dark character in the background was almost lost. As he is an important part of the scene, his image was held back whilst printing, thus allowing him a shorter exposure time than the remainder of the image. Nikon F2, 105mm lens, HP5 rated at 1200 ASA

the print need to be given more exposure in order to bring out the tonal detail. This can be done by cupping the hands to-gether so that a small circle is formed, allowing only a small amount of light to come through from the enlarger, and directing this to the required area. It can also be effected by using a piece of card with a hole cut in it, allowing the light to fall only where desired. It is important to remember that with both the holding-back and the printing-in techniques, the medium used must be *constantly moving*, otherwise there will be an obviously dark or light area on the print that does not blend in with the overall exposure. A further way to bring out extra highlights in a too light area is by constant rubbing of the effected area during the development; this warms up the area more than the surrounding regions, and thus makes the chemicals react faster on the paper.

It can therefore be seen that most theatrical and stage photographs will nec-essitate hand printing in order to produce

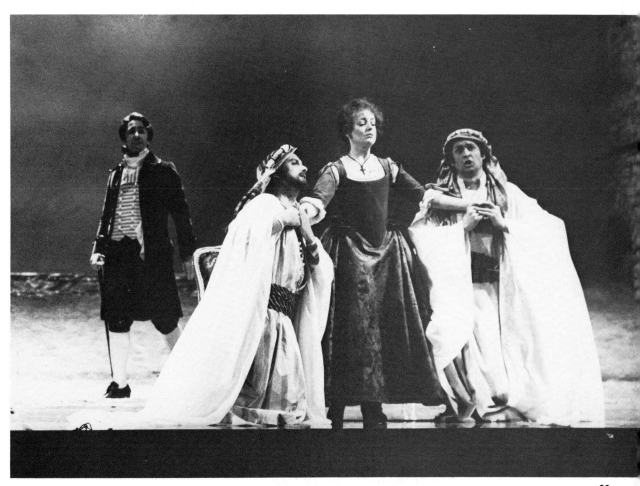

a really good quality print. Automatic printing machines are unlikely to give the tonal quality required.

Photographic paper is available in a variety of grades, which are a classification of the paper's contrast. It is most important to select the right grade of paper, as it will affect the quality and tonality of the finished print. The grades available range from 0–5, 0 being a very soft contrast paper and 5 being an extremely high contrast paper. A negative showing a normal range of tones would usually be printed on a grade 2 paper, but such negatives are rarely produced from a theatrical assignment because of the lighting encountered and the fact that almost always the film selected will have been fast and up-rated. The usual rule for the selection of the right grade is: thin negative of high contrast – print on a soft paper; conversely, dense negative of low contrast – print on a hard paper. This can be seen in some of the pictures in this book: the illustration of Luciano Pavarotti (*figure 22a*) was taken from a very dense negative (the result of using a series of tele-converters, which had substantially degraded the image) and necessitated the use of the hardest paper available, grade 5, in order to make a print of a reasonably acceptable quality. The picture of Frank Sinatra, featured on the title pages, was shot on up-rated Recording film, resulting in a negative of high contrast: consequently, this was printed on a soft, grade 1, paper to produce tonality on the face. An experienced printer will be able to look at a negative and immediately know which grade of paper to select.

It is impractical and uneconomical for a photographer to produce his own colour prints or, indeed, to process E-6 at home, although both are possible. For reproduc-

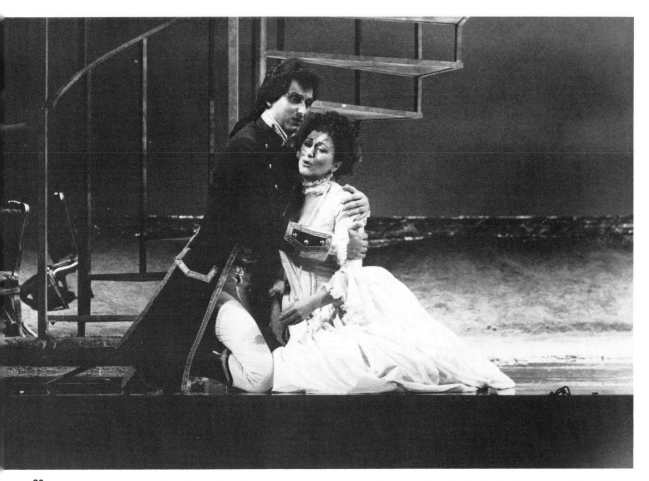

tion, the original colour transparency will be used to make the colour separation needed for printing, and thus a print is not needed. For the large size of print required for front-of-house displays, the printing is best left to a professional laboratory who will be set up to cope with the larger dimensions.

RETOUCHING

Retouching is usually the photographer's secret and consists of 'knifing out' and/or 'spotting-in'. It is necessary when a print is marked either by dust or scratches, where the subject in the picture has some small blemish which can easily be rectified in this manner, or where an otherwise perfect composition is marred by some small photographic oversight and is only evident when the shot is printed. There was an example of this very problem some time ago on a ballet poster. It was to be used to advertise a modern ballet and

consisted of a ballerina in a plié position, with another ballerina behind her on point with one leg in the air. Unfortunately the tip of this dancer's shoe came directly underneath the crotch of the bending dancer – nothing short of obscene! – and so the whole of the offending toe had to be knifed out and spotted to cover up the knifing; the picture was then fit to use – and indeed was, to very good effect.

Another example of retouching to remove a blemish was again connected with a ballet picture. Two famous ballet stars were photographed dancing together; again the composition was excellent, but the female dancer's facial expression of extreme pity was rather unphotogenic. Her forehead was lined and her neck looked very sinewy; so out came the knife and retouching paint and off came the lines. A smooth forehead and beautiful

continued on p. 49

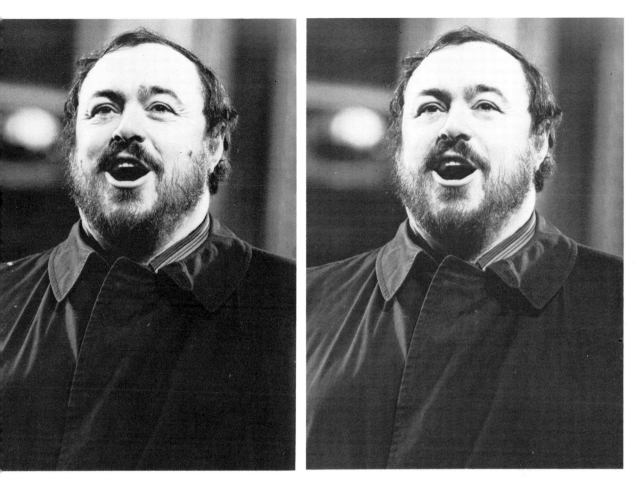

30 OPPOSITE: *Cosi fan Tutte*, (Opera North), Leeds, 1982
This is a good example of a picture that could be considerably improved by a certain amount of retouching. The girl's forehead is badly lined, making her photographically unattractive, and the shadows on her forehead and cheek could be removed at the same time, making a much more usable picture without changing the obvious emotion in her expression. Nikkormat FTN, 200mm lens, HP5 rated at 1200 ASA

31a and **b** ABOVE: Luciano Pavarotti, Royal Albert Hall, London 1982
a These two examples of the same picture show the 'before and after' of what a little knifing and spotting can do. The first picture, besides showing some obvious dust marks and hairs that were on the negative during printing, show Pavarotti with wrinkles around his eyes, and a 'laughter line' running from the side of his nose to the corner of his mouth. Although it would not be usual to remove these natural characteristics, it was felt that it afforded a good opprtunity to illustrate the art of the retoucher! It was taken a stage further and his three moles were also removed – one on either cheek and one above the eyebrow.
b The fully retouched print, making him look many years younger and with a blemish-free skin, thus showing just what a difference this technique can make to a picture and so why it is so very useful, not to say obligatory, in the realms of ballet and opera. Nikon F2, 200mm lens, HP5 rated at 800 ASA

1 *The Rules of the Game*, (Leonard Rossiter and Mel Martin), Theatre Royal, Haymarket, London, 1982
An effective cameo portrait showing good contrast and colour against the dark background, and with excellent skin tones. Nikon F2, 105mm lens, Ektachrome 160 Tungsten rated at 800 ASA

2 *Der Rosenkavalier*, Glyndebourne, 1982
The opulance of the set is typical of a Glyndebourne production. The predominantly red and white costumes have come over extremely well in colour, and illustrate well a dramatic moment in this opera. The designer for this production was Erté. Nikon F2, 200mm lens, Ektachrome 160 Tungsten rated at 1000 ASA

3 *Zarathustra* (Carlotta Ikeda and the Buto Dance Company Ariadone), Roundhouse, London, 1982
The lighting, being predominantly white, enhances the silver on the backcloth and floor, throwing a warm light onto their bodies, which were powdered. The overall composition shows a good shape, and the picture is very indicative of the production. Nikon F2, 105mm lens, Ektachrome 160 Tungsten rated at 800 ASA

4 *The Rivals*, Chiswick Arts Festival, Chiswick Home, London, 1979
Some dramatic productions take place out of doors and this can mean that the photographer will begin using daylight film and, as it gets darker, switch to tungsten-balanced film. This picture was taken early in the scenario, when it was still possible to use daylight film. Nikon F2, 200mm lens, Ektachrome 400 rated at 800 ASA

5 *Arms and the Man*, (*Left to right*: Richard Briers, Peter Egan and Richard Pearson), Theatre Royal, Haymarket, London, 1982
Although a pleasing picture of the three main characters, this picture illustrates the effect that occurs when daylight-balanced film is used in conjunction with tungsten lights – all the hues are in tones of orange. Daylight-balanced film can be used in the theatre as long as a colour compensating filter is used, such as the Kodak Wratten 80B. Nikon F2, 105mm lens, Ektachrome 400 rated at 800 ASA

6 Meatloaf, Wembley, 1982
This picture is extemely typical of the artiste, and has captured him at a most expressive moment. Nikon F2, 200mm lens, Ektachrome 160 Tungsten rated at 1000 ASA

7 *Cosi Fan Tutte*, (Opera North), Leeds, 1982
A well-composed picture that has been caught at exactly the right moment. The special effects of the lighting in conjunction with smoke have just cleared enough so that, although still giving a good feeling of the atmosphere of the production, it still shows excellent definition, to the point that the faces of the artistes to the rear of the stage are visible. This picture would certainly enhance any front-of-house display. Nikon F2, 200mm lens, Ektachrome 160 Tungsten rated at 1000 ASA

8 *Song and Dance*, (Wayne Sleep and Linda May Brewer), Palace Theatre, London, 1982
This photo shows very good body lines and eye contact and has caught the artistes at the peak of the movement. Pentax 6 × 7, 105mm standard lens, Ektachrome 160 Tungsten rated at 800 ASA

9 *Windy City*, Bristol Hippodrome, 1982
This encompasses the majority of the set, arranged on two levels, during the opening number of the show. It is a remarkably clear picture that was taken under very difficult photographic lighting conditions. Pentax 6 × 7, standard lens, Ektachrome 160 Tungsten rated at 1000 ASA

10 Freddy Mercury of Queen, Milton Keynes Bowl, England, 1982
It was not possible to take a great selection of pictures at this performance as the press photographers were allowed access to the photo-pit for only one number each ! However, some good pictures resulted, and this one captures the mood of the performance. Pentax 6 × 7, 66mm lens, Ektachrome 160 Tungsten rated at 1000 ASA

11 *Hobsons Choice*, (Penelope Keith and Anthony Quale), Theatre Royal, Haymarket, London, 1982
A good close-up of the two stars of this production and one that has caught them at an expressive moment. Nikon F2, 105mm lens, Ektachrome 160 Tungsten rated at 1000 ASA

12 *Song and Dance*, (Marti Webb and Wayne Sleep with the company), Palace Theatre, London, 1982
A well-structured picture of the 'finale' showing all the members of the company. Pentax 6 × 7, 105mm lens, Ektachrome 160 Tungsten rated at 800 ASA

13 Rolling Stones, Bristol Football Ground, 1982
This picture was taken from the terraces and, as such, shows the sort of shot that an amateur could expect to get. Although it is difficult to see the artistes without enlarging the picture considerably, it portrays the colour and excitement at such a show. Nikon F2, 200mm lens, Ektachrome 400 rated at 800 ASA

14 *Cosi Fan Tutte*, (Opera North), Leeds, 1982
This photograph was taken in order to capture the effect of the mirrored floor, and although the level of lighting on their faces is rather low, it does not mar the overall quality of the picture. Nikon F2, 200mm lens, Ektachrome 160 Tungsten rated at 1000 ASA

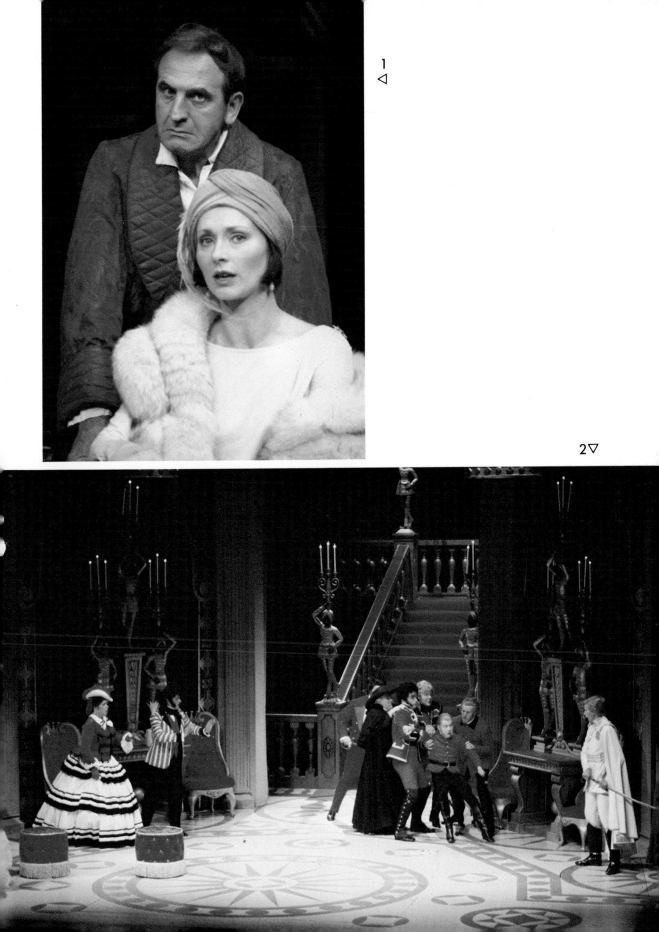

1 ◁

2 ▽

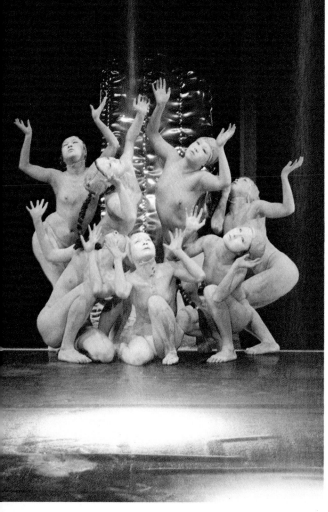

3
◁

4
▷

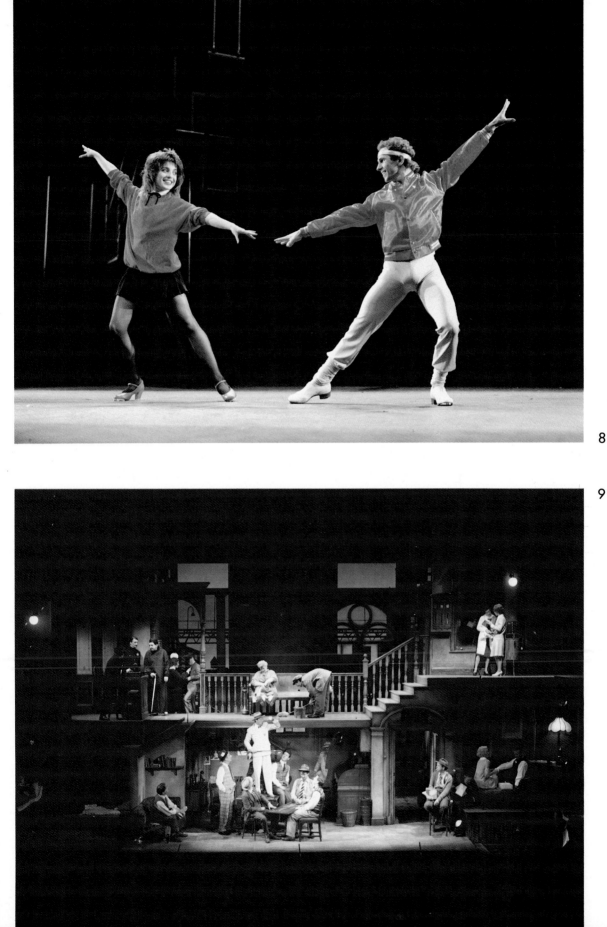

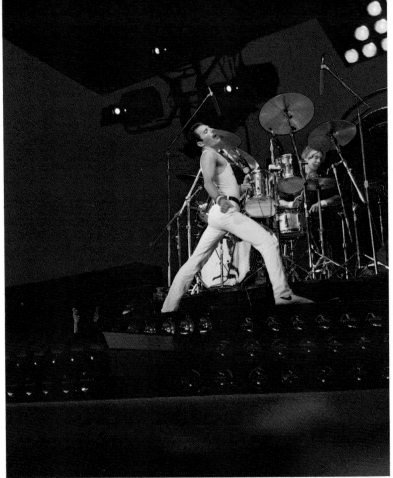

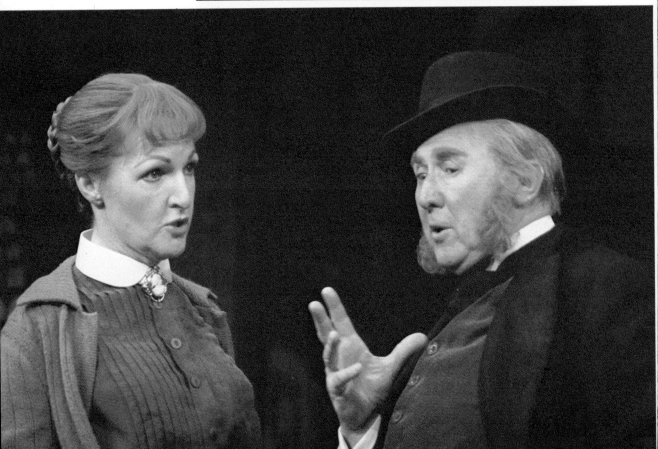

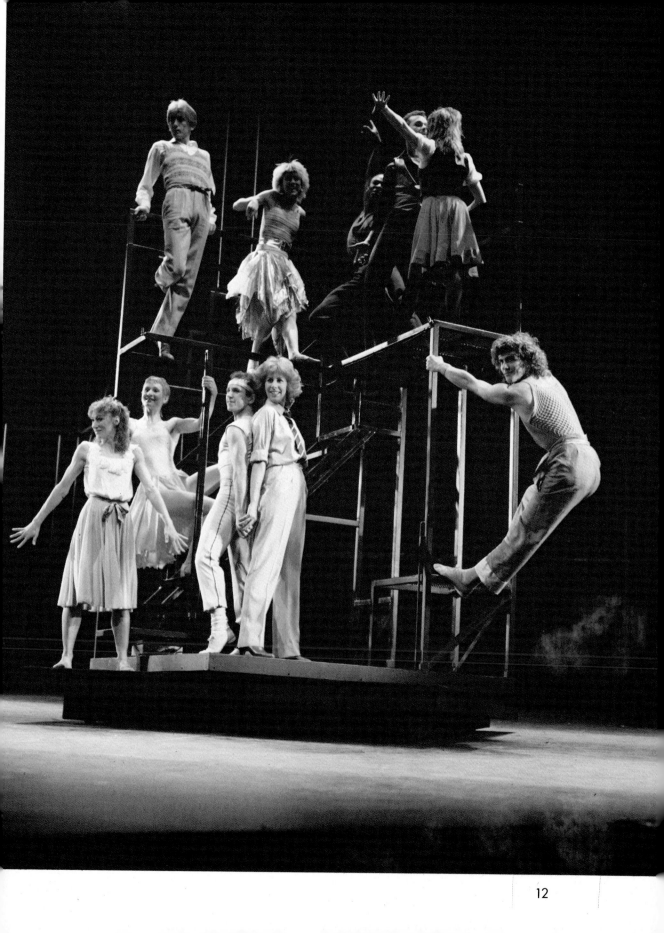

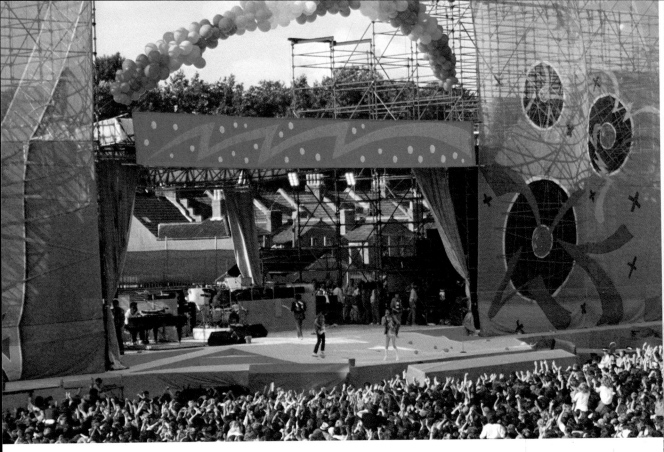

13△

▽14

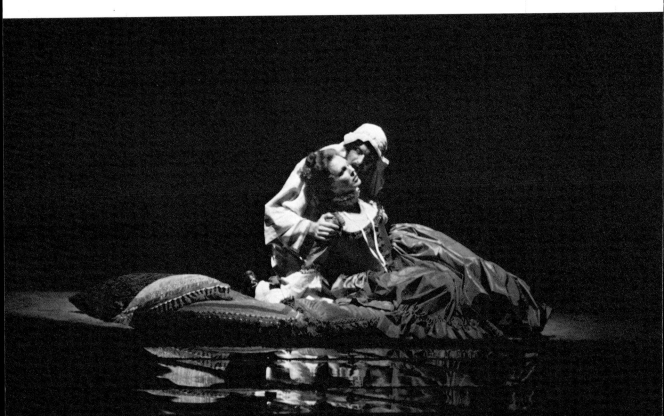

neck resulted, and that photograph has never been seen in its natural state by anyone other than the photographer and his assistants.

Retouching can be done on a glazed glossy print of any kind, but as the retouching medium is matt, the 'spotting' will be rather obvious. Many modern papers are resin coated and these, although needing a shorter time for developing and drying, create problems when retouching. It is still possible to spot any dust marks on such prints, but it is not possible to knife as the emulsion surface of the paper is akin to plastic and would peel away from the base. Therefore, if any large amount of retouching is to be done, the print concerned must be produced on a paper such as bromide, with a matt, or glossy, unglazed finish, which will knife easily on the particular area required.

If a colour picture needs to be retouched then some disaster has befallen it; the scene has been badly lit, the subject has done something which couldn't be rectified at the time of shooting, or not enough shots have been taken to cover all eventualities. There are, of course, extenuating circumstances in every case! Retouching colour pictures is an extremely skilled job and can only be done on transparencies. They need to be professionally handled and are best sent to a studio which specialises in this type of work.

If your black and white photo has been printed on the correct paper but needs to be retouched, you will need a retouching blade, a very fine paint brush, some black retouching paint, and spit! Swan Morton make surgical scalpel blades and the 10, 10A and 11 (which have a fairly oblique angle) are most suitable for 'knifing'. You then proceed to scratch the surface of the print very gently until the offending area is clear. Great care must be taken not to indent the paper in any way or, far worse, tear the surface by indenting too hard. If a very large area is to be removed there is an alternative to the knife; Farmer's Reducer, as the name implies, is a type of bleach that will reduce the density of tone on the print – it is applied on a piece of cotton wool or small sponge directly onto the surface and, by gentle rubbing on the affected area, will lighten or totally remove the image.

Most people who retouch have their own idea as to how to dilute the paint, but licking the brush seems to be the easiest and most effective method. The brush needs to be quite dry and very little paint is necessary because you have to spot the picture to replace the grain dots where you have knifed. Not only do they have to be small enough but they also have to match in colour. This can be quite tricky depending on how light or dark is the area to be retouched (dust spots on a black background are naturally easiest but those on a 'white' background are much more difficult to match as it is often extremely light grey, to almost white), and also the size of the photograph being retouched.

In 1969 there was a musical in London's West End in which a famous American film and stage star was appearing. Her 'official' publicity photo being used out of town for front-of-house purposes bore very little resemblance to what the lady actually looked like, since it had obviously been taken many years before. The management wished her to look as young as this in all the London front-of-house photographs. None of the colour portraits taken were considered 'young' enough to be used but since most of the black and white photographs had been taken from the auditorium, the definition was not so clear, especially in respect of age. However there was one very large black and white close-up portrait, measuring about six feet long by four feet deep, which made her face enormous and the grain the size of a pea. The lines and shading to be removed could only be seen by standing about six feet away from the photograph and then it all had to be spotted in because knifing out was not of much use except to lighten the shading. The photographer made a very successful job, after much time and patience, and at least 20 years were removed from her face, but unfortunately, the management still felt it was not flattering enough and did not use it. The theatrical photographer must learn to get used to this kind of frustration!

4 Taking Pictures within the Theatre:
Photo Calls, Dress Rehearsals and Live Performances

PHOTO CALLS

Photo calls, as the name implies, are scenes from performances, specially called for the photographers of the press and other interested parties. They are organised by the company or person in charge of the publicity for the production, and a list of the forthcoming photo calls is usually circulated to the photographers several weeks in advance, together with a cast list, biographical details of the artistes and, in many instances, a brief resumé of the play or musical – all intended to make the photographer interested in attending the photo call, if he hasn't already been commissioned to do so; details of access to photo calls are dealt with in the chapter on this subject.

Unlike dress rehearsals and live performances, photo calls are very necessary to the production for publicity purposes and so are arranged for the photographer, and aim purely to make his job as straightforward as possible. The director and/or producer of the piece will have chosen particular parts of the action that are most typical or particularly spectacular, and will have organised for these to be performed briefly for the press. The aim is to produce photographs that will whet the appetite of the would-be theatre-goer.

These photographs, more often than not, are taken to be used in conjunction with the theatre critics' reviews in the newspapers following the official first night, to which the critics have been invited. Naturally, however, the photographs are taken beforehand so that the photographer has time to print, choose and sell his photos to whichever publication wants them (if he has not already been commissioned to take them).

It should perhaps be pointed out here that procedure is rather different in the United States, where it is unusual for the press photographers to be invited to a photo call. It is the production photographer who covers the event and how his role varies in the States is dealt with in Chapter 5.

Photo calls are most usual in the theatre (opera and ballet usually being covered photographically during the dress rehearsal). Unlike most areas of press photography, which is often a somewhat 'survival of the fittest' affair, it is true to say that those photographers who cover theatrical assignments are generally real 'gentlemen of the press', and everyone is afforded the opportunity of taking the pictures he requires. By way of contrast, there was an incident involving a professional photographer who was asked to cover a photo call for the first time. Being used to the somewhat cut-throat approach needed at rock concerts, he assumed that the same techniques would be needed for any theatrical situation involving a number of photographers and proceeded to take as many pictures as he could with no regard for anyone else. Not only did he prevent some of the photographers from getting any really good pictures, but also made himself unpopular with both the artistes and the management.

There is also a unique opportunity at photo calls to move the actors about on stage; for the purposes of press reproduction the real placings of the actors on stage may be too far apart to give any impact in a reproduced picture and the artistes are therefore usually amenable to having the

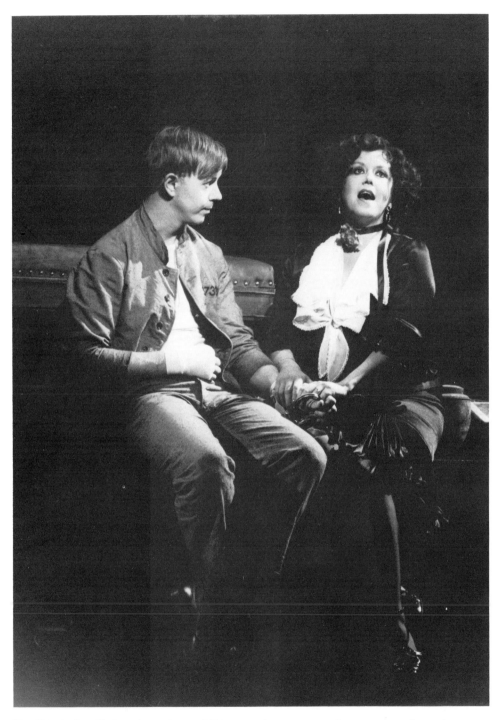

32 *Windy City* (Robert Longden and Diane Langton), Victoria Palace, London, 1982
This is a good picture showing excellent composition; the faces of the two artistes have come across very well, and give the viewer a real feeling for the scene portrayed. The picture also leaves one in no doubt that this is a scene from a musical, as it is obvious that she is singing rather than speaking. This picture was taken during a photo call, where such typical scenes are specially re-enacted for the benefit of the press photographers. Nikon F2, 105mm lens, HP5 rated at 1200 ASA

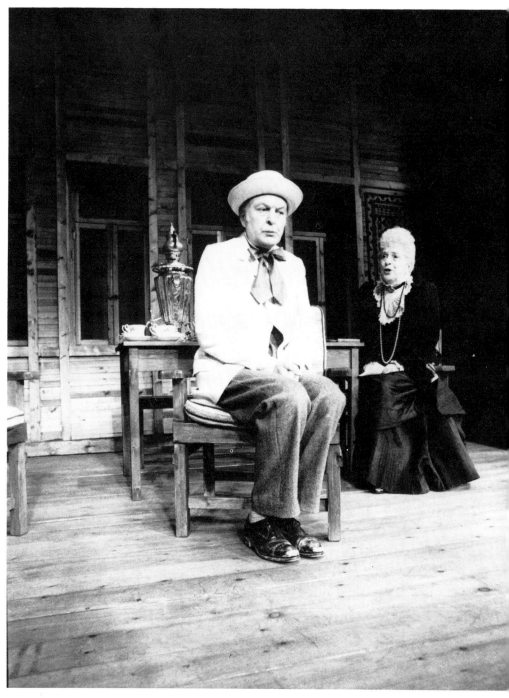

33 *Uncle Vanya*, (Donald Sinden and Margaret Rawlings), London, 1982
This shows good characterisation in both the artistes faces and displays the general atmosphere of the play. The picture was taken from the stage, using a wide angle lens. The shot could have been cropped to give a larger image of the two characters, but as it is it gives a great depth, making the viewer feel that he is on stage too. When film is up-rated there is a loss of subtle tonality in the highlights and, despite a considerable amount of printing-in to try and get more detail in the jacket, there could still be room for more definition. Nikon F2, 24mm lens, HP5 rated at 1200 ASA

34 LEFT : *Hobson's Choice* (Penelope Keith), Theatre Royal, Haymarket, London, 1982
A typical shot from this production, showing the main character in a very apt pose. However, the part torso of the maid in the background is a little distracting and the picture would have been better if all of the maid had been in the frame or if it had been taken from a different veiwpoint so that she was not visible at all. Nevertheless, this would be unlikely to make the picture unusable as it is still most evocative of both the performance and the character. Nikon, 50mm standard lens, HP5 rated at 1200 ASA

35 BELOW : *Uncle Vanya* ([*from left to right*:] Bill Fraser, Donald Sinden, Ronald Pickup), London, 1982
This picture was taken when the photographer was allowed on stage for the photo call, and a wide angle lens was used to give a greater depth of field, thus allowing for all the artistes to be in focus. This illustrates the comedic quality of the principal actor, showing that there can be lighter moments in a usually gloomy play. In order to get this pleasing composition, it was necessary to move the actors about on stage as, in the real scene, the three actors are much further apart than depicted here: this is something that the photographers can only do at a photo call and not at a dress rehearsal. Nikon F2, motor drive, 24mm lens, HP5 rated at 1200 ASA

a

b

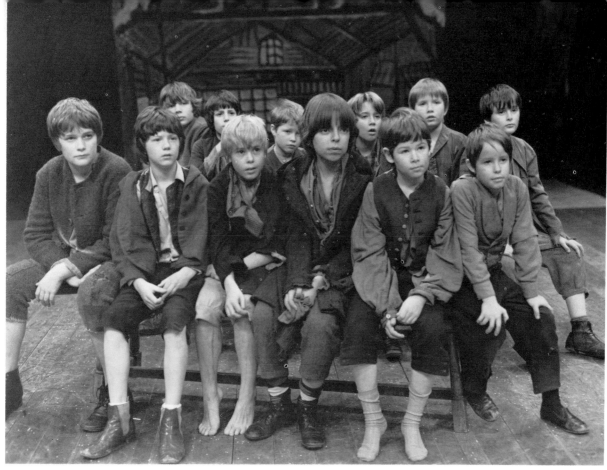

c

36a, b and **c** *Nickleby and Me*, (The Boys from Dotheboys Hall), Chichester Festival Theatre, 1982

photographers ask them to perform certain sequences in a slightly different way (obviously within reason and within the context and confines of the performance). The objective is to produce one picture that will sum up the whole production and also include the main stars, as the latter is obviously a selling point to the general public.

The number of photographers at a photo call varies, but for most theatrical productions is rarely more than a dozen and so there is no need for them to get in each other's way. They are also rarely in competition with each other, as most will probably have already been commissioned by a particular newspaper or magazine. It is a severe breach of etiquette to get in the way of another photographer, and to prevent others from taking good pictures. In fact, more often than not, they will chat amongst themselves, and make sure that they have all taken the pictures they require. If, for some reason, this is not the case, it may be possible to arrange for further photographs to be taken either after the photo call or at another mutually

Three pictures, showing different camera angles and poses. All the pictures were taken from the stage at the end of a matinée performance. The boys are featured in their 'raggedy' costumes and, to be true to the performance, really should have dirty faces to go with the costumes! It was very difficult to get them to concentrate for any length of time as they were still very excited from the performance, and all the action shots ended up in a 'rough and tumble'. The photographer's aim was to get a series of pictures indicative of the show, but this proved to be more difficult than it would seem.

a This picture is representative of the scene as a whole, but three of the boys are not looking at the camera.

b This is a 'put-up' shot, as in the real scene they were much farther apart and it would not have been possible to get them all on one frame. To make them behave more naturally, we asked them to sing one of the numbers from the show. Although, for this picture, they were not meant to look at the camera, two of them still did!

c This was the one picture where we managed to get all the boys concentrating and looking in the same direction at once. However they all look fairly static and the picture itself, while endearing, is not particularly interesting as the boys are not actually 'doing' anything. It was very difficult to get them all to look at the camera, but it was even more so to get them *not* to look at it! All three photos were with a Pentax 6 × 7, 55mm lens, and HP5 rated at 1000 ASA

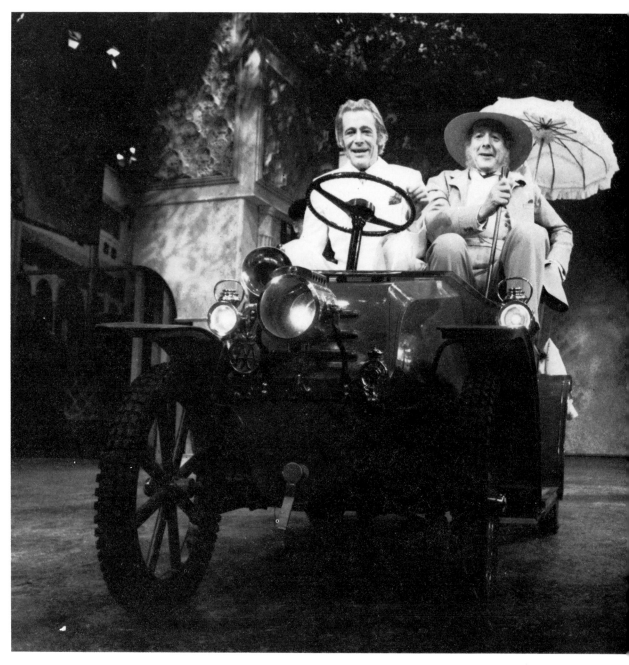

37 *Man and Superman* (Peter O'Toole and James Grant), Theatre Royal, Haymarket, London, 1982
The car was obviously a highlight of the production, and was brought out at the photo call to give a good publicity photograph. The photographer was allowed on to the stage, and so was able to make the car a real focal point and at the same time portray the nature and period of the production. Nikon F3, 28mm lens, HP5 rated at 1200 ASA

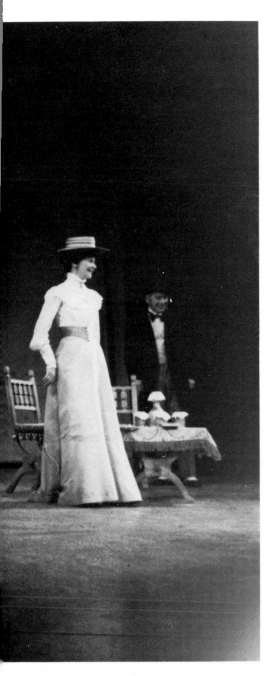

for photographers, there is no problem with regard to the suitability of equipment – anything goes! It is most usually found that the choice of equipment will be 35mm format, but some will use 6 × 6cm or 6 × 7cm formats such as Hasselblad or Pentax. As the session only normally lasts thirty minutes or so, and several different scenes will be portrayed during this time, speed is of the essence and most photographers will use motor drive so that they miss none of the action. The majority of the resulting pictures are destined for use in newspapers, so black and white film is normally used; indeed, it is rare for colour to be required. As the house and stage lights are at full brightness during photo calls, most photographers will use a fast film pushed one stop, e.g. HP5 or Tri-x Pan, for which the recommended rating is 400 ASA, pushed to 800 ASA. This will normally allow a working aperture of f5.6 when shooting at $\frac{1}{125}$. In order to save changing lenses when the time available is limited, it is normal to employ several camera bodies, each with a lens of a different focal length.

Most photographs are taken from the stalls (US: 'orchestra'), but sometimes, dependent upon the director and the production team, it is possible to take pictures from the stage itself. Although close to the stage, the stalls area has certain disadvantages for the photographer, for example in the case of musicals, when care must be taken to avoid getting the top or, worse still, the whole of the back of the musical director's head in the bottom of the picture. Many otherwise excellent shots have been ruined in this way because this intrusion makes cropping impossible and nonsense of the picture as a result! His baton too can get in all the wrong places when you least want it, and musical instruments can also be a hazard. Pictures taken from the stalls will actually be looking upwards since the stage is often set higher than the stalls seats and this causes distortion and cut off; if one moves up to the dress circle the opposite will occur, as any pictures will have an overall viewpoint that is looking down. Obviously, to be on the same level as the subject would be the most advantageous viewpoint, but this is not always practical or

suitable time for both photographer and artistes, the press officer liaising with relevant parties to achieve this, since lighting and very often music are also a vital part of the session. This, however, is not a usual occurrence as most of the time the photographer will be satisfied with the quantity and variety of pictures he has taken.

As photo calls are arranged specifically

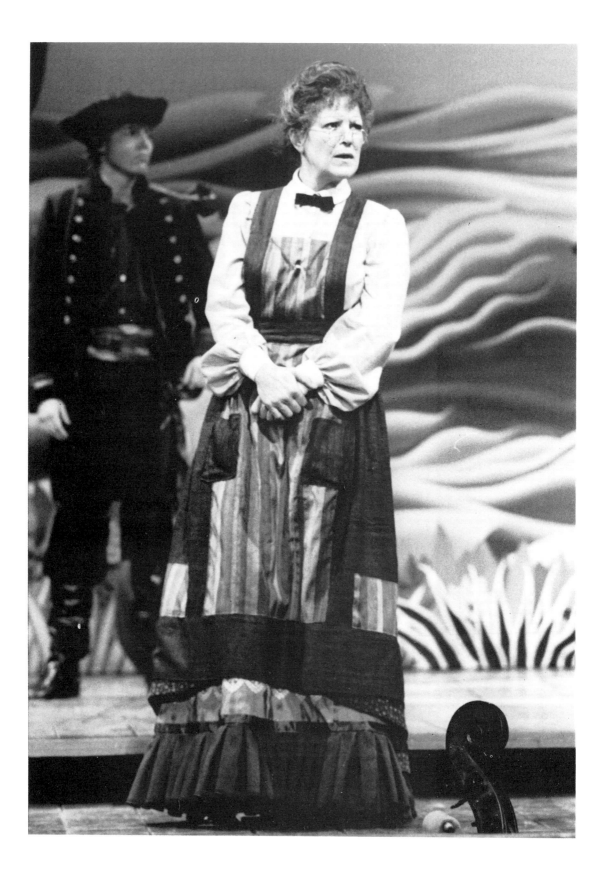

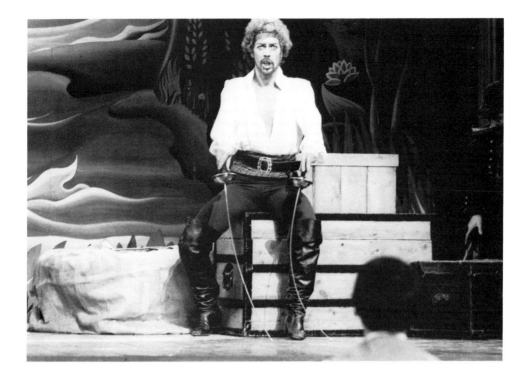

38a and **b** *The Pirates of Penzance,*
(**a** Annie Ross and **b** Tim Curry), Theatre
Royal, Drury Lane, London 1982
These two pictures show good examples
of superfluous foreground detail that would
be difficult to crop out successfully without
ruining the picture. Picture **a** shows the top
of a double bass, while picture **b** features
the back of the head and shoulders of the
musical director! These are typical
intrusions that the photographer will come
up against at a full run-through, as the
orchestra is obviously an important part of a
musical's dress rehearsal. The production
photographer would arrange for a special
session in order to photograph these main
artistes when there is nobody else around.
Nikon F2, 105/200mm lenses, HP5 rated at
1600 ASA

practicable. In order to overcome the
viewpoint distortion, photographers will
either set up a tripod to the required
height or, more often than not, will stand
on either their camera cases or the seats, to
gain an extra bit of height.

As a general rule, the photo call is the
easiest way for a photographer to get good
pictures, but because the situation is 'con-
trived' it could lessen the drama of the
performance and this might reflect in the
final pictures.

DRESS REHEARSALS

The dress rehearsal is, with few excep-
tions, the domain of the production pho-
tographer, where he will have his oppor-
tunity to take the pictures that will ulti-
mately illustrate the production to the
general public – as these shots will be
displayed outside the theatre and in the
official brochures. Except in the fields of
opera and ballet, where there are rarely
photo calls, the press are not usually
admitted to the dress rehearsal so the
production photographer can get on with
his work without any harassment. The
dress rehearsal is not principally put on
for the benefit of the photographer, but to
serve as a final 'dummy run' for the whole
show prior to the first performance.

The role of the production photo-
grapher is dealt with in a separate chap-
ter, so here we will concentrate on the very
specialised fields of opera and ballet.
Although the camera techniques vary
little from other forms of theatrical pho-
tography, it is so very different in respect
of the technically artistic details of the
performance itself; indeed, to make sure
that every detail is perfect, it is often
necessary to resort to the talents of the
retoucher's knife and brush.

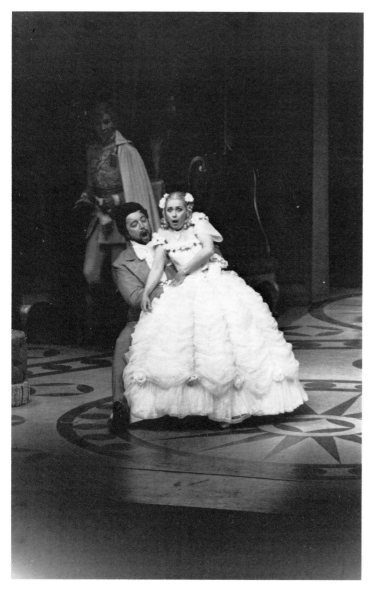

Whatever the type of performance, it is most important for the photographers (other than the one employed by the company) to keep a low profile, and this is for two very good reasons. Firstly, since it is a full dress rehearsal, the production team will require a completely unobstructed, continuous view of the stage; they will normally set up a production desk in the middle of the stalls, from which they will operate. Secondly, the production photographer must also have an unobscured view; he will usually set up his tripod at the best viewpoint, but may occasionally wish to photograph from an alternative angle, and care must be taken not to prevent him from so doing. In general, keeping out of everybody's way often means working from the side of the stalls!

Frequently, only the production photographer will be allowed access to the stalls area and the other press photographers will be relegated to the dress circle. Although this can mean a slightly downward viewpoint and, unless some very long telephoto lenses are employed, difficulty may be experienced in obtaining close-up shots, some excellent full stage pictures can be obtained, as well as good group shots and full-length photographs. From the dress circle the view will be unobstructed and, as there are only a few photographers normally present, there will be adequate space for everyone to get the pictures they want.

It may be necessary to use slightly modified equipment at dress rehearsals, particularly if it is important that noise is kept to a minimum. At one provincial opera dress rehearsal the photographer was asked to stop using a motor drive as the performers were becoming distracted as they had never heard the noise before! Some photographers, especially when working close to the stage, will select a quieter piece of apparatus such as a rangefinder camera, but it is becoming more commonplace nowadays, particularly with the larger productions, to use regular SLR equipment.

Because opera and ballet are both very precise forms of theatrical art, the resulting strain may often be reflected in the performers' faces and bodies as they try to

39 ABOVE: *Der Rosenkavalier*, Glyndebourne, 1982
At opera dress rehearsals, the press photographer often has only limited access and is restricted to taking his pictures from the dress circle, thus giving a downwards viewpoint to the resulting pictures. Nikon F2, 200mm lens, HP5 rated at 1600 ASA

40 OPPOSITE: *Don Giovanni*, (Welsh National Opera), Mold, Wales
The lighting situation that the photographer is faced with can often cause great problems. This is a picture taken at a dress rehearsal and, although little light was thrown onto the subjects, it was still possible to get an interesting shot. There is very little depth of field but, by printing on a hard (grade 4) paper, it has been possible to produce a suitable and usable image. Pentax 6 × 7, 105mm lens, HP5 rated at 1600 ASA

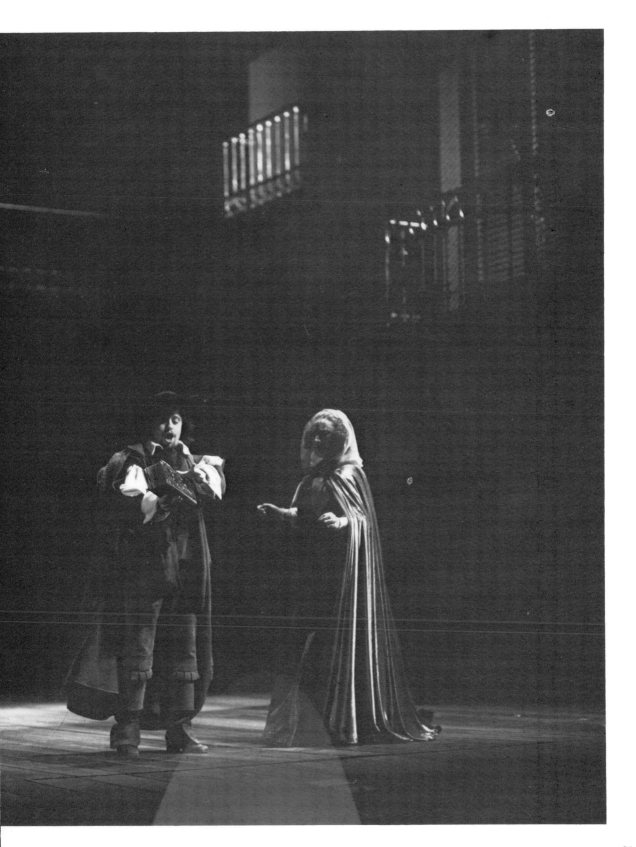

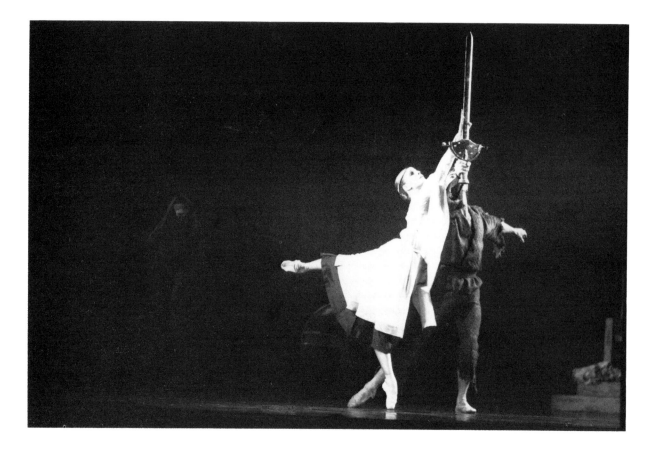

attain the 'perfect performance'. One ex-ballet dancer, when asked how dancers felt about being photographed, aptly replied that 'ballet dancers must be the most difficult artistes to photograph as the dancers are so rarely completely satisfied with their own performances, knowing that they can do better, so how can the photographer be expected to make a perfect picture?' For this reason, when a large front-of-house display is required, certain technically precise movements can be re-enacted for the benefit of the production photographer until the photograph is as near perfect as possible. Any minor flaws will be knifed out and retouched. For this reason, if a photographer is not known to the company, he may well be asked to submit any pictures to the press officer before allowing them to be used for publication. This would not be necessary for any personal portfolios, but the point is well illustrated by this quotation from a letter circulated to photographers by a London ballet company:

41 ABOVE: *The Swan of Tuonela*, (Sadlers Wells Royal Ballet), London, 1982
Although the composition of this picture is good, this well illustrates the loss of detail when using ultra-fast, up-rated films, as most of the detail in the folds of the dancer's skirt have been lost. Double the amount of exposure was given to this area during the printing stage, but it is still not of an acceptable quality. Nikon F2, 105mm lens, HP5 rated at 1600 ASA

42 OPPOSITE: *The Swan of Tuonela*, (Sadlers Wells Royal Ballet), London, 1982
Technically, this is a fairly good picture of a ballet. The ballerina's leg is obviously in motion, as it is slightly blurred, but this does not necessarily detract from the overall picture. However, as with many modern ballets, the costumes are quite different from those used at more classical productions and can fall in strange folds that are not always flattering. Here it is very difficult to see the exact shape of the man's leg and feet because of the loose trousers and leggings. Nikon F2, motor drive, 105mm lens, HP5 rated at 1600 ASA

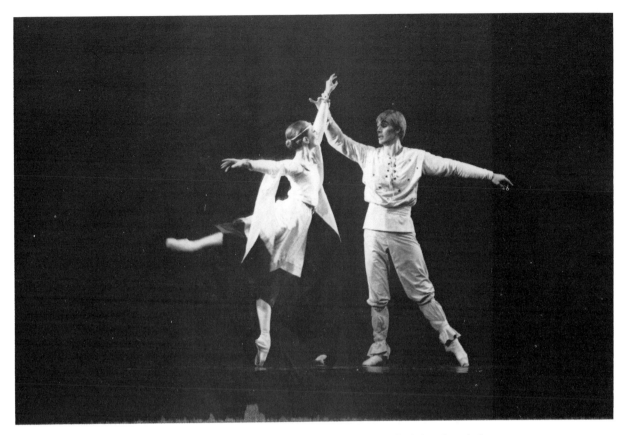

... photographers are invited in to general rehearsals on the understanding that photographs are taken for personal folios, etc. and not for publication. If any pictures are to be published, we should like to see the photographs in question. Ballet photography is rather different from other fields of theatre, as slightly different skills are required, and it is often that a picture which looks good shows a dancer in an incorrect technical position, and can cause a certain amount of distress within the company. It is for this reason that we request to see any photographs to be used publicly. We do appreciate the importance of encouraging and giving facilities to new ballet photographers, but at the same time have to safeguard the company's reputation from having poor pictures in circulation.

Modern ballet productions can prove more difficult than classical ballet, as with the latter there are certain positions and movements that are well defined and the costumes used are such that they will allow these positions to be clearly seen. In modern ballet productions the costumes quite often obscure the body movements, so that although these might be quite correct technically the costumes themselves can fall in an unattractive baggy way, making the general stance look ugly.

Ballets from the Far East are as different to western ballet as is their music, and this can make it difficult for a western photographer to understand exactly what he is meant to be aiming for. Much of the impact in such productions is provided by the facial expressions, some of which can seem exceedingly strange to the western eye. Unlike western ballet, where the dancers are as quiet as possible on stage, some of the effect of oriental dancing is actually to create noise, either with the feet or the vocal chords. So, by and large, one has to aim for a stunningly patterned shot or a picture which is either particularly pretty or particularly grotesque.

In opera as in ballet, the artistes are

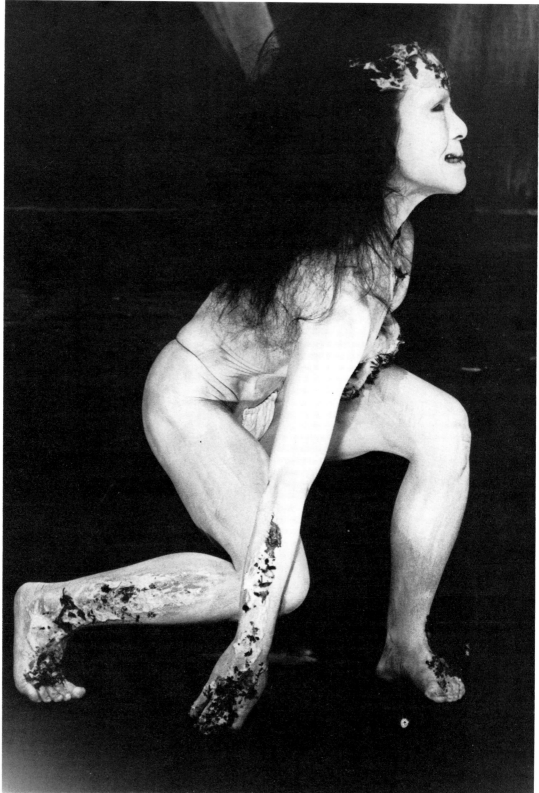

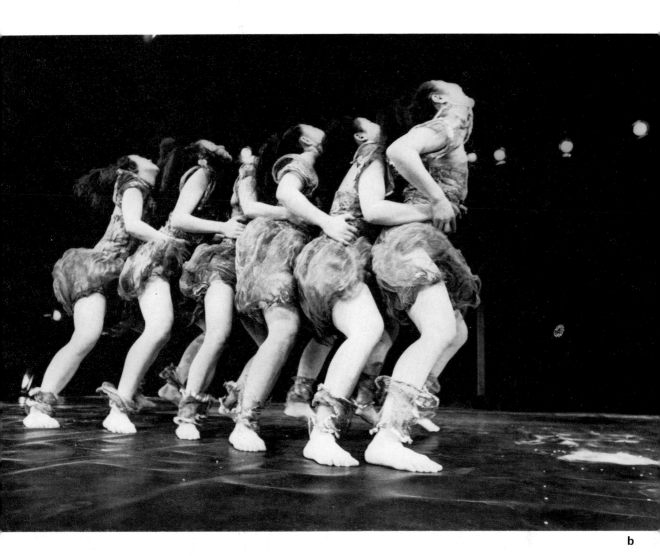

b

43a, b, c, d, e, and **f** *Zarathustra*, (Carlotta Ikeda and the Buto Dance Company Adriadone), Roundhouse, London, 1982
A series of pictures from a modern oriental ballet. All the pictures were taken at a specially called rehearsal for the photographers, who, presumably because of the shock value of the nudity, turned out in their dozens! Unless the photographer is well-versed in the nuances of modern oriental dance, it is difficult to know exactly what is a technically good picture from the production's point-of-view. As this was, in essence, a photo call, it was assumed that those scenes portrayed were indeed typical and that this was what the producers wished to have depicted in the press. As there seemed to be a communication problem – the Japanese team did not understand English any too well – this somewhat added to the confusion!

Throughout this series of pictures, it will be noticed that there are hundreds of white specks on the stage floor: these are *not* dust specks on the negative, but grains of rice which poured down onto the stage to give a special effect during one scene. As they were integral to the production, they have not been spotted out!

a A very expressive picture of, to the western eye, a rather grotesque position. As this was specially set up by the production, it must be what they wanted the photographers to picture!

b A good composition showing the girls in unison, giving the feeling that there is a certain ecstacy in the picture. Without actually showing any blur, there is a tremendous suggestion of movement, particularly in the skirts.

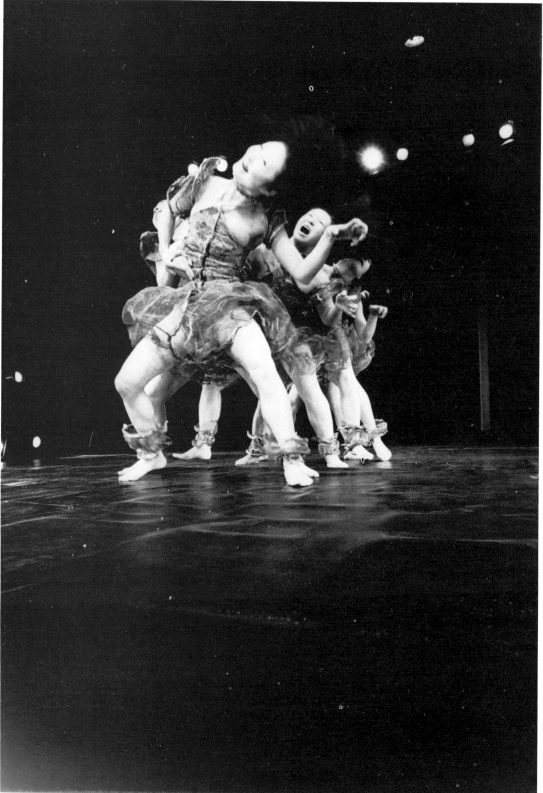

c

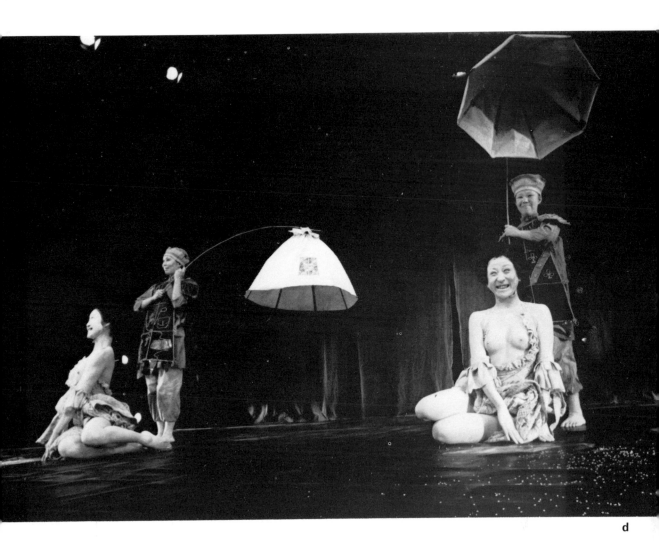

d

c A combination of movement and grotesque facial expression epitomises the essence of the production. It is interesting to note the natural starburst effect without using a special filter in this shot.

d This is probably the most representative shot of the show and, for promotional purposes, would be a nice photograph as well as being a good advertisement. Whilst the dancers are revealing their breasts, there is no way that this picture could be termed pornographic and so, if used as an advertisement, would not encourage an audience who have such preferences.

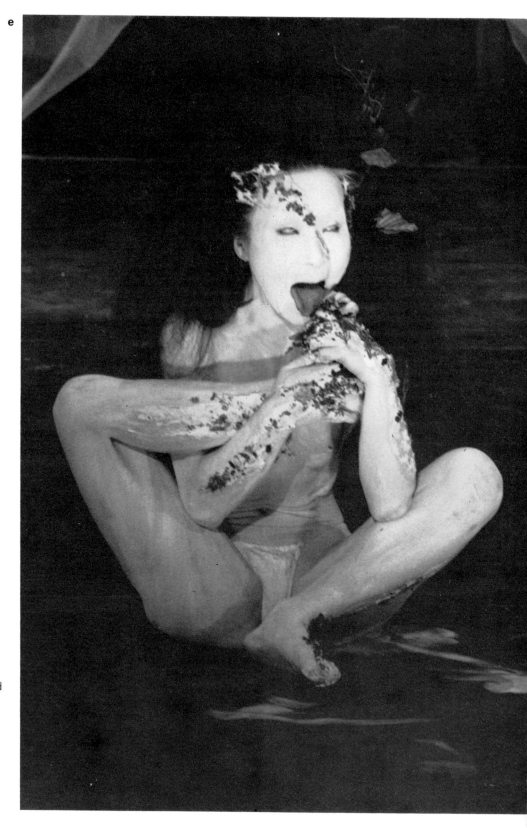

e and **f** Although both these pictures are very grotesque, they are extremely illustrative of what the audience should expect to see. This series of pictures were taken with a Nikon F2, motor drive, and a Nikkormat FT2, 24mm and 105mm lenses and HP5 rated at 1200 ASA

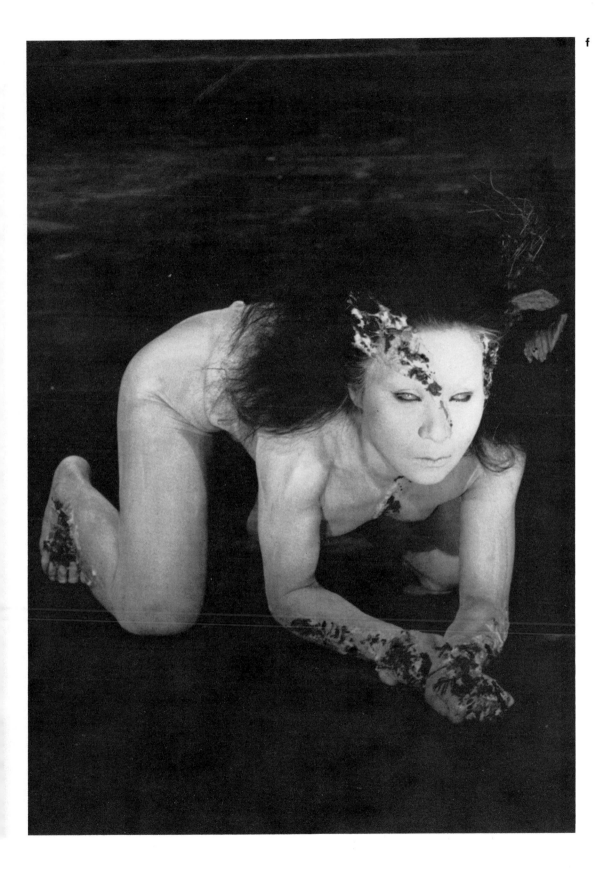

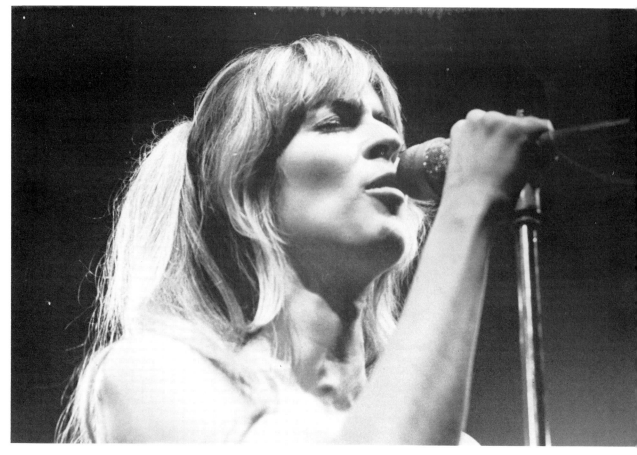

44 Carlene Carter, The Venue, London, 1980

This would be typical of a picture that an amateur could take with the right equipment. There was no special area set aside for photographers, and so this picture was taken amid the milling throng of the audience which, quite frequently, meant that the photographer was jostled and his job was not made any easier. The picture was taken very close to the stage and, with a medium length telephoto, this pleasing portrait was produced. A soft (grade 1) grade of paper was used to give good skin tones and by pushing the film only one stop, the grain has not become too large. Nikon F2, motor drive, 105mm lens, HP5 rated at 800 ASA

trying to achieve perfection in their performances and this can often result in unnatural facial expressions which makes life difficult for the photographer. It is therefore sometimes better to aim for longer shots to make close-up expressions less clear. Opera singers are chosen for their voices, not necessarily for their beauty, so it is often preferable to show the dramatic impact of the production, as the stage effects can frequently be quite breathtaking. Again, for purposes of front-of-house display and programme inserts, if close-up shots of the artistes are needed to help the audience recognise the characters, this would usually be dealt with at a portrait session; close-up pictures of singers actually performing will invariably require a little retouching to render them flattering enough for display or publication.

Finally, dress rehearsals will not always run according to schedule, as the director may well stop the action if all is not

perfection; he may even insist on a re-run of a particular scene/piece of the production. Another point worth noting is that occasionally only some of the cast will be in costume: certain costumes may be unfinished or an understudy may have taken over with too little time for costume adjustment! Whatever the reason, it is important not to take any shots when out-of-costume characters are present. An example of this happened during the first dress rehearsal of a new musical which opened in Glasgow prior to its London opening. All the chorus girls were in costume – or at least, they were when the rehearsal started. But, unnoticed by the photographer, one young lady's godet (*see* Glossary of Technical Terms) had been removed from the bodice of her costume, for alteration by the wardrobe department, and there in glorious technicolour for the remainder of the rehearsal was one fully exposed white brassiere! Luckily, this defficiency was noticed by interval time and so not too much film was wasted; but all the photos in which she appeared had to be scrapped.

LIVE PERFORMANCES

Within the confines of the normal theatre, there is very little scope for 'live' pictures. As explained elsewhere, most performances are covered photographically by either photo calls or dress rehearsals. The only real opportunity for live photography lies in the field of rock and pop concerts. Although it may be possible for the amateur to gain admittance to such concerts, it is very rare that he will be able to take good shots without a 'facility' pass. For the professional, it is quite a simple task to acquire one. These passes allow one into a security area, very close to the stage, so that pictures may be taken without the problems of having an audience in front of you. Without either being employed within the media or having a bona fide 'press pass', such opportunities cannot be afforded to the amateur. With the increasingly high risk from lunatic fans, the security is extremely heavy; indeed, some performers will allow only their 'tour photographer' to take pictures. Bearing this in mind, 'live' photography will be treated in two sections; firstly the

opportunities open to the amateur and, secondly, the way that the professional would handle such assignments.

Live Performances for Amateurs

So, you have bought your ticket and found your seat! If your intent is to try and take really good pictures, then the nearer you are to the front the better – if in a venue (such as a large arena) where there are no seating arrangements, try to arrive as early as possible (as soon as the doors are open) so as to obtain a really good viewpoint. From a position in the general auditorium, long lenses are an absolute must and preferably should be as fast as possible. Many amateurs tend to believe that film must be exposed at the recommended rating; this is not so and, indeed, for the purposes of this type of photography (where flash is all but useless) film must be exploited. In the technical chapters of this book the details of up-rating films are laid out, and this is a technique which must be learned – it cannot be done with all film types, but Appendix II lists those that can be treated in this way.

The instamatic and polaroid cameras are of little or no use on such an occasion; the format is too small and the film available is too slow to register any worthwhile image. At many concerts it is noticeable that amateurs try to take flash pictures with such cameras; unless you are very close to the front this will serve no purpose other than to illuminate the head of the person seated in front of you. It is a pity to waste film in such a way, as the results will always be disappointing, despite the fact that you think you have a really wonderful shot lined up in your viewfinder.

Suffice it to say that the minimum equipment for such photography is a 35mm system with interchangeable lenses and a built-in light meter; this need not be too expensive but, on the day, you get what you pay for. So, the better the equipment you can afford, the better the results are going to be. Certainly, unless you arm yourself with a battery of Nikons or Canons, you are not going to get the quality of picture seen in the press but, if your aim is to record some pictures for your own album, you should find that the

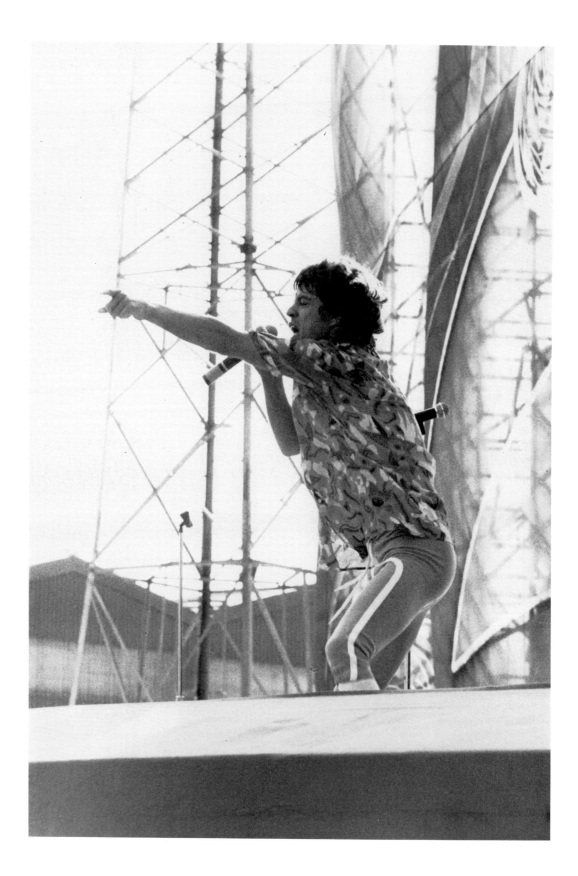

46 ABOVE: Meatloaf, Wembley, 1982
Flare from backlights can play havoc with
the exposure evaluations and, as the
lighting changes so quickly, it is not always
possible to change the exposure fast
enough. This picture shows this well as,
although the exposure is correct for the girl,
the effect of flare is quite evident to the top
and right of the picture. Nikon F2, motor
drive, 200mm, HP5 rates at 1600 ASA

45 LEFT: The Rolling Stones (Mick Jagger),
Bristol Football Ground, 1982
A very typical action shot of Jagger that
necessitated, despite the production being
in daylight, the use of up-rated film or the
action would not have been frozen, as
shown in this picture. Nikon F2, motor drive,
200mm lens, HP5 rated at 800 ASA

47 Bob Dylan, Earls Court, London, 1978
Microphone stands and leads can be an awful nuisance but, as
they are an important part of the on-stage equipment, there is not a
lot that the photographer can do to remove them! Olympus OM1,
75–150mm zoom lens, Tri-X rated at 1600 ASA

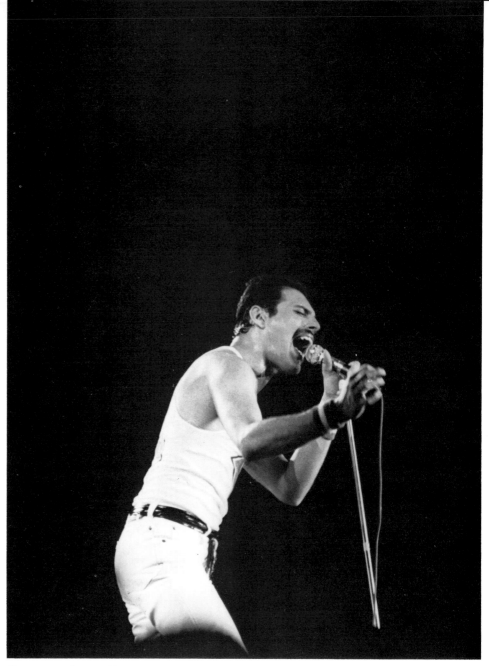

48 ABOVE : Queen (Freddy Mercury),
Milton Keynes Bowl, 1982
A dramatic picture showing good
definition and typical expression in the
performer. This was not an easy shot as the
photographer was balanced on a small
platform about 3ft square, and was only
allowed access to the photo-area for one
number. The large amount of black area
above the artiste would allow an overlay of
copy if the picture were to be reproduced in
conjunction with an article. Nikon F2, motor
drive, 200mm lens, HP5 rated at 1600 ASA

49 RIGHT : Carlene Carter, The Venue,
London, 1980
The use of a wide angle lens can give an
unusual viewpoint, and a fast shutter speed
will help to capture a moment of action,
thus resulting in a pleasing picture. With
excessive backlight it would have been very
easy for the camera light meter to have been
'fooled' and for the resulting picture to be a
silhouette. This has been avoided by taking
the reading from the lower area and stage
floor and the backlight has been
concentrated into a feature by the use of a
starburst filter. Nikon F2, 24mm lens, HP5
rated at 1200 ASA

results are quite presentable as long as they are not enlarged to any great magnitude. To avoid any blur from slow exposures, the minimum speed should be $\frac{1}{125}$ second (and faster if possible). This can only be achieved by pushing or up-rating the film (*see* Chapter 3). It is also most important to use plenty of film; the action happens so quickly, and the lighting conditions change so fast, that inevitably a lot of the pictures will be of very little use. When a professional is covering this type of assignment he will probably use at least two or three rolls of film, or even more. The best way to learn is by making mistakes, and understanding how these mistakes were made.

Having assessed the lighting for the show in general by taking a separate, hand-held meter reading, you will have a fair idea of what sort of tolerance your film should have. This is where a built-in meter really comes into its own – the lighting can vary so quickly that even the best professional does not have time to take hand-held light readings during the performance. Again, this points out the type of equipment you should choose; some systems have really good built-in meters, but this often applies only to the more expensive systems – in the cheaper ranges it will frequently be found that the meters, although adequate for an average light situation, are not suitable for the subtler requirements of live photography, and the pictures are likely to be disappointing. The modern automatic camera can give excellent results, but care must be taken to ensure that the reading is accurate, as the automatic metering can be

50 Meatloaf, Wembley, 1982
Probably not one of the most attractive performers ever to grace the stage, but certainly one who always puts on a good show! An expression such as this is momentary and within a couple of seconds this petulant pout will turn into something quite different – so good anticipation and speed on the part of the photographer are of the essence if such shots are to be taken. This particular show was quite dangerous, as heavy objects were thrown off the stage into the photo-pit, and even the audience had fun throwing bottles at the photographers! Nikon F2, motor drive, 105mm lens, HP5 rated at 1600 ASA

'fooled' by the dramatic sequence changes in the stage lighting, and takes time to adjust to a new exposure. Unless it is a centre-weighted operation, it can give you wonderful silhouettes, as the meter can be fooled by excessive light, especially if it is back light and the meter is not pointed to the darkest area of the stage.

Another consideration to bear in mind is to avoid getting in the way of other members of the audience – you may well want to get some good pictures, but there is nothing more annoying than to have somebody with a camera standing in front of you throughout an entire performance. With the price of tickets nowadays, you will certainly not be too popular for blocking someone's view! It should also be remembered that not all performers will allow the audience to take photographs, and that hand baggage may be searched for equipment prior to admittance to the auditorium.

Having already suggested the type of camera which may be used successfully, the next step is to select a suitable lens or lenses. A zoom lens would seem the most obvious choice, as this will give several focal lengths within one lens, but unless a very good one is used (such as those in the Nikon range) the optics may not be of an acceptable quality. It is generally regarded as better to use fixed focus lenses, but this will necessitate the photographer carrying around a considerable amount of equipment. Again, it really depends on what the pictures are to be used for when selecting your equipment. If a zoom is employed then the most useful would be, say, an 85–200mm lens, as this will give a reasonable coverage of the stage from the auditorium but will also allow for close-up shots.

As can be seen from the illustrations, the selection of the shutter speed is all-important and can vary the mood of the picture quite considerably. A fast speed, such as $\frac{1}{250}$ second, will mean that most of the action will be frozen, with perhaps the odd slight movement from a hand or arm, whilst a slower speed, such as $\frac{1}{60}$ second, will allow some degree of movement which in some instances can considerably enhance the effect in the finished print. Movement can add a certain dramatic and

theatrical impact, that is lost in a completely sharp, static image. It is important to remember the difference between a picture that is just plainly out of focus, and that which has subject blur; this is clearly seen when enlarging the negative as the grain in the blurred picture will still appear sharp, although the image will not.

It is possible to use various filters to add to the impact of the performance, but these will cut down on the already limited light in most instances. The most commonly used of these is the starburst filter, which will give a four- or eight-sided star from wherever light is reflected; this can give some extremely pleasing effects but can also be most distracting if over-used, and is not usually necessary at most concerts where the stage effects are already so much part of the performance. The use of special effects is more fully discussed in Chapter 9.

Finally, having talked about the use of film, and up-rating, it is important to remember that unless you do your own processing, it is essential to find a processor who is capable of dealing with film rated at anything other than that recommended by the manufacturer, i.e. as shown on the wrapping. This may mean having to use a professional processor, who will most certainly be more expensive than an amateur one, but the results will be worthwhile – in any event, remember to identify all such films to whoever is to do the processing. Also bear in mind that only films which are 35mm or larger can be up-rated, and that it is a technique which cannot be used for instamatic or polaroid films.

Live Performances for Professionals

Details are given elsewhere on how to gain access to the press area but there is no hard and fast rule regarding when and where pictures may be taken. Some performers allow the press into the enclosure for the entire performance, whilst others will only allow, say, press access to the first two or three numbers. The promoters organising the event will normally give you advance warning of the situation, or instructions may be written on the press pass. If not, the security personnel who will be guarding the press enclosure will usually be able to give some information as to what will happen. If you find you are limited in the pictures you can take and/or the areas into which you may venture, there are usually good reasons for these restrictions. Some performers behave in a wild manner on stage and are not averse to throwing large objects off the stage which, more frequently than not, end up in the press enclosure! At one concert in Wembley, all photographers entering the enclosure were warned by the security people to keep away from the central area unless actually taking pictures, and to make sure that any equipment not in use was left well to the side of the area. We were all told that such items as speaker monitors were quite likely to come hurtling down into the area, and that we would be well advised to stand well out of the way not just for the sake of our own safety but for the protection of our equipment. This state of affairs can mean a lot of jumping about to get the pictures you want, as you cannot position yourself in one suitable area in order to get a good vantage point; however, there is always one photographer who either does not listen or does not want to, and the offender on this occasion was rewarded by a speaker landing heavily onto the equipment he had left in the centre of the press area, so writing off his precious Hasselblad.

Perhaps this is a good time to mention that live performances have been known to be somewhat dangerous, and if they are to provide the mainstay of your livelihood then relevant insurance policies should be taken out, taking care to inform the brokers that the equipment will be used for live rock concerts; if this is not done and the equipment is insured only for normal professional engagements, any claim may well not be accepted as this

51 One of the many faces of David Bowie, typifying the character he was putting across to the audience at this point in his life. The detail in the picture is extremely good, with excellent skin tones. The picture was taken from the photo-pit. Olympus OM1, motor drive, 75–150 zoom, Recording film

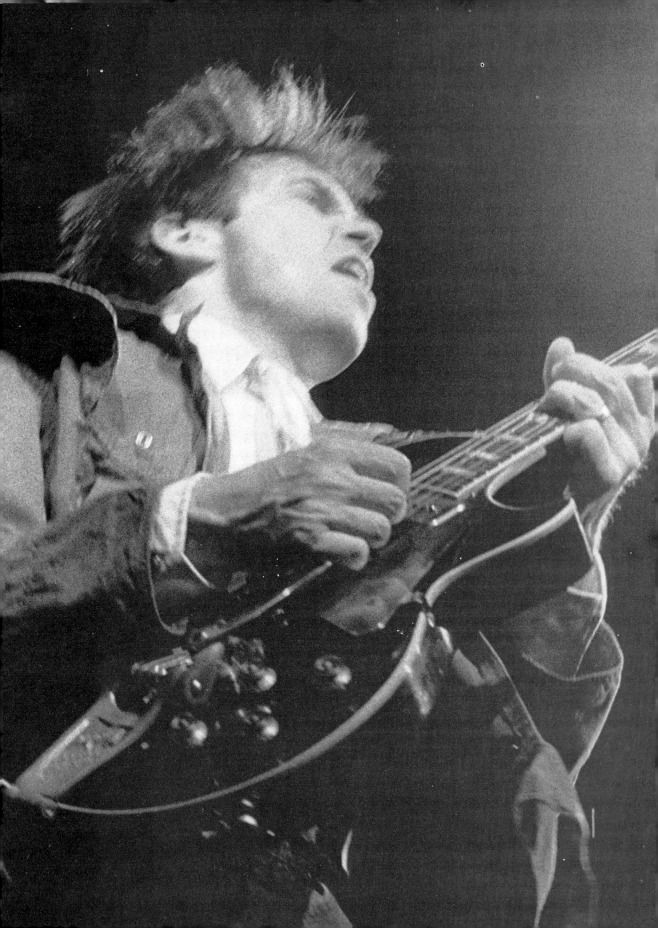

52 LEFT: Neil Young, Wembley, 1982
In order to bring out the atmosphere of a
live performance it is not always necessary
for the picture to be perfectly sharp. Indeed,
it is often more effective to produce a
picture such as this which really brings
across the idea of action and excitement.
Nikon F2, motor drive, 200mm lens,
recording film rated at 2000 ASA

53 ABOVE: the Rolling Stones, Bristol
Football Ground, 1982
Surely the best-known and longest-
surviving rock band in the business, but still
able to bring in packed audiences and put
on an action-packed show, as this picture
from their recent world tour shows.
However, as is often the case today, the
photographers were allowed only limited
access and had permission to enter the
photo-pit for 20 minutes – not a lot of time
when you have a subject that moves as fast
as Jagger, who rarely seems to have his

feet on the ground! Coupled with this, the
photo-pit was on one side of the stage
which meant that the photographers had to
shoot directly into the brilliant sunlight.
Although it is a fallacy to think that you
cannot shoot into the sun because 'the light
will get down the lens', it does make
photography more difficult and with a
subject who is constantly on the move it is
almost impossible to get an exact meter
reading. On this occasion a reading was
finally taken from the stage floor, and the
given exposure was bracketed to one stop
either side. This, fortunately, worked, and
this print was considered the best
representation of the pictures taken.
Although it would not normally be
necessary to up-rate in good daylight, it was
decided to push the film one stop so that a
really fast shutter speed could be used to
freeze the action. Nikon F2, motor drive,
200mm lens, HP5 rated at 800 ASA

aspect of photography is generally thought of as being outside the norm!

The techniques used for live photography depend a great deal on how much time is available. When the photographer is allowed access for the entire performance and encores, there is obviously going to be more of an opportunity for getting better pictures than at a concert where one is allowed access for only one number. So it is sensible to do some research into the performance before taking pictures. As mentioned in the chapter on the role of the photographer, it would be normal for the front-of-house photographer to watch several rehearsals before attempting to take pictures that will end up depicting the typical action that the audience will expect to see in a play. This is obviously rarely practicable in rock photography unless there are going to be several performances in one location, as the performances frequently vary from venue to venue. One way of getting a rough idea of the type of show to be expected is by watching video tapes of live performances, which are quite frequently available in the case of better known groups.

The best way to capture the pictures you want at these concerts is by being fast. This is live action, happening quickly, and if a shot is missed, the moment cannot be recreated. In order to capture one fleeting part of this action, or a particular expression, the photographer will need to muster a considerably amount of foresight, anticipation, imagination and, frequently, luck!

As the main aim is to portray action, it is not always essential for the resulting pictures to be perfectly sharp; indeed, as previously mentioned, it can sometimes be preferable to produce a somewhat blurred shot that totally encompasses the concept of the performance, i.e. movement in conjunction with the special lighting effects. The type of picture taken is normally determined by its ultimate usage or the original shooting brief. If the picture is destined to go no further than the photographer's portfolio then there is certainly scope for experimentation. However, most newspapers and periodicals have their own requirements and even within the music press the type of picture reproduced varies considerably from one publication to another. Thus a freelance photographer should be well versed in the various requirements when trying to sell his work.

Daylight productions

Thus far in this section we have considered 'live' performances as being represented by rock and pop concerts, but there are occasionally daylight theatrical productions that would not normally have photo call coverage. These are very often staged in famous local buildings by local art trusts or festivals; on a larger scale there are such productions as those at Regents Park Open Air Theatre and Kenwood in London, the York Mystery Plays in Yorkshire, and those presented by the National Trust where the scenario is usually one of Britain's famous stately homes. Obviously, as there will be a paying audience, the photographer should try to be as inconspicuous as possible – this will often mean having to be to one side of the 'stage' so as not to block the view.

The productions usually take place on summer evenings and will thus start in daylight, but towards the end the sky will be dark and illuminations will be needed. This means, if shooting in colour, films balanced for the changing lighting conditions will have to be taken along – using daylight film at the outset and, as the natural light fades, switching to tungsten-balanced materials. If it is inconvenient to have several film types, the differing light conditions can be counteracted by the use of colour correction filters – this will also avoid having to change over films suddenly, possibly wasting unexposed frames in the process. These compensating filters are discussed in Chapter 3, suffice it to say here that they are basically gelatine sheets that will affect the colour of the light reaching the film emulsion.

5 The Role of the Photographer

The field of professional stage and theatre photography may be categorised easily into three distinct areas, each of which serves a quite individual purpose. The photographers' aims and briefs can be quite different, and varying means will therefore be employed to come up with the right picture for the particular occasion.

The production photographer, employed by the company or its agents, will provide prints of pictures required for poster-size displays outside the theatre, within the foyer and also those photographs which are to feature in the official and souvenir brochures. The press photographer will be taking pictures for the newspapers, either on a commission basis or as a freelance operative, and will aim to get just one good shot that epitomises the entire production. Finally, the tour photographer will operate within the area of rock photography, and in his official capacity will normally be expected to do anything and everything!

As each of these particular assignments requires quite different photographic techniques, they are dealt with separately.

THE PRODUCTION PHOTOGRAPHER

The production photographer is the person employed to record the show on film

54 *Pirates of Penzance*, (Tim Curry), Theatre Royal, Drury Lane, London, 1982 A good picture of Tim Curry showing a typical expression of 'pirate king'. It would be excellent for front-of-house purposes, as it epitomises both the actor and the character portrayed. Nikkormat FT2, 200mm lens, HP5 rated at 1200 ASA

for display, publicity and general advertising purposes. His fee will include all film expenses, i.e. purchase of film, developing and printing, contact sheets and a certain amount of 10 × 8in work in the case of black and white pictures. For colour pictures, it would include processing of transparencies and (possibly by use of black cartridge paper, or purpose-made black card mounts) 'framing' them for ease of individual viewing.

In the States, production photography tends to be dealt with by a single agency, sometimes using as many as six photographers, positioned at various points in the auditorium. The resulting product is usually the property of the management and is circulated for press publication.

In Great Britain, however, the producing management will initially contact the photographer they believe would be most suitable for taking the pictures of the show. They will check his availability, giving some idea of likely shooting dates, indicating whether rehearsal pictures will be required and advising on dress rehearsal locations (because if the show is opening out of London on a try-out basis prior to coming to the West End, the photographer's other commitments must allow him time to travel there). A number of photographers have been known to fly in from New York to London and head straight for Manchester for a photo session, staying for a day or two's shooting and then whizzing back to London and onwards – a busy life! The photographer will also need to know the management's wishes in respect of shooting, both in colour and black and white, and whether there is to be a coloured souvenir brochure of the show or perhaps a record sleeve – this is becoming quite usual in the case of big musicals. The photographer will then decide his fee and submit it to the management. It is extremely rare for a photographer to lose the job on account of fee negotiations as most managements have their own favourite production photographer and will try and use him whenever they can; it is more likely that the job will be lost because of the photographer's other commitments. Once an agreement has been reached between the two parties a letter of agreement will be drawn up and

55 *Windy City*, Victoria Palace, London 1982
A typical company shot that the production photographer would take for front-of-house purposes to illustrate a dramatic scene from the show. However, owing to the harsh stage lighting necessary

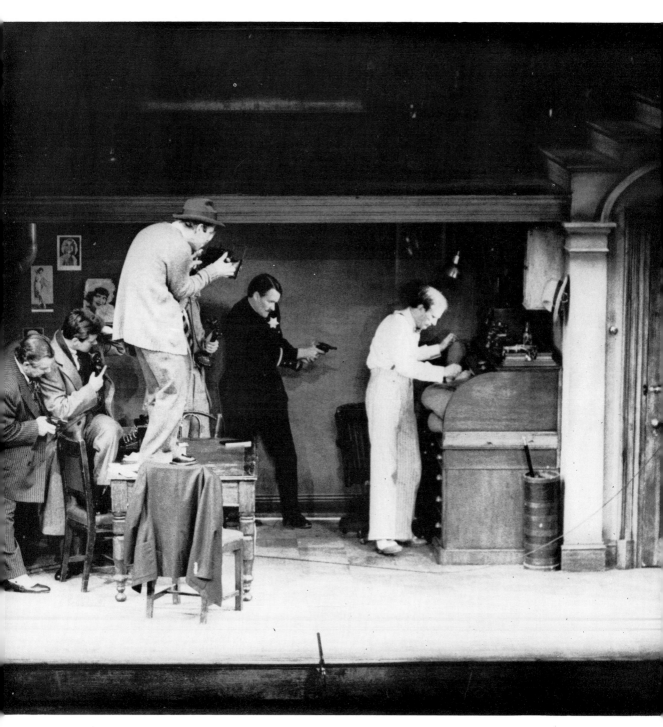

in the theatre because of the overhang on
the set (the stage set was arranged on two
levels) there is very little detail in the high
contrast areas, giving the picture an overall
'flat' appearance, although still being clear.
This picture would be more effective in
colour as the problems would not be so
obvious. The production photographer
would prefer to shoot in this medium when
producing the pictures to be displayed
outside the theatre. Nikon F2, 50mm
standard lens, Recording film

56 ABOVE: *La Bourèe Fantasque*, London Festival Ballet (Kathleen Munson and Freya Dominic)
The lighting was obviously very good as the dark dresses are easily discernable from the black background, and there are excellent skin tones of the faces and shoulders. It is beautifully framed, showing perfect harmony between the two performers, almost to the point of looking like a trick of the camera. It is a beautiful illustration of the piece, epitomising the gentle art of ballet. (*Photograph, courtesy of Anthony Crickmay*.)

57 OPPOSITE: *Hobson's Choice* (Penelope Keith and Anthony Quayle) Theatre Royal, Haymarket, London, 1982
Contact sheet: this shows a good example of a typical photo call. Not all the pictures are perfect, but there is a good selection from which suitable pictures could be chosen for the press requirements. It would be normal to 'chinagraph' those short-listed and make a final selection from a few enlarged prints. Photographs are identified from the contacts by the negative number nearest the centre below the image. At photo calls the lighting remains constant at full power, so that the contacts show even exposures, which would not often be the case at a dress rehearsal where the lighting is more variable. Nikon F2 105/200mm lenses, HP5 rated at 1200 ASA

the photographer is accordingly engaged for that show.

Quite often the photographer is required to take candid pictures of the cast and creative team during rehearsal. This can cause certain problems because the rehearsal venues are often extremely dingy and unsociable. The correct film and lenses are of paramount importance as flash can be most disturbing and, indeed, disruptive (*see* Chapter 2). The photographer will usually sit in on several rehearsals – this sometimes amounting to full days, depending upon his availability – and in order to get his candid shots he must become as unobtrusive as possible. These photographs will be exclusive to him as no other photographers, either amateur or professional, will be allowed in the vicinity. There can be certain perks or spin-offs from the job as the cast get to

58 *Song and Dance*, Palace Theatre,
London, 1982
A good picture showing a piece of the
action frozen at just the right moment. The
dancers' eyes show good contact as they
are both looking at each other. Nikon F2,
motor drive, 200mm lens, HP5 rated at 1600
ASA

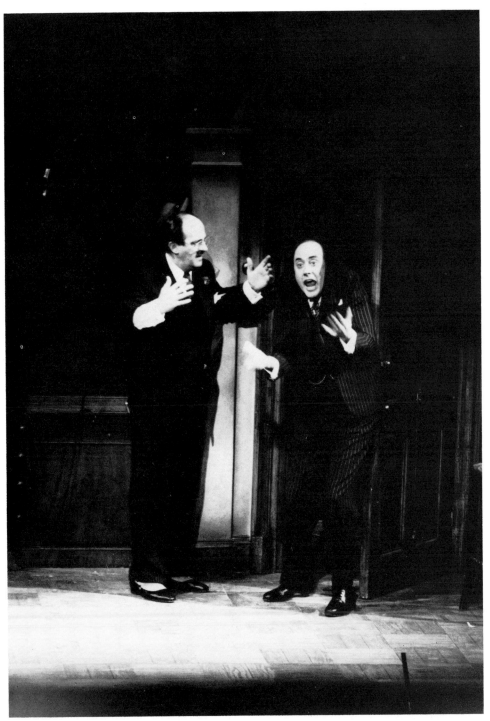

59 *Windy City*, (Anton Rodgers and Victor Spinetti), Victoria Palace, London, 1982
A well-composed picture showing rather grotesque comedy. The overall image is pleasing as it shows a very typical piece of the action in this scene, however, Victor Spinetti's hands are moving, making his left hand look extremely deformed. As this shot very indicative of the scene the production photographer would arrange to re-shoot this particular picture with the actors in a more static pose. Nikon F2 200mm lens, Recording film

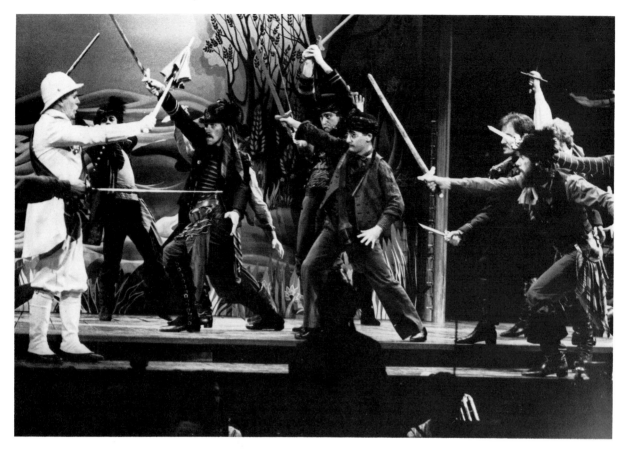

60 ABOVE: *The Pirates of Penzance*, Theatre Royal, Drury Lane, London, 1982
A good action shot showing well the excitement and animation of the production. However, this picture was obviously taken during the dress rehearsal as several members of the orchestra and most of the back of the musical director's head are clearly visable at the bottom of the picture, and could not be removed by selective cropping of the total image without spoiling the picture. In cases like this, where the production photographer would have been in attendance, he would have had to ask for specially set-up pictures to be taken at a later date in order to get this piece for the front-of-house display or souvenir brochure. With a production such as the 'Pirates' this would be done for many of the front-of-house pictures after the production photographer had viewed the full run through at the dress rehearsal. Nikkormat FT2, 105mm lens, HP5 rated at 1600 ASA

61 OPPOSITE: *Don Giovanni*, (Welsh National Opera), Mold, Wales, 1982
This would be a typical picture to illustrate both the artist and the character he is portraying for front-of-house purposes. The shot is extremely sharp showing good tonality and would well stand the great amount of enlargement needed for the front-of-house display. It would also be usable in the official programme as the singer concerned is easily recognisable. Nikon F2 motor drive, 200mm lens, HP5 rates at 800 ASA

know him and trust him, as it becomes an easy matter for newspapers or periodicals to arrange with him to take exclusive pictures of the creators and cast – naturally, extra fees will therefore be forthcoming. Any specially-staged pictures (i.e. in colour and/or in costume), for pre-publicity purposes or for articles in colour supplements and for Radio/TV Times covers, will need to be shot well in advance to enable editors to plan ahead so as to coincide with the London opening of the show.

Having taken his black and white rehearsal pictures he must now arrange for the 'contact' prints. The luxury of colour photographs is not normally viable from the expense point of view at this stage – and, in reality, unnecessary, since no colour photographs appear in the normal programme. These rehearsal pictures and both colour and black and white shots will appear in souvenir brochures. The contact sheets are sent to the management for selection and the photographer will print

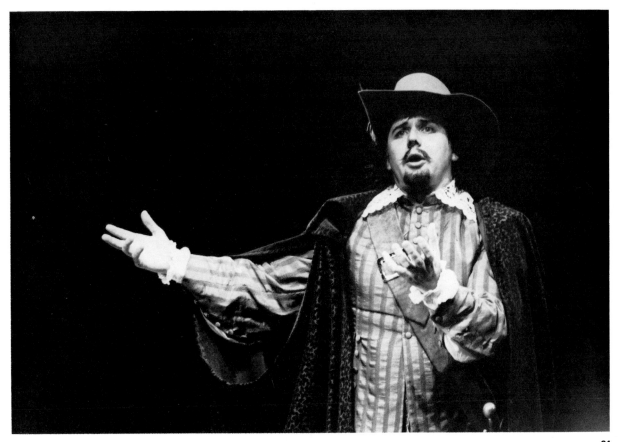

the required pictures in due course, 10 × 8in. being the usual size. The management will deal with their inclusion in their choice of programme, etc.

Liaison with the company manager of the production is obviously of the greatest importance, since the photographer may face availability problems in the event of the production failing to meet its pre-scheduled dates. Nothing can be more annoying to the photographer than to discover, too late, that the dress rehearsal he has come to shoot is no longer in costume, but has become a continuation of the technical rehearsal (*see* Glossary of Technical Terms). This may represent to him losses in terms of money as well as time. It goes without saying that the production photographer must know his stuff, and when he regularly photographs shows he becomes extremely perceptive and aware of the next sequence in the action – this is a tremendous asset when actually shooting, and particularly so in the case of ballet. He will get to know

intimately the preparation for an exciting lift or jump, so that he is then able to capture on film the exact peak of the movement – not a moment too soon nor too late – which is essential for such photographs. He must therefore do his homework, which can easily be arranged; he sits in on as many rehearsals or shows as he requires, having first ascertained dates and times thereof.

A large number of photographs will be taken 'live' during the dress rehearsal; these will be both in black and white and in colour. Sometimes an entire rehearsal will be shot in one medium and another rehearsal in the other; in this way the photographer can avoid being laden down with cameras slung about his person, or littering the auditorium with tripods. This, of course, depends upon his having the luxury of being able to shoot at more than one dress rehearsal. Any pictures which he feels he hasn't captured but would be necessary to complete his brief can be organised at special photo calls. In

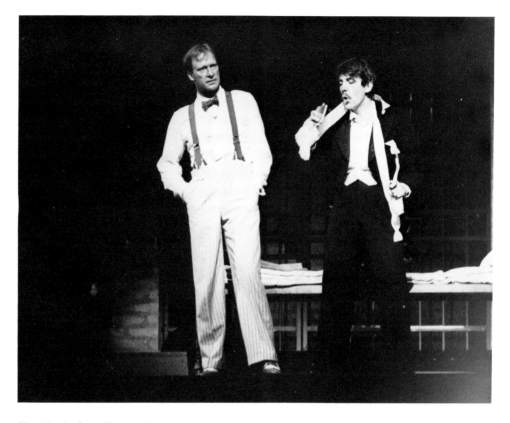

62 *Windy City*, (Dennis Waterman and Maurice Lane), Victoria Palace, London, 1982
This is again an example of the sort of picture that the production photographer would aim to get, as it features the star performer and leaves you in no doubt as to his identity. The picture is a good illustration of both the particular scene and the production as a whole. Nikon F2, 105mm lens, HP5 rated at 800 ASA

some instances certain scenes are best covered photographically by setting up a special performance in front of the camera – which can if necessary be repeated again and again until the photographer is satisfied with the results. Obviously, he must be careful not to overdo this! Such sessions would typically become a two or three hour photo call (longer if required) set aside solely for this purpose. 'Mug shots' or portraits (*see* Chapter 6) could be organised to coincide with this session. Should there be additional needs for special shots, e.g. for colour brochure or record sleeve purposes, other than at the set photo call or dress rehearsal, arrangements would be made between the company manager and the photographer.

When he has his production pictures and is satisfied as to full and satisfactory coverage, the photographer will follow the same procedure of printing and developing as for the earlier rehearsal shots. Management will again select the pictures they like and the layout of the front-of-house photographs and they will give him the deadline for erection of the front-of-house display. The photographer will then ensure that all the photos selected are really sharp (and at the same time check for any glaring errors), before he starts to print them. He will also ascertain what the front-of-house site looks like, and possibly draw a plan of the layout of the frames, complete with exact measurements of each (*see* Appendix II). Some theatre managements may well be able to provide this but it is always advisable for the photographer to check the details for himself. He then sets about getting the photographs printed on the appropriate size of paper, and having them mounted if

necessary (*see* Chapter 10). Once this has been done he makes sure they are all satisfactory and completed to his exact requirements – no blemishes or, worse still, the wrong photograph – before he has them delivered to the theatre. As it is likely that he will not be there when this happens, he must number or mark the photographs very clearly as to where they are to be positioned on site. He will no doubt have organised a site plan (numbered also) for the Company responsible for front-of-house display. This is normally mutually agreed upon by the management, the photographer and the advertising company and thus everyone knows what is expected of them and what to expect – deadlines would normally be arranged to be mutually suitable for all concerned.

The production photographer will usually attend the press photo call himself – just in case there is something he has missed – and will take the opportunity of looking for a better-posed shot than he may have hitherto taken.

Once the front-of-house photographs are erected and the programme pictures settled and printed (along with any sou-venir brochure shots) there is not a great deal left for him to do to complete the particular assignment. He will naturally be able to provide production shots at any time for interested papers or periodicals – thus earning additional fees for his work. He will be publicised in the programme and credited wherever his photographs appear – providing, of course, he has arranged this as part of his contract. The cost of printing his photographs is normally extra to his fee as prices change with shape and size and from time to time, so he will be expected to submit bills to the management, plus fees, travelling and hotel expenses and additional photo calls not covered by the original agreement.

63 *Hobson's Choice*, (Penelope Keith and Trevor Peacock), Theatre Royal, Haymarket, London, 1982
As the role of the press photographer is quite different to that of the production photographer his brief will be to produce one picture, usually to include the billed artistes, that will sum up the production. This is the sort of shot that would usually accompany a critique. Nikon F2, 105mm lens, HP5 rated at 800 ASA

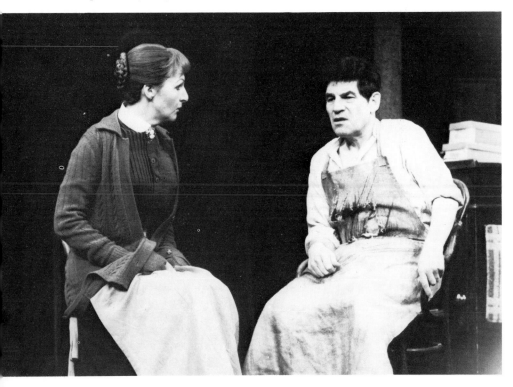

64 ABOVE: *Song and Dance*, Palace
Theatre, London, 1982
Although this picture is most
representative of the production it would be
unlikely to be used for press purposes as
the star performer is not featured. It shows
a good composition and makes an
interesting and dramatic picture, but the
dancer in the dark trousers looks as if he
has one somewhat thin leg as the darkness
of the costume has been lost in the black
background. It is, however, a good
illustration of dance as the artistes are just
touching fingers and with eye-to-eye
contact. Nikon F2 105mm lens, HP5 rated at
1200 ASA

65 OPPOSITE: *The Pirates of Penzance*,
(Pamela Stephenson and Michael Praed),
Theatre Royal, Drury Lane, London, 1982
This tells a lot about the show and would
make a good publicity picture. It would
be suitable for press purposes but it
would not be so good for front-of-house
display as the actors have lost their outside
hands. Nikkormat FT2, 105mm lens, HP5
rated at 1200 ASA

It has to be stated at this point that the
production photographer must be pro-
fessional in his approach to all aspects of
the professional theatre, as it saves time
and aggravation both from his point of
view and that of the management.
Provided everything has been properly
organised, everyone enjoys working to-
gether and thus the best possible results
are achieved in a relatively smooth and
easy manner.

THE PRESS PHOTOGRAPHER

The press photographer is employed, or
commissioned, by a particular newspaper
or periodical or he works freelance, and
his aim is to supply a selection of pictures
that would be suitable for reproduction.

Press photographers within the theatre
are usually experienced and well versed in
the requirements of their picture editor.
The normal assignment is to produce one
single photograph that will sum up the
performance, and will incorporate the

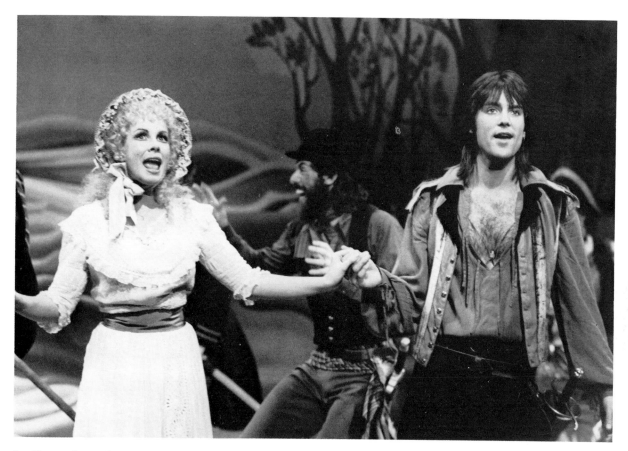

leading artistes, thus encouraging the general public that this is a production that they cannot afford to miss! If, however, the photograph is used to accompany the paper's critic's review, and should that be adverse in its judgement of the production, then sometimes not even the most exciting and truly representative picture will be able to lure the audience into the theatre to see that particular show. Some photographs are used as 'trailers', as in the Sunday papers, the week before the review is to be featured. This is where the press photographer comes into his own to help publicise a show. His photo and a brief caption below may well be the only pictorial advertisement for the show – which is a wonderful 'free' advertisement for the production.

The photographer's pictures are filed away for immediate future reference should a news item (or scandal of some sort) be reported and the editor requires a photo in context and immediately to hand. A good example of this happened recently

when a West End star in a musical became newsworthy but it would have been difficult to take a special photo of him. Of the pictures that appeared in the various papers, two were from the musical's photo call, one was from his most recent television play and two were others from his television series.

The press photographer's job has been largely covered in the chapter covering photo calls, as this is the most usual way in which he will be able to take photographs. Within the national press, it is usually found that those photographers covering the theatre are specialised, and will not cover other assignments such as sporting events, news items and general photo-reporting. However, with the local press it is quite different, as their photographers will cover any assignment, from weddings and christenings to local events and dramas, including theatrical performances. The local press is the starting point for most journalists and press photographers and it is by diversifying that

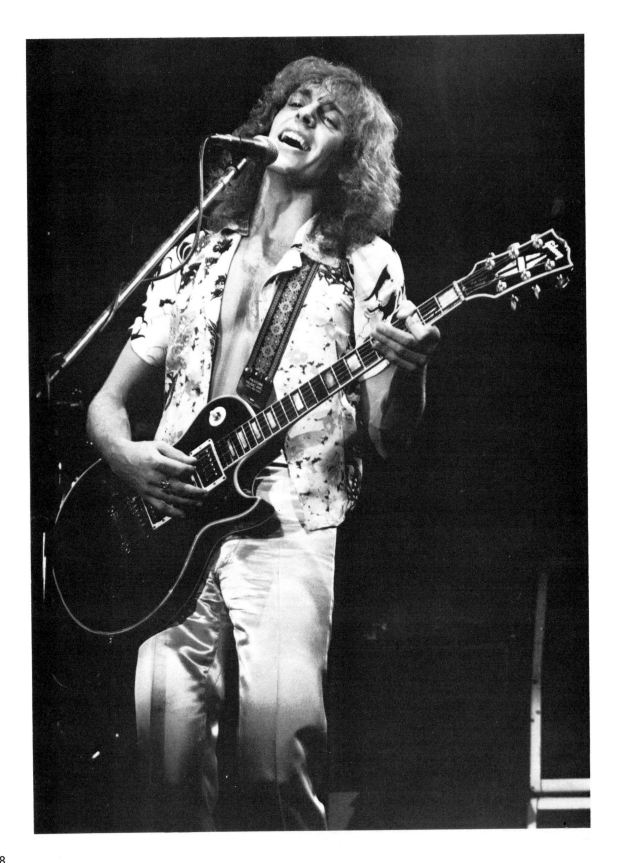

many will identify their specialist subject and go on to do great things within their field.

The essence of press photography is speed – pictures are always required urgently – in most cases they were actually needed 'yesterday'! This means that the photographer is frequently covering more than one session in the same day, rushing back to the office with the films and then dashing off to another assignment. For the freelance photographer, this will involve him in all of the many aspects – taking the pictures, developing, contacting, selecting the right picture, circulating it in hope to the papers and then, maybe, going off to another assignment. The press photographer's lot may not always be a happy one – but it certainly keeps him busy!

The experienced press photographer working in the theatre will know exactly what to do; his brief will have been explained and his prior knowledge of this type of work will ensure that he comes up with the right shot.

THE TOUR PHOTOGRAPHER

The tour photographer is employed by the band to record the whole tour, both on- and off-stage. Whereas the press photographers are allowed access only to the designated press enclosure, and then often only for a limited part of the performance, the official tour photographer is part of the crew and as such is afforded access to all areas, even the stage itself, at any time.

The type of photographs required will vary greatly, and many cannot be strictly called 'theatrical'. Apart from the obvious requirement for good stage shots during performances, and candid off-stage studies of the artistes, other members of the crew may require pictures for their own purposes. The lighting company may require pictures of their rigs, the stage set designer photographs of the set, perhaps

66 Peter Frampton, Wembley, 1976
The virtue of this particular picture lies in the wonderful expression of happiness that has been caught at just the right moment. Facial expressions are an important part of theatrical photography and in this picture it has made the difference between a good or a mediocre picture. Olympus OM1, 75–150mm lens, Tri-X rated at 1600 ASA

even the trucking company needing shots of their fleet!

By the very nature of rock tours a photographer's job is not at all easy. Tours rarely have a logical itinerary and the venues are far apart, meaning a lot of travelling and sleepless nights. It is not unknown for venues to be altered, or even cancelled, or, as one photographer put it '..... if it's Friday, it must be Milan; the only trouble is we're all in Genoa and that's not even on the itinerary!' In Europe, tours rarely take notice of country borders and one country may be travelled through many times in the course of a few days; because of the many customs posts that have to be passed, it is of the utmost importance to have a carnet for all equipment carried. The carnet is organised from the country of origin, and lists all the equipment that is, in effect, being temporarily exported but being used for professional purposes. As the price of such equipment is likely to vary from country to country, the main purpose of the carnet is to enable the customs officials to see that none of the equipment has been sold during the journey. Without a carnet it is often impossible to get through customs, and it is quite likely that both photographer and equipment will be returned to base (and at his own expense!). The tour management will organise all the carnets as they are also required for the musical instruments, lights, sets etc., but further information can be obtained from H.M. Customs and Excise or the Chamber of Commerce.

A considerable amount of equipment will be needed, usually a good selection of 35mm, with several bodies and motor drives (in the event of mechanical failure) and a range of lenses. By choosing a universally-known type of camera, such as Nikon, it will be possible to hire equipment (e.g. extra lenses) for a short term if needed, in most countries (if, that is, the photographer is in one country long enough to take advantage of this!). It is best to purchase all films prior to departure and, in the case of colour materials, to have them processed in the country of purchase as both the manufacture of the film, and the processing, can vary from country to country. Again,

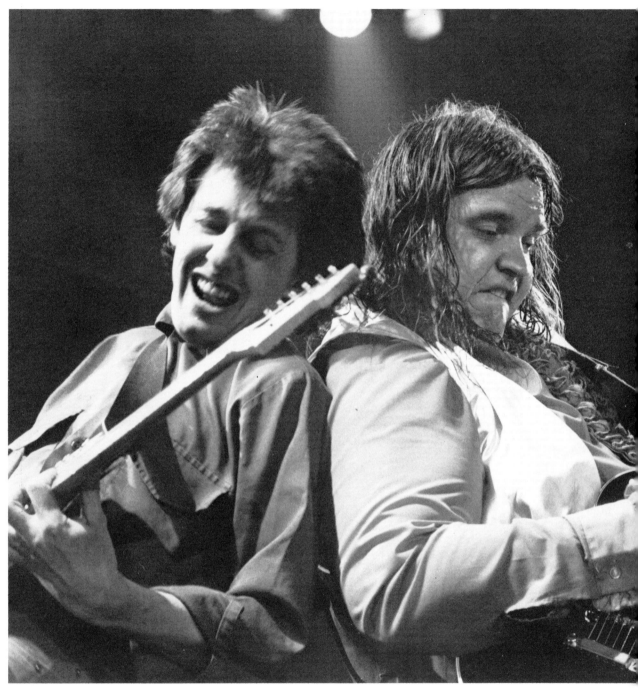

67 Meatloaf, Wembley, 1982
This must surely sum up a typical rock
concert – lights, action, loud music and
sweat! – and two performers give twice the
dramatic impact. No special effects
were used to produce this picture, just a fast
shutter speed and an observant eye to know
when to trip the shutter. Nikon F2 motor
drive, 200mm lens, HP5 rated at 1600 ASA

travelling by air, and to keep both exposed and unexposed films in an X-ray-proof, lead-lined container so that no fogging will result from exposure to metal detectors. Also, it is not totally unheard of for baggage stored in the aircraft hold to arrive at a strange destination or, indeed, to disappear completely!

To become a tour photographer, apart from being competent with a camera, as often as not entails having more than one's share of luck, such as being in the right place at the right time or knowing the right contacts. The most usual way of getting into this field is by impressing the artistes' record company or manager, and having good pictures of the group from a previous tour will certainly help to impress. Any previously published work should also be shown, for if it is good enough to make the music press, or related publications, the photographer will be seen to be a professional, and it will be realised that future pictures would be produced without the artistes being adversely affected in any way.

As with all forms of theatrical photography, the photographer is a necessity but is usually required to be as near invisible as possible; many artistes do not like being photographed, but are usually absolutely delighted to see really good pictures of themselves (especially if they did not realise they were being taken). The tour photographer will have to learn to cope with the many sleepless nights caused by the extensive travelling. One point always to be remembered is to avoid taking photographs of anything that could be considered remotely illegal or illicit as this could cause great embarrassment if the resulting pictures were published.

Some artistes may not even want a tour photographer, but there are usually ways of persuading them otherwise! An unusual idea, such as a book of the tour, may appear an attractive proposition as it will publicise both the artistes and the photographer. However, in the rock business things are rarely logical and one would-be tour photographer, albeit extremely competent and with a good folio of published work, eventually clinched the deal because he happened to have a four-wheel drive vehicle that was capable of towing a

unless a mobile darkroom has been organised it is often difficult to arrange black and white processing abroad, but it may be possible to arrange with international organisations such as Reuters or Associated Press to use their facilities.

It is important to keep all cameras and films with you as hand luggage when

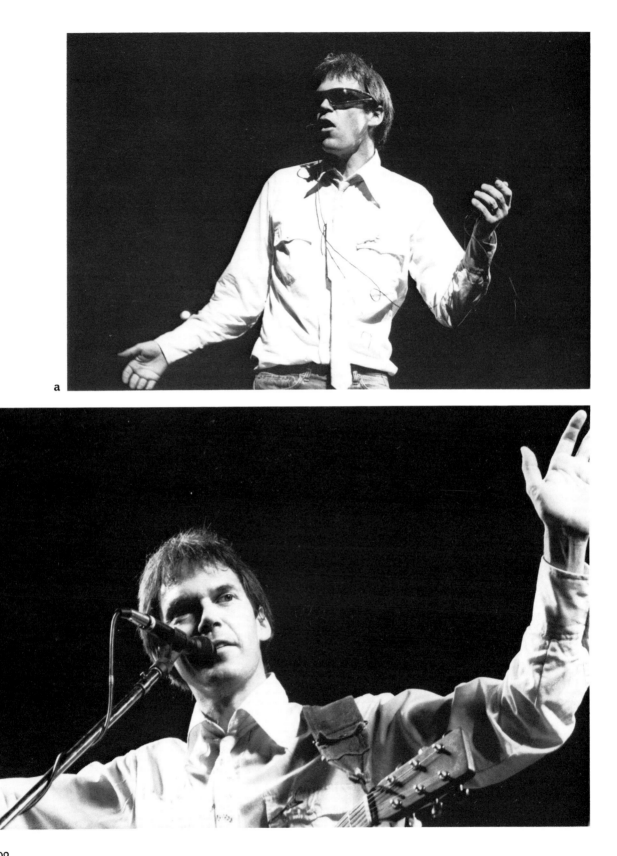

a

b

68a and **b** LEFT: Neil Young, Wembley, 1982
Two very different pictures showing the same performer, during the same performance, that well illustrate his versatility. Both these pictures show a remarkable definition and sharpness not usually associated with this type of work.
a Doing his electronic, 'computer age' act, complete with a 'vocoder' to synthesise his voice.
b A quite different smiling performer playing an accoustic set. Nikon F2, motor drive, 105mm lens, HP5 rated at 1600 ASA

69 ABOVE: Wings, featuring Paul McCartney
This close-up picture, despite being shot on ultra fast film, is very typical of this well-known performer during a live performance. This sort of picture would be most useful to include in the photographer's portfolio as it gives an excellent indication as to his artistic and technical capabilities, and would hopefully serve to secure him further commissions within this field. Olympus OM1 motor drive, 300mm lens. Recording film rated at 2000 ASA

trailer which, till then, the management had found impossible to get across Europe!

All things considered, tour photography is probably best suited to the younger person, as the strain and stress encountered, the flashing lights, the excessive pulsating sound and, to a certain extent, the enjoyment of the artistes and their performance, is unlikely to be appealing to the older person; as with all forms of photography, if you don't enjoy what you are doing, it will most certainly be reflected in the pictures at the end of the day.

6 Associated Forms of Photography

So far this book has endeavoured to cover the various techniques needed to photograph the actual performance, whether live or at a specially convened rehearsal, as it happens on the stage. There are, however, a number of other aspects of theatrical photography that should be mentioned as they are pertinent to the photographer's activities within this sphere.

It would be quite usual for the photographer to be asked for a number of portraits for brochure and programme purposes. He may also be required to take photographs of the more technical aspects of the production, however, as the production team may well need illustrations of the stage sets, the lighting effects, and the like, to enable them to finalise details in one respect or another (or perhaps to compare effects from one scene to another, which would obviously not be possible without the aid of photographs). Each of these activities will call for somewhat

70 Johnny M.
A typical portrait, often referred to as a 'mug shot'. As the most important feature is the facial expression, the exposure was taken for the skin tones, allowing the white suit to be purposely blown-out – this effect is known as 'high key'. The spectacles were sprayed with a dull-matting spray to stop any reflections but, as this could cut out the 'sparkle' in the eyes, they were placed low in the nose. In order to get as much facial tonality as possible, this was shot on a slow (50 ASA Pan F) film and printed on a Grade 2 paper so that there would not be too much detail in the suit, but plenty of subtle tones in the face. Pentax 6 × 7, Standard 105mm lens, Bowens Monolite 750 reflected into white umbrella, Pan F

differing techniques, and accordingly, are treated separately.

PORTRAITS

Most performers will require 'mug shots' at some time in their careers. The most common use of these pictures is for publication in one of the artistes' yearbooks, such as *Spotlight* in the UK, which will be circulated to many casting directors, and the picture will hopefully bring in more work for the performer. These portrait photographs are also used for programme biography illustrations, usually in black and white, and in souvenir brochures so that patrons can easily identify and recall the people they have seen on stage. Sometimes, facilities permitting, it is possible to re-create a scene on stage in which the artiste is currently engaged. Illustrated here is the actor/crooner Johnny M. The plain 'character' shots show how versatile his face can be, thus increasing his chances of getting varied roles rather than being typecast. These were all shot on stage, with a 'pseudo-studio' being created on site. This was a very simple set-up, but gave the desired effect. A plain background was selected so as not to have any distraction from the subject, with a simple lighting system consisting of one Bowens Monolite 750 and white umbrella reflector to give a soft, even and flattering light. The light was placed slightly to one side to give a chiaroscuro effect, adding a touch of drama to an otherwise static shot. It is important to set the lighting very carefully when photographing a subject wearing spectacles, as it is very easy to get unwanted reflections. This is another reason for off-setting the lighting, and also for getting the subject to place the spec-

71 LEFT: This is essentially the same as the preceeding picture: the actor, cameras, lighting and film are all the same. The differences are the use of a Hessian background, gun and a hat and, most importantly, the actor's subtle change of expression. Whereas the last picture shows him with a rather comical smile, this has now changed to a much more sinister look, showing just how versatile his face can be. The smoke from the cigar could equally well have come from the gun, and this all adds to the atmosphere

72a, b and **c** RIGHT AND OVERLEAF: All three of these pictures,

a

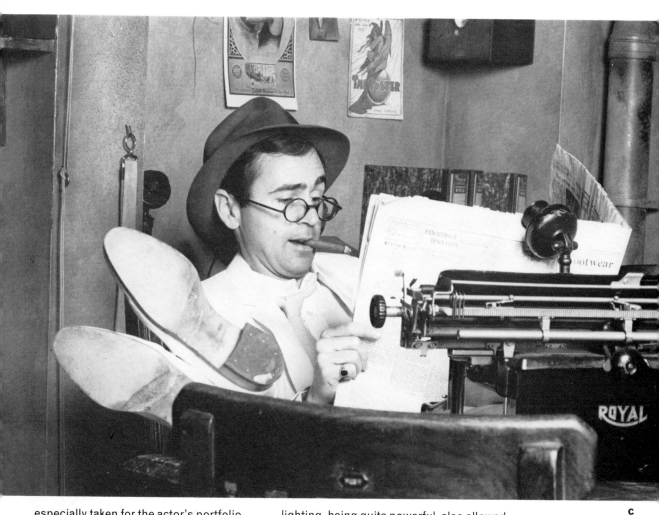

especially taken for the actor's portfolio, were shot under the same conditions. It was felt that if the real atmospheric stage lights were used as the sole source of lighting, in order to capture any action, the film used would have to be up-rated, and this would not give sufficiently good quality prints for the purpose for which they were intended. The use of direct flash would not only kill any atmosphere, but would also leave unpleasant hard shadows behind the subject. therefore, although the pictures were quite obviously taken on a stage set, the same lighting as in the previous two shots was used, taking advantage of the reflective umbrella to prevent any shadows – indeed, it is only the quality of the prints that gives away that these were not taken during a real performance. The studio

lighting, being quite powerful, also allowed for a smaller aperture to be used, thus increasing the depth of field so that not only is the actor in focus but so is the all-important stage set as well. At the time Johnny M. was appearing in the musical *Windy City* in the role of a policeman, which the shot **a** depicts. He also wished to be photographed in some of the other roles and, as the costumes were available, this was easily done. Picture **b** shows him as the escaped convict, who in the course of the musical has to fall through a skylight window whilst he is escaping. The last picture **c** shows Johnny as one of the reporters taking a break to read the paper. (**a** and **c**) Nikon F2, with 105mm lens, Pan F rated normal ; **b** Pentax 6×7, 105mm standard lens, Pan F rated normal

73a and **b** *Windy City*, (**a** Shaun Curry, **b** Ian Burford), Victoria Palace, London, 1982 Although both depicting the same character, these two pictures show the principal **a** and understudy **b**. The brief for the pictures included the production of extremely large blow-ups of each, 30 × 40in. With this in mind, the pictures were taken on a medium format camera, Pentax 6 × 7, and the film selected was slow (Pan F, 50 ASA), so that the grain would be fine enough to be relatively unnoticeable when the negatives were enlarged to the required size. The full technical details on how these pictures were taken appear in Chapter 6.

74 *Windy City*, Victoria Palace, London, 1982

This shows the purpose for which the previous pictures were intended, and the enlargement of Shaun Curry can be quite clearly seen on the stage set. This picture was taken during the photo-call and, although it features none of the billed artists, it is a very typical scene from the show. Nikon F2, 105mm lens, HP5 rated at 1200 ASA

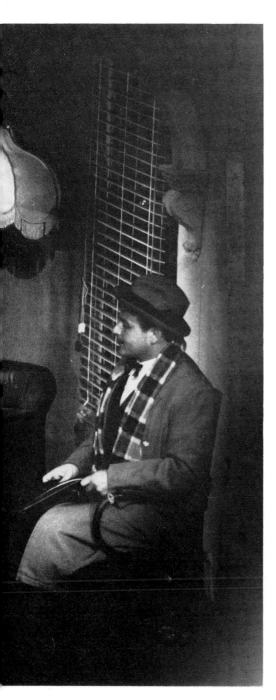

tacles lower on his nose than in normal use. Ilford Pan F (50 ASA) film was chosen, to get a fine, grain-free image and, as the resulting pictures were not going to be greatly enlarged, 35mm format was chosen (Nikon F2 with 105mm lens).

The actor also required some action shots from the production in which he was currently engaged; those taken at the dress rehearsal and photo call had involved all the cast and were unsuitable for close-ups of the actor in question. It was decided to re-create certain pertinent parts of the performance, but using studio flash instead of the house lights; although this cuts down on the dramatic effect of the real theatre lighting, it gives a much better result for the actor's portfolio. Again, a slow speed film was selected as the flash was strong enough to freeze any movement, and the same camera was used but with the standard 50mm lens. This allowed the image of both the actor and the background scenery to be distortion-free and, by setting the lighting to accept a working aperture of f16, gave a good depth of field.

Another example of the static shot sometimes being required in the theatre is when a picture is actually to appear on the stage. The picture illustrated of Shaun Curry was required as a large framed portrait to go on the set, and also to be used as 'billboards' to be carried around on the stage, for the London production of *Windy City*. The character depicted is the Mayor of Chicago and the picture is meant to be his campaign picture to win him back into office. As the character of the Mayor is not particularly pleasant, it was felt that his expression should show a somewhat sardonic smile. The brief stated that the picture would be enlarged to 30 × 40in., so it was taken on Ilford Pan F, on 120mm format, with the lighting set-up as previously mentioned, but taken in a badly-lit rehearsal room. The actor was dressed, top-half only, in the hat and hastily assembled period clothes (as his costume wasn't quite finished) against a grey back wall during the lunch-break – it being the only time available to take the portrait. The same picture had to be taken of the understudy so that, if the principal actor were absent, this portrait could be

substituted for the original and thus consistency maintained for the production. The same 'studio' conditions were created and the actor posed against a neutral wall in the wings on stage, but in this instance he was in the proper costume (again top half only) borrowed from the principal between the matinée and evening performances.

These sort of photographs usually have to be fitted in at odd times and in all sorts of places like theatre bars, dressing rooms, the foyer or the auditorium, more often than not where there is insufficient light, either natural or artificial, so the photographer must always be prepared. Sometimes he is allowed the luxury of taking portraits on the set, where there will be an abundance of light, but time is usually the main factor preventing this as the stage cannot be spared from rehearsals for a long enough period to accomplish the sort of pictures the photographer needs. As a result he has to grab the relevant artistes whenever they have a spare moment and whisk them off to his allocated space. If the portrait is to be taken in costume, care in liaison has to be taken so that no time is wasted on either side, and to avoid the artiste having to don his costume specially for what will amount to a three-minute session.

A final, and somewhat different, type of off-stage photography is illustrated by the singer/guitarist Philippe Dubois (see figure 75). He required a good picture of himself to send out to would-be clients as a photo-leaflet. The finished size of the portrait would be A4 and, as a large run-off was required, the picture would be screened prior to printing. It was decided that 35mm would be sufficient for quality, as the result would not be greatly enlarged, and this allowed many more exposures to be taken without changing the film. This last point is of quite considerable importance when photographing this type of performer; although actors and actresses are well used to knowing how to look their best and how to act in front of a camera, this can often be a daunting experience to someone unused to photographic sessions; so expending a full 36-exposure roll of film and relaxing the model by talking to him whilst shooting can serve to make a much more natural picture. The set-up was carried out in the studio with a Balcar studio flash, with flash head diffused through perspex (US: plexiglass), producing a soft light; highlights were picked out on the guitar by use of a starburst filter, to add a little extra interest to an otherwise simple study. Bearing in mind that the final result would be screened out for a long print run, a medium speed (125 ASA) film was selected to ensure that the reproduction would show good definition.

Further details of studio portraiture, which is what these pictures really amount to, can be found in many specialised publications, one of which – Bruce Pinkard's *Creative Techniques in Studio Photography* – is in this series.

OTHER WORK THAT MAY BE REQUIRED

Some other, and not necessarily obvious, things a photographer may be required to enter into concern pictures of the artistes for costume design purposes, and of the set-model for rehearsals.

In some instances the designer, in this case the costume designer (sometimes there is a set designer also, or one person can occasionally fill both roles), may be an American or other non-Briton, and may be unable to come into the UK until much nearer the rehearsal dates but, in the meantime, must design the costume in good time for the work to be put in hand. Naturally he will need to know details of the artistes for whom the costumes are to be designed, so the photographer is called in after the final casting session to take both full-length shots and head and shoulder close-ups. This would normally be done in black and white, with perhaps a colour polaroid shot to indicate hair and eye colour, and an idea of the artiste's

75 It is not only actors who require publicity pictures, and this picture of the singer/guitarist Philippe Dubois was required to promote his act to clubs in London. To be evocative of the type of performance he gives, his guitar was also included. Nikkormat FT2, 105mm lens, Balcar studio flash diffused through perspex, FP 4 rated normal (125 ASA)

76 Another example of a publicity picture, this time of a rock band. The picture was required to be sent out with a 'demo' tape to various record companies and, as at the time the band had no name, it was difficult for the photographer to come up with a suitable idea for a picture that would be relevant to the purpose. In the end, the band were taken leaning over the mixing desk, giving the impression that they had just finished recording. In order to get all six of them in and, as they had requested, a fair amount of the desk as well, a wide angle had to be used. Nikon F2, 24mm lens, FP4 film, Bowens Monolite 750 reflected into an umbrella

complexion. These pictures may well be taken in the theatre in the Green Room (*see* Glossary of Technical Terms), a dressing room or, more suitably, a rehearsal room. The photographer may even be afforded the rare luxury of being able to shoot in a studio. This is not the norm, however, and so the photographer will need to equip himself with cameras and lighting equipment for the session. The photographs, with all the artiste's measurements attached to the relevant picture, are then sent off to the designer so that he can get on with his valuable pre-production work.

On the first day of rehearsals the set designer will present the director and cast with a model of the set – built to scale and painted down to the finest detail – not just an accurate model, more a work of art!

This model has to go off to the set builder/painter immediately, and that is the last the director or cast will see of it. As there are likely to be several scene changes (and possibly because the model may be multi-level and therefore difficult to remember), the photographer will now really justify his existence! He will be required to take photographs of the entire stage area and each different setting, from all possible angles, and produce 10 × 8in. black and white prints of each. This would usually be done wherever the photographer felt was most appropriate (e.g. his own studio or the Manager's office), and he will be given a completely free hand so far as lighting and photographing the model is concerned; an anglepoise lamp would prove most useful for overhead illumination, perhaps. He will undoubt-

77 This shows the model of Carl Toms' set for the West End production of *Night and Day*, at the Phoenix Theatre London. It was originally taken in colour, but is reproduced here in black and white. The model was lit from both above and front by two anglepoise desk lamps

edly be asked to make several complete sets of prints so that they can be distributed to the departments most needing them. Many a large, complicated show has been made much easier by having these photographs attached to rehearsal room walls – the pertinent photo being studied by the cast so that they can visualise more easily what the set will look like, and thereby feel more at home when they actually come to work on it for the first time.

7 A Look at the Theatre from an Amateur Viewpoint

As has so far been explained, with very few exceptions there is little place in the world of professional theatrical photography for an amateur. However, there are also amateur productions and these offer a lot more scope for the non-professional.

Amateur productions can be just as varied as their professional counterparts and more often than not will be pleased to have a keen amateur photographer take pictures for them, particularly as they would not normally have the funds available to employ a professional. The first step would be to contact the organisers to see if they would like to have a photographer on hand.

As these productions would not normally have the extravagance of a special photo call, the opportunities for photography would naturally be restricted to the dress rehearsal, or to an actual live performance – the production team would advise as to their preference.

Whichever time is selected for taking pictures, it is most important (as with all theatre work) for the photographer to remain as inconspicuous as possible. As with a professional production, the dress rehearsal would be the final check for the cast, lighting and production team to ensure that all will run as smoothly as possible on the opening night. This means the photographer must not block their view, get in the way or distract the cast from their work; this will usually mean that flash cannot be employed. It may be possible, time permitting, to arrange a special session at the end of the dress rehearsal if the photographer requires a picture that he thinks he has been unable to get at the full run-through. This might be a picture of the full cast, a portrait study of the leading characters, or perhaps a quick re-creation of an action-packed scene; it would normally be possible to use flash under these circumstances but, as explained elsewhere, this will tend to kill any atmosphere although allowing for a slower film to be used. The photographer should also bear in mind that the

78a and **b** Children from Fairdene School, Chipstead, Surrey, England, Christmas 1982 Amateur theatrical productions are often a good way for the amateur photographer to start taking pictures, and the school Christmas play gives plenty of scope! Amateurs, especially children, can easily be put off their stride during a production, or rehearsal, if there are photographers flashing lights around them. So, employing the techniques laid out in the previous chapters, the keen amateur can put away his flash gun, up-rate his film and, hopefully, get some good, representative pictures.
a A close up of the group of 'angels' – none of them seems particularly worried by the presence of the photographer who was only a foot or so away from them. However, no flash was used and, as the lighting consisted of rather dim spotlights, the auditorium was so dark that it is unlikely that the children even realised that their picture was being taken!
b A view of the finale with all the children who had taken part on the stage. It is quite clear the picture was taken during a performance, as the parent's heads can be seen as silhouettes in the foreground. Although this picture very much gives the audience's eye-view, the photographer has tried to get too much into it and it is far less effective than the first picture. Nikon F2, 24mm lens, HP5 rated at 1600 ASA

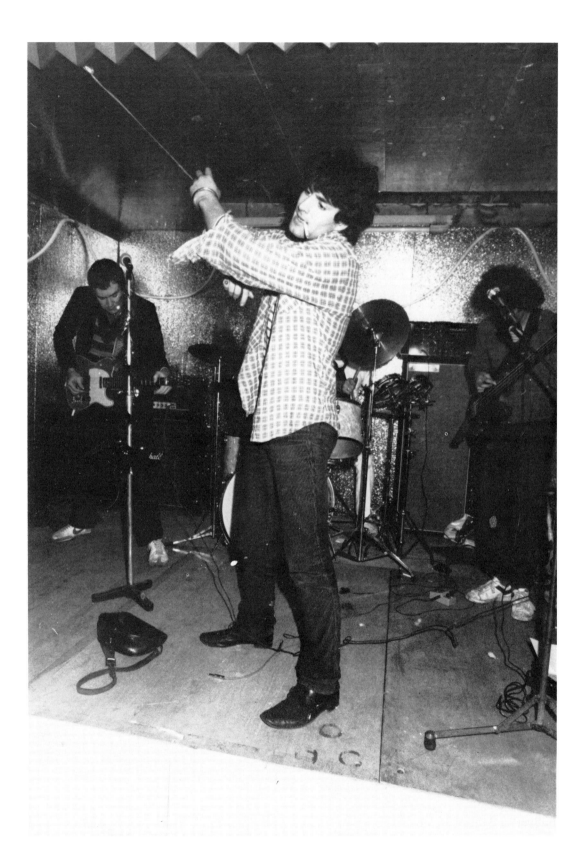

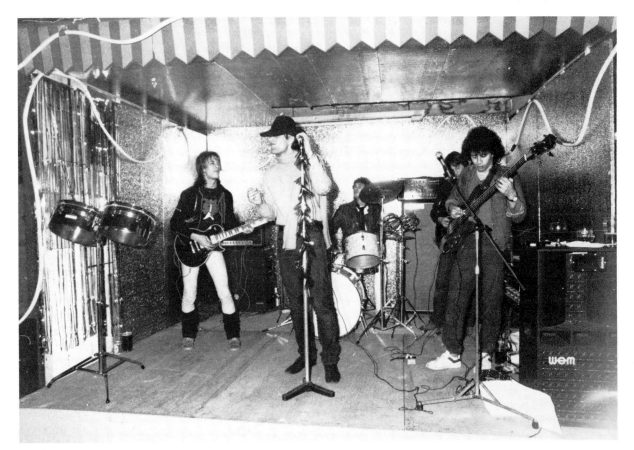

79a and **b** These two pictures were taken at a company's Christmas party, where they had a live amateur band playing. This time the use of flash was employed, as it really was far too dark to render any image worthwhile without it! In order to get as much as possible into the pictures a wide angle lens was used.

a An interesting angle to the full-length shot of the singer very obviously in action.

b An overall view of the stage, showing all four musicians – not always easy as the drummer is usually obscured by one of the others! Nikon F2 motor drive, 24mm lens, computer flash gun, HP5 rated at 800 ASA

production company, or individual artistes, may wish to have some pictures of themselves.

From most points of view the techniques and the equipment used in the theatre are the same for both amateur and professional productions; the photographs will differ only in respect of the equipment chosen (or determined by budget) and the amount of experience the photographer has in this field. Theatrical

photography is so very different from most other forms of photography that it will certainly take some time before enough experience has been gained for the photographer to feel competent enough to undertake this type of work with the sure knowledge that his pictures will be good!

Perhaps one of the greatest failings of the amateur is the way in which he treats his film. Unlike many forms of photography, where it may well be possible to get a good picture after expending only two or three frames of film, this will rarely be the case in the theatre. Film is comparatively cheap, so use it, and plenty of it! It is the cost of producing prints that adds so much to the overall expense, but a lot of prints should not be necessary at first. From the 35mm format upwards it will be possible to have contact sheets made, and from these it will be possible to see small, negative-size, positive images of the entire roll of film on one sheet. Until one is used to viewing contacts, and assessing the merits of the various frames, it can be

quite difficult to see if any one frame is perfectly sharp or not, as the contact image is quite small, but this can be overcome by two methods. Firstly, one can purchase a good quality hand magnifying glass or special photographic 'Agfa-lupe', which is designed specifically for this purpose. Secondly, enlarged contacts can be made, but this will normally necessitate using a professional laboratory. A roll of 36-exposure 35mm film, cut into six strips, will fit onto a 10 × 8in. sheet of paper, but will also fit into a 10 × 8in. negative carrier – thus allowing the whole roll of film to be enlarged, most usually to size 20 × 16in. This will make viewing much easier, and will still work out cheaper than having an en-print (or postcard) sized print made of each picture.

When selecting prints, only choose the very best, as inferior quality prints will not enhance the reputation of the photographer – it is far better to have only a few really good prints than many which are of mediocre or poor quality.

Colour transparencies are another good method of assessing the quality of the photographs, as it is possible to view them quickly at a greater enlargement by projecting them onto a screen. This, however, can usually only be done with 35mm transparencies as there are still very few projectors made today that can cope with the larger formats. If one particular slide looks promising, an enlarged print can be made relatively cheaply through either the R14 or Cibachrome processes; again, it may be necessary to go to a professional photographic colour laboratory.

It is most important for the aspiring photographer to log a record of everything; memories fade with the passing of time and, as one always learns by one's mistakes, it is important to have a record of how these mistakes occurred. Whilst a small notebook can serve admirably, a better idea would be to have loose-leaf sheets suitable for a ring-binder, as then details could be sorted and stored next to the relevant negatives and contact sheets. A suggested log sheet can be found on page 157 in the Appendix, but this is intended only as a guide and the photographer would be expected to adapt the format for his own purposes.

Small, private theatrical productions will often give a real opportunity for amateur photography – who can resist taking pictures of their toddler in her first school play or Christmas production? Equipment may often let the photographer down in these instances, for in spite of his enthusiasm for the occasion, realistically good pictures will depend upon good equipment being used. Whilst the instamatic is not the best camera for such work, it should nevertheless be possible to obtain pictures for the family album if a few basic principles are followed. Firstly, realising the format limitations as explained in Chapter 2, it is best to aim for middle-range shots – nothing too close-up or of an extreme wide angle. Secondly, it is advisable to concentrate on smallish groups of, say, four to six people and the instamatic will require the use of flash for good results in this situation; the flash incorporated into the camera should be able to illuminate this type of shot adequately without giving the 'red-eye' effect that is often seen on close-up pictures when a direct flash of this type is used. 'Red-eye' is an effect seen when a direct, un-diffused flash is aimed straight at the subject; the light goes directly into the eye and illuminates the blood vessels behind the retina, thus making the whole eye appear red in colour. When taking close-up shots with this type of equipment, the only way to lessen this effect is by ensuring that the subject is not looking directly at the camera – so that very little light actually travels through the eye.

It would obviously be better to have a 35mm system, as this will give much more versatility and will afford the amateur far more scope for experimentation, as detailed in the technical chapters. Once a more sophisticated camera format is employed, the scope for creative talents is endless and the resulting pictures, for the keen and proficient amateur, could eventually be just as good as those taken by a professional (in some instances perhaps even better!). Indeed, building up a good, interesting and creative portfolio from smaller or amateur productions may well serve as a passport to the exciting world of the professional theatrical photographer.

8 Behaviour within the Theatre

This chapter may best be regarded as a miscellany of theatrical 'do's and 'don'ts', suggestions and hints, that do not readily and neatly fit the other chapter headings.

Access to the theatre and stage for photographic purposes is afforded for various reasons, and there are points of protocol and etiquette that must be observed; if the production team or artistes, or both, have for whatever the reason been irritated by the photographer, this will inevitably be apparent in the resulting photographs. If there is a lack of rapport between him and his subject, the photographer's task becomes that much more difficult if good, usable pictures are to be forthcoming. Similarly there will be problems when artistes do not really wish to be photographed; here the professional must find a way of putting everybody at ease – not always a simple task!

With these sort of problems to contend with, it can be extremely useful to make use of an assistant, if only to perform the more mundane chores such as film-loading and -unloading, leaving the photographer free to concentrate on more important things.

THE 'ILLICIT' CAMERA

There is always a notice in the official programme (and nowadays notices affixed to the walls) to the effect that 'the use of cameras and tape-recorders in the auditorium is strictly prohibited' and, with the introduction in recent years of internationally-accepted symbolic signs, there are quite often additional signs attached to the walls front of house which, in the style of road signs, depict a camera inside a red circle with a diagonal red stripe across it. These are as easy to understand, whatever one's nationality, as the 'No Smoking' sign in common use.

People who do manage to get their camera into the auditorium, and are clicking away merrily, are often very surprised when they are accosted by one of the theatre staff and told to stop. 'How did they find out?' they ask. With flash, of course, locating a forbidden camera is simplicity itself – even down to the seat number. Without flash is obviously more difficult, but even if light glinting on the lens does not give the game away it is surprising how easy it is to locate the contraband (no matter how far back in the stalls or dress circle the camera may be) purely from the click of the shutter. As to the rotten sneak who spilled the beans to the theatre officials about illicit picture-taking – this more often than not will have been the actor himself! If a flash photograph has been taken the actor may telegraph the fact to the stage manager in the prompt corner with just a quick glance; the alerted stage manager will then use his spy-hole to pin-point the offending photographer. Once identified it becomes a straightforward matter for the theatre manager or an attendant to be advised and the transgressor approached and asked to cease. Alternatively, the actor will come off stage at the appropriate moment and indicate 'Camera – left hand stalls – fourth row – sixth or seventh seat from centre aisle – lady with pink jumper', or some similar clues as to the whereabouts of the smuggled equipment.

80 An excellent example of how not to take a picture at a photo call! Not only are the principal characters out of focus, revealing a pin-sharp image of the maid in the centre of the frame, but it is obvious that the artistes are chatting to one of the photographers, as his head can be seen quite clearly in the centre bottom of the picture! It is important for the photographer to befriend the artistes, but it is not really necessary to photograph the other photographers doing so!

'MAKING FRIENDS' WITH THE ARTISTES

Artistes appearing regularly in Rep productions or in the West End get to know the theatrical photographers, as the same faces tend to appear at photo calls. This will put the actors more at their ease thus making the photographer's task that much simpler. When the production photographer is known to the artistes the personal 'portrait' sessions almost become fun, and for this reason it is a good idea for the photographer to ensure that he is introduced to the cast, so that they know he is their friend and not some alien from the press who must be regarded with some suspicion (it matters not that their ally from time to time earns his living from the papers!). He may well appear from rehearsal time onwards and the more the artistes come to know him and trust him the better future sessions will be – this does not mean, of course, that the photographer annoys the actors with incessant chatter, but a friendly hello and the odd cheery wave by way of a greeting can be of great help.

DEALING WITH DIFFICULT ARTISTES

There are some artistes who loathe being photographed and accordingly will go out of their way to make it as difficult as possible for the photographer to get anything that resembles a sensible shot, some even going so far as to ogle at the camera with gruesome face distortions. Others will keep the photographer waiting interminably. The photographer is obliged to be there and must get the pictures he needs; it appears that he is expected to accept gladly what is happening, as at the end of the day the end-picture is all-important. There are, of course, occasions when the photographer is quite unable to stay, as another photo call may have been arranged (more often than not just as important as the current engagement). On the whole, however, photo calls are arranged so that they do not clash, the press representatives realising that good attendance and the resulting good coverage is all-important. Extreme tact and diplomacy must be brought into play to persuade the actor that the whole thing will

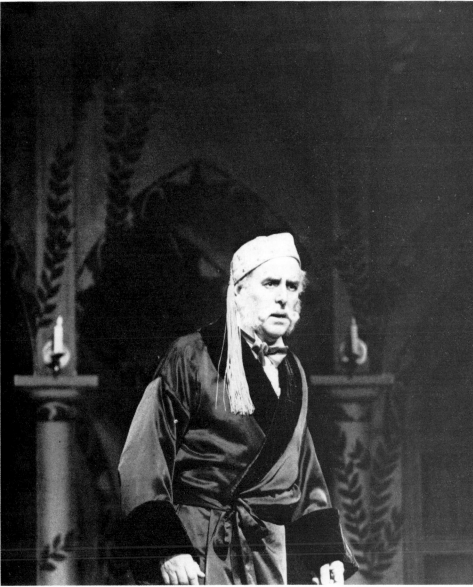

be short and quite painless. There is always the danger that the photographs could reflect the actor's dislike of the whole affair, but a let's-end-this-session-as-quickly-as-possible type of compromise will normally be reached; at the end of the day, however, it is up to the photographer to persuade the actor to co-operate, at least to this extent. Nonetheless, whilst some artistes will always see the photo call as a boring chore, most actors will at least tolerate it and see that it is an essential part of the whole production.

81 *The Pirates of Penzance*, (George Cole), London, 1982
A typical intimate character shot that would have been achieved after the photographer has asked the artiste to pose specially for the picture. Nikon F2, motor drive, 200mm lens, HP5 rated at 1200 ASA

USING AN ASSISTANT

When the production photographer attends the dress rehearsal it can sometimes be a good idea (if he can afford it) to take along an assistant, so that while he is busy shooting the assistant can be loading the next camera (more than one camera being of paramount importance, as we have discussed elsewhere). Where a Hasselblad is used, several fully loaded 'backs' (or magazines) mean that only one camera body is required, and in this instance the assistant would be occupied with reloading the exposed backs. The assistant (and indeed the photographer himself) will need to be considerably adept at loading cameras in the dark, as at most dress rehearsals there will be little or no light within the auditorium other than what is required on or adjacent to the production team's console (and that is the most important place to steer clear of!). Of equal or greater importance is the need to organise the whereabouts at all times of the exposed film. It is advantageous to unbox a number of films and lay them out for ease of location before the rehearsal begins, and it would obviously be relatively easy to mix the exposed and unexposed films up if they are not kept apart. The photographer (and his assistant) must also realise that the best way to improve and maintain good relations with the theatre staff is to clear up after himself; boxes and cellophane wrappers, film containers, leaflets etc. should all be neatly bundled up and disposed of in the appropriate rubbish receptacles.

ETIQUETTE AT PHOTO CALLS

When photo calls are arranged for the press (or in some instances for the production photographer), the scenes to be shot are usually decided upon by the director in conjunction with the company manager. These will normally be scenes featuring the stars and main billed artistes, rather than the larger, spectacular scenes, as in the case of musicals. The shots will therefore be much more intimate and representative. The press photographer will not normally address the artistes or stage manager directly. If he wants something done, for example more light on stage or a re-enactment of a particular piece of action, he must approach the press officer for the show (who will be in attendance) and it is he who will liaise with the artistes through the stage manager. Nevertheless, it is customary for the photographer, when taking a close-up picture of an actor on stage, to ask him to look in a particular direction, smile a little, not wrinkle his nose at a certain point, look as though he is saying something dramatic, open his eyes, etc., etc. The actor will quite happily do as he is asked provided one doesn't take liberties and the session doesn't go on for too long.

TECHNICAL REHEARSALS

It is extremely unusual for the photographer to be called to take any photographs during a technical rehearsal ('tech') except in extraordinary circumstances. It will undoubtedly be an utter waste of time, as certain parts of the set may be unfinished (so any sequences taken will be incomplete, therefore inaccurate, therefore useless!), or certain actors may be in costume (depending upon how technical the rehearsal is intended to be) but possibly not the entire costume or the finalised costume. There may or may not be scene changes, or perhaps only certain scene changes; if there are to be numerous scene changes then it will be unlikely to be a rehearsal involving costumes, as it is normal to sort out all set and scene change hiccups before adding to the artistes' problems by putting them into costume. Again, if it is a complicated show, the sets are unlikely to be fully dressed (rendering photographic records untrue) and almost certainly lighting arrangements will be nowhere near finished (and fluctuating lighting situations are not normally of tremendous help to the photographer!). The purpose of these rehearsals is to iron out technical problems, this can mean two or more hours per scene in all probability, so the photographer will spend a considerable amount of time just hanging about – unable to contribute and unable to achieve anything, and this coupled with the tremendous activity, friction, and resulting temperamental outbursts from those more directly involved, is likely to induce boredom.

9 Special Effects and Filters

Within the normal spectrum of theatrical photography, special effects are not widely used. As the aim of the theatrical photographer is to capture a true record of the performance, actors, lighting, sets and atmosphere, the addition of special photographic effects would seem superfluous. However, in any form of photography there is scope for a little creativity and it is this that can make the difference between a good and a brilliant picture.

COLOUR COMPENSATING AND CORRECTING FILTERS

Of the many different types of filters on the market, most have little relevance within the theatre. Colour compensating filters have already been dealt with in the chapter on film materials, and these are most important if a daylight-balanced film has been used and needs correcting for tungsten lighting, or vice-versa. Many of the correcting and compensating filters are useful only in daylight situations, where they will darken skies, cut down on flare, remove reflections and the like, and these will serve little purpose, obviously, in the artificial light conditions encountered at most theatrical performances. Again, however, there are odd occasions when productions take place outdoors, in daylight, such as open-air theatre and day-long pop festivals. In such circumstances a skylight filter and a polarising filter could both be useful.

Skylight (or UV) Filters

These will cut through the ultra-violet light that is invisible to the human eye; the effect is to cut out haze and to give better definition to the image.

Polarising Filters

Light consists of waves which vibrate in all directions and these filters allow light to pass through them in only one direction. By rotating the polarising filter it will be seen that at a certain point the sky becomes darker, making the clouds appear whiter – a dramatic sky can considerably improve a picture where a large area of sky is integral to the photograph.

SPECIAL EFFECT FILTERS

These come in many forms, some designed to give effect with both colour and monochrome materials, others being apparent only when working in black and white, and others still apparent only in colour operations.

Starburst Filters

These are most obviously suited to theatre work and consist of a glass screen with criss-cross wire mesh within it; depending upon the amount of mesh, this filter will give a six- or eight-pointed star where light has caught a reflective surface. Great care must be exercised in its use as it is extremely easy to over-do the effect, the best results being obtained when only one or two points pick up the light.

Softar Filters

These usually come in three different 'strengths' and can be used singly or in conjunction with one another; their effect is to soften the image, which can be very useful when taking portraits as it will give the skin an almost glowing appearance and will considerably lessen any lines or wrinkles, thus giving a more flattering portrait.

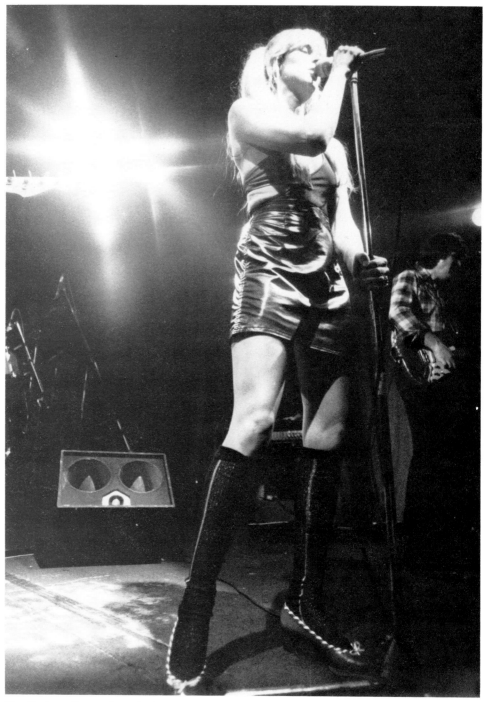

82 Carlene Carter, The Venue, London, 1980
A starburst filter, in conjunction with a wide angle lens, has been
used to produce this picture. However, because of the strong
backlight, the starburst effect has been rather overdone and has
now become more of a focal point than the artiste herself. Nikon F2,
24mm lens, HP5 rated at 1200 ASA

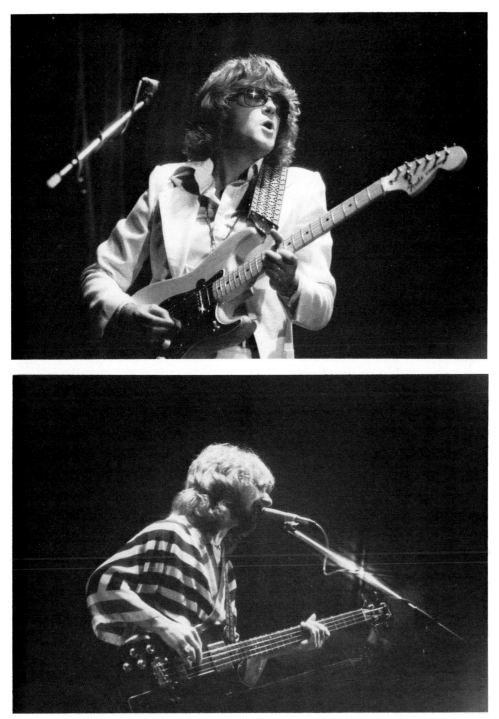

83a and **b** Barclay James Harvest,
Hammersmith Odeon, London, 1977
Both these two pictures illustrate a much
more subtle use of the starburst filter.
a Reflections from glasses can often be a
problem but, by using the filter, this has
been turned to advantage by producing an
impression that he has a 'twinkle' in his eye.
b The starburst effect on the microphone
stand – a static object that cannot be
removed but that has now been given a little
bit more interest and improved the overall
picture as a result. Nikkormat FTN, 135mm
lens, HP5 rated at 1600 ASA

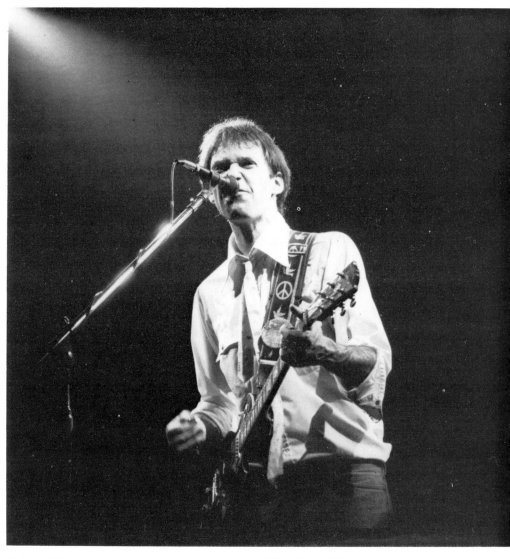

Prism Filters

The effect of these is to give from between three and six overlapping and displaced images on one negative; this is somewhat contrived but can be used to give an unusual picture of one artiste.

Graduated Filters

Sometimes known as 'chromo-filters' these are useful only when working in colour; the filter is half clear glass and half colour-tinted, but where the two join there is not an obvious harsh line but a gentle merging of clear and colour. Their application within the theatre is somewhat limited but could be of use at an outside venue to give an unusual hue to the sky.

The list of filters is enormous and, as many are not pertinent to theatrical photography, they are not relevant to this book. Hoya and Cokin probably produce the most extensive ranges of creative filters, and both have excellent illustrative catalogues, with pictures showing the effects that they produce.

EXPERIMENTING WITH FILM

In addition to 'manufactured' special effects, there are several ideas that the creative photographer could try by experimenting with his film. These techniques are best employed when dealing with concert photography, as the other theatrical photographic fields require a

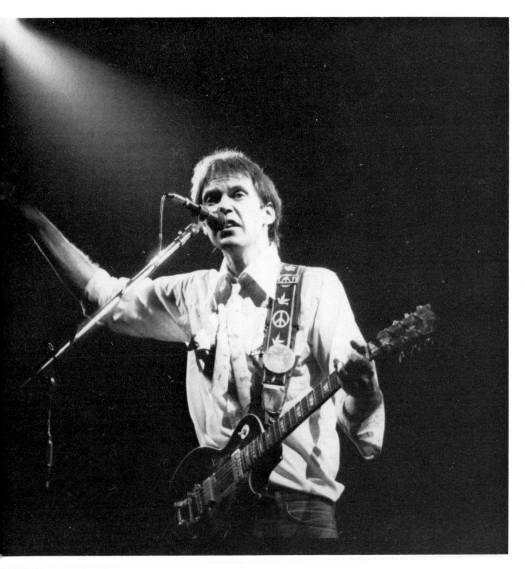

84 Neil Young, Wembley Stadium, 1982
Live rock photography can cause many
photographic problems, but it is still
possible to attempt some more creative
effects. Although this looks like a very
clever double exposure, it was much more
simply produced than that. Instead of
putting the film through the camera twice,
two consecutive frames were shot with the
main subject close to the right on the first
frame and very close to the left on the
second – the two frames could therefore be
printed together, giving the impression that
a double exposure had been made! The full
details of how to achieve this effect are to
be found in Chapter 9. Nikon F2, motor
drive, 20mm lens, HP5 rated at 1600 ASA

AREA PRINTED

85 Neil Young, Hammersmith Odeon, London, 1978
A stunning example of a creative double exposure, showing both the artiste and the outside of the venue advertising the performance. The shot of the venue was taken first on a 28mm lens, and the second exposure of the artiste taken on a 300mm lens from the balcony in the auditorium, ensuring that the image was centralised to give the most impact to the resulting print. The full technical details of how this effect was produced can be found in Chapter 9. Olympus OM1, 28mm and 300mm lenses, HP5 rated at 1600 ASA

much more precise and correct image to be captured and special effects are likely to distract.

Double Exposure

All that this requires other than the camera equipment and film, is a chinagraph crayon. As the film has to go through the camera twice, it is important to mark both the film and the focal plane on the camera with a chinagraph mark; when the film is reloaded, the marks are re-aligned to ensure that the frames do not overlap from the first exposure to the second. This technique could be used in many ways, an obvious one being to double-expose one article so that it appears twice on the same frame (having slightly altered the position of the subject for the second shot, of course); alternatively, exposing the first time for the artiste and the second time for the venue could make for an interesting picture. A word of caution, however – double exposing can affect the exposure considerably and it is advisable to clip-test the film before the final processing.

A technique to give the effect of double exposure without having to put the film through the camera twice involves, very simply, when shooting consecutive frames, keeping the main subject very close to the right on the first frame and very close to the left on the second; as the background will invariably be black, the line between the two frames will cease to be visible. When printing the picture, the negative is sandwiched in the carrier so as to print the picture as if there were only one frame (*see* diagram). If the background does not go black through normal printing, the line can be removed by holding back the main image and printing-in the background (*see* Chapter 3).

Hand Tinting

When working in monochrome, hand tinting can give a pleasing effect, especially if its use is restricted to one region only. Hand tinting, really a type of re-touching, is done with specially made photographic dyes and a fine paint brush. It will take quite a lot of practice before the right depth and evenness of colour are acquired. When working over a large area the most even distribution of colour will be given by applying the dyes on a piece of moistened cotton wool; depth of colour can be built up by re-applying the diluted dye in the same way.

Darkroom Effects

Within the darkroom there are yet more ways of creating effects. There is a wide range of specialist papers currently available. These are exposed and developed in the usual way, but the paper base is available in a range of different colours, including metallic finishes such as gold and silver, so the finished print can look quite different.

Texture screens are available in many finishes and can give interesting results. The screen is a thin gelatine sheet that is sandwiched with the negative in the carrier of the enlarger. When the negative is exposed a 'texture' is also projected onto the paper – the print is then processed in the normal way. These screens are available in such textures as canvas, linen and reticulated, and are usually sold in sets of four.

A final example of effects is that of sepia toning, which is a two-step process carried out after a print has been produced. The first process bleaches out the print, whilst the second tones it back but in shades of beige and brown rather than the original black and white.

These effects should all be used with a certain degree of caution where theatrical photography is concerned; their subtle use can be quite effective, but it is very easy to over-do any effect and this will only serve to make the picture look contrived and totally unrealistic.

10 Filing and Storage

Whether amateur or professional, the system selected for the storage of photographic materials is of the utmost importance. Negatives and transparencies are both easily damaged, so the system must afford good protection. It should also provide for fast and easy location of any particular slide or negative. It will also be useful to keep a certain amount of technical data with the relevant negatives, indicating the speed at which the film was exposed, the camera and lens used, the date and venue of the performance a list of the principal characters, and other such information.

There are several ways of storing negatives, one of the best being the ring-binder file system, as it offers splendid protection for the materials. These can be purchased at most photographic stores, along with their tailor-made sheets in which to hold the negatives. They are available for 35mm and 120mm formats only, and allow a 36-exposure roll of 35mm film, or a 120mm length of film to be cut into strips and filed on one sheet. Because a ring-binder file is used the system is completely flexible and will allow not only the negatives to be stored but also the relevant contact sheet and a sheet of technical information. This means that all the data is stored in one place and is thus easy to locate. The only drawback with the system, especially if there are a large number of negatives to be stored, is that it is comparatively expensive.

A cheaper form of storage involves the use of negative bags, which are long, thin bags designed to accommodate 35mm or 120mm films cut into strips (one film per bag). Unlike the ring-binder file system, where each sheet will store a roll of film in separate compartments, the negative bags do allow the negatives to come into contact with each other; each time one strip is removed it will rub against the other negatives and this can cause minute scratches that could be apparent when the negatives are enlarged. The negative bags can be stored in a filing cabinet drawer, but are not so easily accessible as the ring-binder files. There are advantages and disadvantages with both systems and the photographer must decide which best suits his needs.

Prints are most easily stored in box files. Reproduction requirements are most usually for a glossy, unglazed 10 × 8in. print and it can be convenient to have a selection of prints ready to be sent out when required. Smaller prints, which will be few in number, could be stored in the normal type of photograph album.

Transparency storage is quite different from negative storage as the transparencies are usually required to be individually mounted, with details of the artistes clearly printed on a caption label. The various slide mounts available vary considerably in the degree of protection afforded to the transparency and this, naturally, will be reflected in the price. The most basic, and cheapest type of mount is the cardboard one, frequently found on process-paid films provided by the manufacturers. These are easily purchased and, as they are self-adhesive, are simple to use; unfortunately, they offer little protection to the transparencies. Similar to these are plastic mounts, somewhat sturdier and more rigid than the card

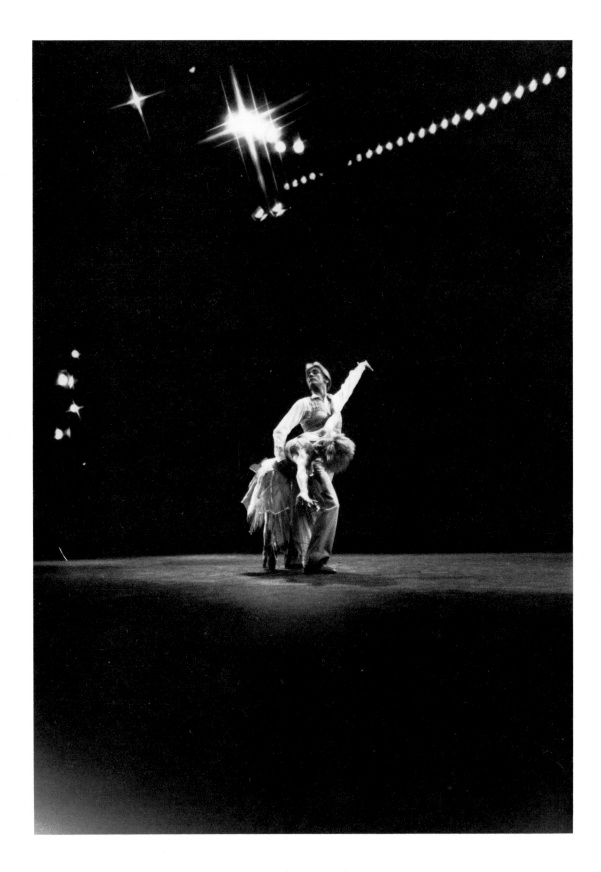

type but still affording little protection to the slide itself. They can be used in conjunction with storage sleeves, which can easily be kept in ring-binder files or, with a suspension bar fitted, stored in a normal filing cabinet. The sleeves are available for 35mm, 6 × 6cm, 6 × 7cm or 5 × 4in. transparencies.

Plastic mounts are also available with glass sheets in them, so that the transparency is neatly sandwiched between glass and is therefore unlikely to incur any damage. However, it must be remembered that slides mounted in glass must never be sent through the post as they can easily shatter. These mounts are excellent for domestic use but are unsuitable if the transparencies are to be frequently submitted to publishers, magazines and the like.

Clear acetate sleeves or bags, usually clear on one side and with a translucent diffuser on the other, can offer good protection as they can be sealed to prevent any dust particles getting onto the surface of the transparency. However, as there is no stiffening, the larger sizes of transparency can be easily bent.

The best, and therefore probably the most expensive, form of transparency mount is that which combines the stiffened card mount with the acetate sleeve. The mounts are black card, 5 × 4in., with a central cut-out to accommodate either 35mm, 6 × 6cm, or 6 × 7cm slides. The transparencies are fixed into the mount with sellotape and then put in the acetate trans-sleeve. As there is a large amount of blank card there is plenty of room to affix a caption label; finally, the sleeve is sealed to prevent the ingress of dust particles. The mounted slides can then be filed in card index files made to take 5 × 4in. reference cards.

The choice of transparency mounts is dependent upon usage and price; if a transparency is to be frequently viewed and/or sent out to magazines and publishers, it would be a false economy to provide a mount that offers inadequate protection. If the only use is to project the slide at home occasionally, a simple mount will often suffice.

For both transparencies and negatives it is important to have a good retrieval system, so that any one artiste or production can be found immediately. There are various ways of doing this, depending on how frequently the slides will need to be removed from stock. It is probably best to file any work under the production's working title, with a cross-reference filing system to give details of the artistes concerned; thus for any one artiste there may be a list of several productions. The photographer will know the frequency with which he is asked for pictures, and whether this is by production title or by the artiste's name, and he will organise his filing system accordingly.

86 *Song and Dance*, London, 1982
Ballet can give an opportunity to do a little experimentation and so produce a more interesting print. This picture shows good composition, with the subtle addition of a starburst filter. Nikon, 24mm lens, starburst filter, HP5 rated at 1200 ASA

Appendix I:
The Amateur in the Professional Theatre

Throughout this book it has been heavily stressed that there are few opportunities open to amateurs in the professional theatre. This is not because an amateur would be unable to take good pictures but, being unused to the situations encountered, he could get in the way or be a nuisance simply because he did not understand the usual etiquette of the theatre.

As an experiment, for the purposes of this book, it was decided to give two keen amateurs an opportunity to take some theatrical pictures as their totally fresh approach could produce some interesting comments and, hopefully, some interesting results too! They were given quite different assignments to cover, taking into account their personal preferences for the type of performance they liked.

The first photographer, Chris Stewart, liked the colour, excitement and action of a musical, so was asked to cover the new 'up-market' production of the Gilbert and Sullivan classic *The Pirates of Penzance* that was due to open in London with an all-star cast. He was given less than twenty-four hour's notice of the performance and, after a hasty twenty-minute lesson on how to operate the cameras, was despatched armed with a battery of Nikons, motor-drives, lenses and a selec-

tion of both colour and monochrome films. He was then on his own and, if a problem were to occur, he would have nobody to turn to and would therefore have to work it out for himself.

The second photographer, Paul Alger, had more classical tastes, so it was decided to treat his experiment in a somewhat different way within the realms of the opera. Instead of being on his own, he came along as the assistant to one of the photographers, but was given ample opportunity to take all the pictures that he wanted. At first he used his own equipment but, as the quality proved unsatisfactory and mis-leading of his true abilities, he was later loaned Nikon equipment to use – and his results improved dramatically. Over a period of a few months he attended three different performances (one photo call and two full dress rehearsals) and it is interesting to see how the pictures improved as he acquired more experience.

Their comments regarding how they felt, coped and reacted in these situations follow.

CHRIS STEWART

When I was first asked to go to the photo-call of *The Pirates of Penzance* I was very excited at the prospect. However, as the day drew nearer this changed to fear. Me, alone, taking photographs of a top musical! The first step for me was to visit the library to try and find out as much as possible about taking pictures in the dark without flash. Sadly, there wasn't much information available but the general idea seemed to be to up-rate the ASA rating of

87 *The Pirates of Penzance*, (Michael Praed), London, 1982
This is probably one of Chris's best pictures, being very representative of both the character and the production as a whole. There is only one criticism – the tip of the finger has been cut off! It is definitely the sort of shot that would be used for front-of-house purposes if it were not for the one small error

88 This is another nice shot of Michael Praed, but it should have been framed to include only him. It could be salvaged by cropping as marked. It is a very clear and sharp picture otherwise, and very evocative of the production

 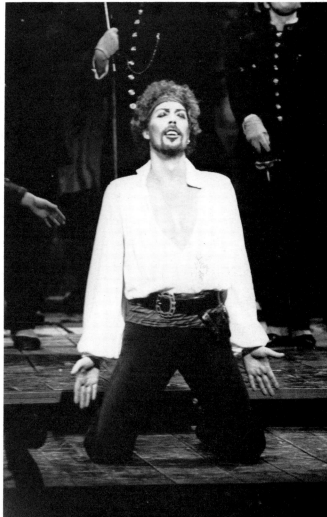

89a and **b** Neither of these pictures of Tim Curry in the role of 'Pirate King' has quite succeeded

a Chris has tried to capture a most typical moment in the production, but sadly the image is not really sharp enough and at that particular moment Tim Curry's leg is in a most peculiar attitude, Making him look almost deformed!

b This is quite well composed but again it is really not sharp enough and the fact that Tim Curry's eyes are closed, although evocative of emotion, would probably render it unusable

a

90a and **b** These two pictures illustrate
that the photographer is not always aware
of exactly what he is taking – and this is not
something that is unique to the amateur!
a A very suitable picture for front-of-
house purposes except that, again, there
are unavoidable distractions in the
foreground. In the centre the music
director's head is quite obvious; to the left
of this is the top of a double bass; and to
the right appears to be some sort of light! It
should be stressed that these last three
intrusions are almost unavoidable when
taking pictures at a dress rehearsal and that
the production photographer would be able
to organise a special re-enactment of the
scene to get the pictures that he requires.
Despite this, the picture is well framed and
conveys the comic element of the show
b This would have to be retouched if it
were to be used for advertising the
production as Tim Curry appears to have
somebody's hand dangling between his
legs, as well as the tip of his sword.

the film from 400 ASA to 1600 ASA, thereby allowing for a faster shutter speed to be used than would normally be possible. Paddy had lent me a Nikon F2 with a motor drive and one of her Nikkormats, so the night before was spent examining, testing and generally experimenting with the unloaded cameras. Confidence started to return gradually!

The show was due to start at 2.30 p.m. at the Theatre Royal, Drury Lane, London. At 1.00 p.m. I had arrived, and spent some time walking around Covent Garden trying to relax. For the first time in my life I entered a theatre by the stage door, and was led through the backstage area into an empty auditorium. Other people started to arrive and by 2.30 everyone was there, eight of us in all: five photographers, the director, producer and assistant. By this time I had made my first mistake: you don't ask the producer who

he is! Still, it broke the ice with the other photographers!

Five minutes or so before the start of the show was spent checking the cameras: had I loaded the film correctly? would the motor-drive work? could I find the other lenses in the dark and fit them? These were some of the questions flashing through my mind. The other photographers were very helpful and gave me some advice from their own experience. Unfortunately, we were not allowed to move around the theatre to look for various vantage points, so had to choose seats: I hoped that my choice was a good one. My motto became, if in doubt, stick close to the professionals.

The lights dimmed and the show started – I was now on my own. I had to make a difficult choice between watching the show and taking photogtaphs; in the end I compromised and watched the show

91 This is the most successful picture that Chris took and it is indeed worthy of reproduction. The picture shows exactly what this young lady is all about, portraying both her own unique charisma, and the character that she depicts. It is very typical of the production in general and would be an ideal picture to use for a front of house display. It also shows that, as she is most obviously singing, the production is a musical, but also that it is fun!

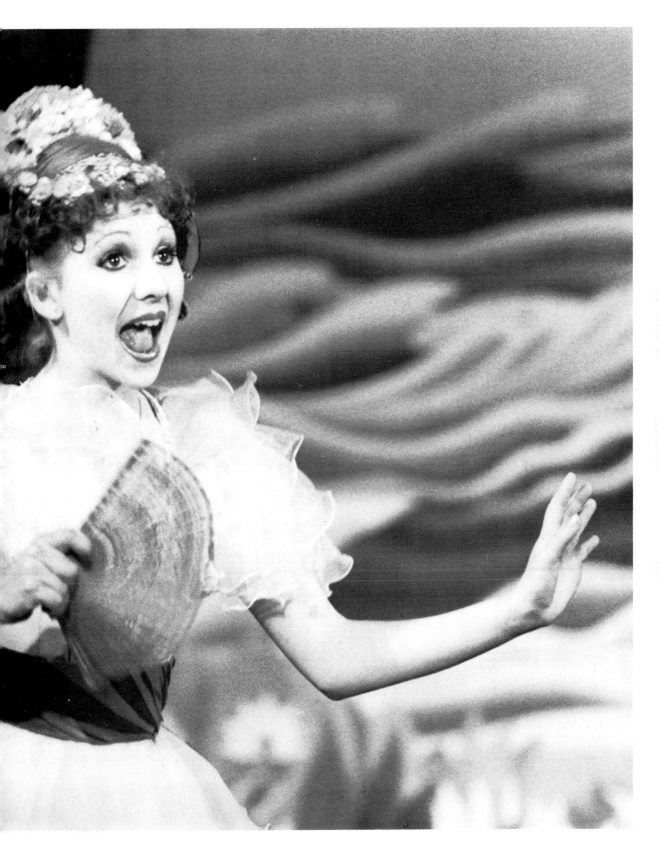

92a and **b** Two good pictures showing correct exposure, and sharp focus **a** has plenty of detail in the highlight areas and **b** has caught a moment of great expression. However, they both have one over-riding fault – the framing of the pictures is terrible! They have been printed full-frame to demonstrate this: if only they had been taken as full length portraits they would have been perfect!

through the camera viewfinder. A word of warning – when you laugh, you laugh alone! It's an eerie feeling being in a theatre without an audience reaction.

The show went on and I snapped away merrily, using more film than any of the other photographers. I thought that I was using too much film too quickly: I only had four films. Just as I was loading the third film came the interval; what a relief – there should now be enough film left! Three of the other photographers left at this stage, one having dropped his camera, cracking the lens in the process. By the time the show had finished, I had used almost all the film. I felt quite proud of myself, having coped with loading and unloading the films, changing lenses and film speed settings, and all of this in almost total darkness. Then reality struck: what if the films were under- or over-exposed, out of focus or just plain blank!

The next three days were nerve-wracking as I waited to hear how my films had turned out; eventually the telephone call arrived: 'Hey, those are pretty good photos.' What a relief! Now my nerves settled and the glow of pride returned.

It was an unforgettable experience, and one that I was very lucky to take part in. I had conquered my worries and had learned a lot about a part of photography that the amateur rarely has the chance to explore.

Observations

Although Chris had been warned two or three days prior to the show that I might ask him to cover the performance, it was not until the day before that I confirmed that he was to go along! The evening before, he came over and collected the equipment – and had a quick run through on how the cameras were operated, lenses changed, meter readings taken and films loaded and unloaded. Chris was used to a 35mm system, but had never used a Nikon or motor-drive before, neither had he ever had to change lenses and films in the subdued lighting which is encountered in the theatre auditorium when the production is in full swing. I suggested that, as it was a full run-through rather than a photo call, he would have the time to take the pictures without being too rushed and that it might be an idea to take a friend with him – firstly to boost his confidence in the strange surroundings and, secondly, to act as an assistant to pass him lenses, films etc., when they were required.

The equipment he was given consisted of a Nikon F2 fitted with a motor-drive; a Nikkormat FT2; 50mm standard, 105mm and 200mm lenses; and three rolls of HP5 and one of Ektachrome 160 tungsten film.

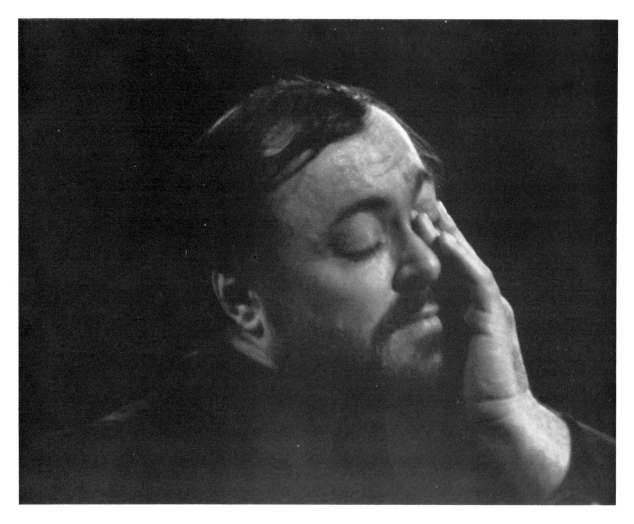

93 Pavarotti at the Royal Albert Hall
One of Paul's first attempts at theatrical photography and,
despite having caught Pavarotti in a most expressive moment, has
been let down by the quality of the lens he was using.

Chris was asked to write a few words describing what he felt when he had seen the resulting photographs and whilst taking them, how he had coped with problems, and whether he was pleased with the results.

On the whole Chris had managed extremely well and produced some pictures that could have been very usable if they were destined for reproduction purposes. From his own comments, he seemed to have done all the right things with the one possible exception of asking the producer who he was! As previously mentioned the press photographers work-

ing in the theatre are usually very helpful to newcomers, and Chris seemed to have befriended them so that, if anything had gone wrong, he could have asked for some help or advice. He arrived early, so that he could have time to find a seat with a good vantage point, and to organise what combination of cameras, lenses and films he would use.

The reason Chris thought that he was using more film than the other photographers well illustrates the difference in attitude between the amateur and the professional. The other photographers would know excatly what sort of pictures they wanted, and of whom, whereas Chris was shooting what he thought to be a good picture; he was not experienced enough to anticipate the shot he wanted, let alone recognise it when it happened! Watching

the show through the view-finder is not to be recommended for not only does the photographer end up boss-eyed, he misses the opportunity to watch out for the good shots coming up. It is funny how quickly one learns to recognise the signals for what will be a potentially good picture and as a result the observant photographer would shoot several frames around that moment to obtain the good shot. However, speed is of the essence at all times in these cases.

One problem that Chris encountered, and did not mention, was that one of the TTL light meters was not working. He assumed a lighting evaluation from the meter on the other camera and took the whole roll of film at the same speed and aperture. He felt that by doing this that, although many frames would not be correctly exposed due to the varaible light, at least some would be all right and this proved to be the case.

At the end of the day, although, not surprisingly, there were a large number of shots that showed obvious errors, there were also some very good pictures – expressions captured at just the right moment, with clear uncluttered backgrounds, correctly exposed and in sharp focus. Here, also it must be remembered that the professional never reckons on a 100 per cent success rate either. The main problem that Chris seemed to have encountered is that of 'framing' the pictures in the viewfinder – again this is not always an easy task when the photographer is confined to taking pictures from the auditorium as this will give a distorted angle of view (i.e. slightly upward-looking) that will often cause cut off on the bottom of the frame from stage. However, the resulting pictures he should be justifiably proud of since, with his limited experience in this field, he had done very well.

PAUL ALGER

Back in the late seventies, I acquired my first ever SLR camera and after a couple of years I realised that every so often a 'snap' appeared which almost justified the cost of the film and the processing. Over a period of time I added a moderately priced flash unit, extra lenses, tripod, cable release, a few special filters and a couple of tele-

converters. I became a subscriber to a weekly magazine aimed at the novice photographer, and eventually acquired a rigid aluminium carrying case to add a touch of authenticity to my (assumed) air of the much-travelled Assignment Photographer. I felt I was achieving some small success, insofar as I was able to convince myself that at least one, occasionally two, and on one glorious occasion, three frames from my 36-exposure roll were worth keeping; I also found myself being more selective before firing the shutter, and I was now looking for suitable subjects rather than just photographing what lay in front of me. In other words, I suppose I had become a keen amateur.

Knowing this, and also being aware of my penchant for fine voices, Paddy Cutts telephoned me one morning to see if I would like to assist her on a photo call at the Royal Albert Hall, at which the incomparable Pavarotti would bless our ears with a preview of his special Royal Performance – 'Bring your camera equipment,' she said, 'I'm sure you'll enjoy yourself.'

We met at the appointed time and venue, and joined the small band of press photographers who were assembling for the photo call; having arrived with time to spare, we downed a coffee as we checked over our cameras, lenses, etc. When we eventually made our way into the auditorium Paddy pointed out that television crews were in attendance and suggested we watch out for cables and video-cameras (particularly in respect of getting in their line of vision!); she also warned that the use of flash would be prohibited as it would distract the performer and interfere with the smooth running of the video-filming. As I had no separate exposure meter, Paddy advised me of the general exposure for the overall lighting situation (house lights being on full) that would prove best suited for the up-rated (400 ASA HP5, pushed to 800 ASA) black and white film I would be using. For finite adjustments I relied on the in-camera metering system. Kurt Adler was conducting the orchestra in a shirt-sleeve rehearsal and I shot four frames to ensure the film was properly loaded and the camera functioning correctly. For this I

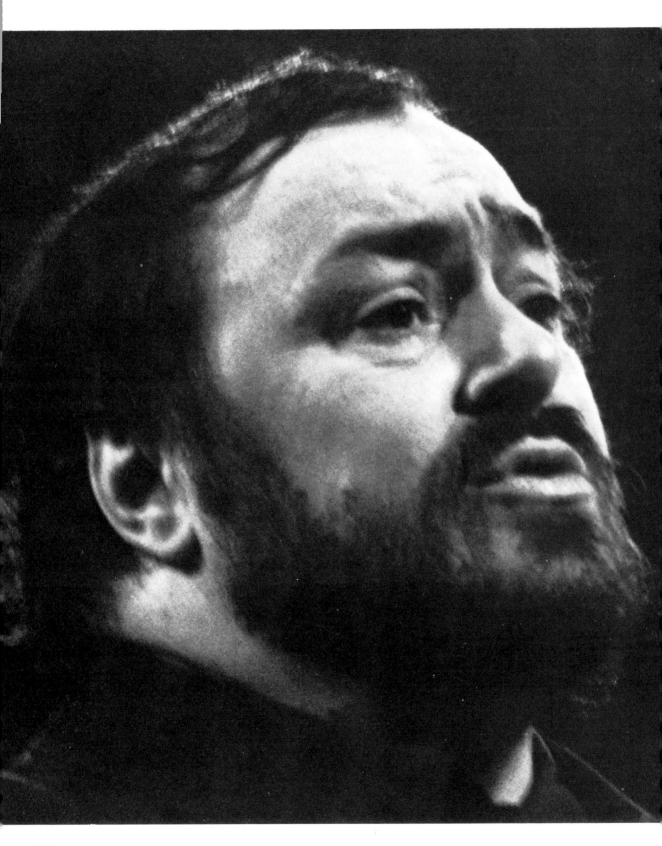

used a 200mm telephoto on my Praktica LTL3 (with and without 2x and 3x tele-converters), braced on seat-backs or against pillars, to get the 'feel' of light conditions and the likely difficulties in handling the longer lenses if one could not get close to the performer. (On examining the results at a later date I was extremely pleased to find no obvious signs of camera shake.)

Then Pavarotti appeared, the session got under way, and I received a totally unexpected shock – after an initial, minor surge forward, the gentlemen of the press (including my 'guardian angel') *quietly* and *unobtrusively* set about the task in hand. Tripods were raised, lowered and repositioned, shutters clicked and motor-drives chattered; technicians crept about overhead on gantries, adjusting lighting rigs, television cables snaked about everywhere, and photographers scuttled hither and thither to new positions care-fully avoiding getting in each other's way. I had somehow expected a jostling, mil-ling throng of sharp-elbowed, foot-grinding, 'scoop-hungry' newshounds – what I observed was a display of courtesy which in no way hindered the proficient, purposeful and business-like approach of these professionals. The Maestro conduc-ted, the Great Man poured liquid gold upon our senses and in no time at all the session sadly came to an end.

For my part, I had quickly realised that we were to be allowed access to the stalls area immediately in front of and below the stage, and I accordingly switched to a 135mm telephoto lens (occasionally using one of the teleconverters for extreme close-up work); this was the shortest tele-photo I had and as Pavarotti was perform-ing in street-clothes I realised that a standard 50mm lens would not give me the close-up facility I would need to both capture the critical detail of facial ex-pressions and lose the rain-garb. There were some instances when the available light rendered it almost impossible to pick up detail in the viewfinder, but on the whole it was feasible to select one's view-point, aim the camera, assess the moment likely to be of most dramatic effect, and fire away; for some strange reason this was more difficult than I would have imagined, as having the camera at one's eye somehow interfered with my audio-visual synchronisation (to the extent that my ears felt as if they were working overtime!). This may have been occasioned by there being less demand for concentration by the optic nerves as I was viewing the subject in close-up and through a narrow field of vision, with little or no distraction.

I found myself all over the press area during the photo call, kneeling on one knee, lying on the floor, crouched across seats, even straddling stairway balus-trades, all to find the right angle from which to immortalise the performer (and all the while he sang he turned this way and that for the benefit of the assembled photographers, smiling graciously when not actually singing, and treating the session with gentle good humour – I believe he even poked out his tongue at one stage!). In retrospect, whilst appre-ciating the professional need for the use of motor-drive it is not a medium I would have been attracted to in this instance, as the anticipation of the right moment for shooting seemed somehow to gel with the richness of the music and the eloquence of the voice.

After the photo call, Paddy took the film away for processing and for the next couple of days or so I found myself unusually excited, as I waited for the moment of truth, would there be an image on the film at all and, if so, would it have the slightest photographic merit? In the event, and as feared, the lens system proved to be inadequate in dealing with the low light levels, even with the up-rated film; nevertheless it was felt that the results were extraordinarily good for a camera so moderately priced and, more importantly, I was very pleased that a number of the pictures seemed to me to

94 This shows even worse definition than the previous picture as, in order to get a close-up, Paul has used tele-converters which have degraded the image to the point where it was almost unprintable. Both of these pictures illustrate that it is not the photographer who is at fault, but that the equipment that he is using is not capable of coping with this sort of situation

have captured the mood of the occasion. Additionally, Paddy had requested contact sheet printing, with which I was unfamiliar, and another 'first' was therefore established; I was impressed with both the cost-effectiveness and the convenience of viewing associated with the contacts.

The whole photo call experience had been unforgettable, so you will be able to imagine my reaction when Paddy asked, a few months later, if I would like to try my hand again, but using her camera and lenses for black and white shooting (HP5 up-rated to 1600 ASA), at an evening dress rehearsal in Leeds of Opera North's *Cosi fan Tutte*.

Unlike the morning photo call, this was a full run-through in costume with complete sets and effects. On this occasion I found myself loading and unloading a strange camera in the gloom of the auditorium and checking camera settings in the dim glow from 'Emergency Exit' signs; movement around the stalls was severely restricted by the need to avoid interfering with the production team and the company photographer – nevertheless, it was a most enjoyable experience and all concerned at the theatre were most helpful. The Nikkormat FT2 with 50mm and 105mm lenses coped admirably with the low lighting levels in all but two or three brief scenes, and the resulting pictures proved infinitely sharper than my earlier efforts. Checking the results confirmed that my personal choice of lens would be for the telephoto, as the close-up shots carried dramatic impact that (other than in action sequences) was lacking in group and full-stage scenes generally pictured with the standard lens. As the dress rehearsal photographs had not all been close-ups, Paddy was able to give one or two suggestions for improvement in 'framing', as I appeared to have taken occasional shots which were neither 'head and shoulders' nor 'full length', i.e. they were 'chopped off' at the calf, knee or thigh and (particularly in costume) as a result undeniably suffered.

Finally, I gratefully accepted a third offer from Paddy, this time to accompany her at a dress rehearsal in Mold of the Welsh National Opera's *Don Giovanni*,

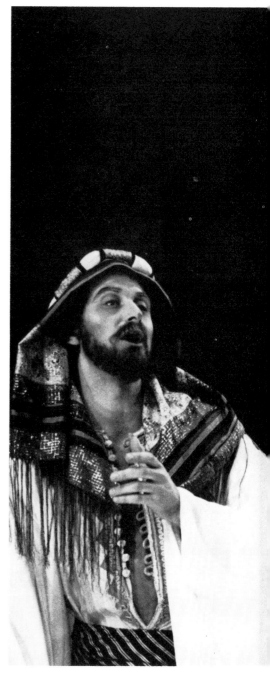

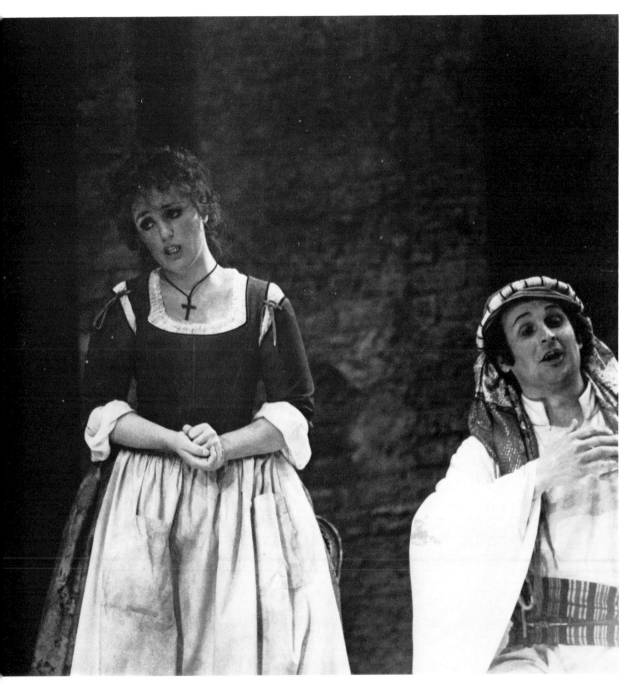

95 *Cosi fan Tutte*, (Opera North), Leeds
This is quite an improvement! The image
and exposure are much better, although it
was taken under much more difficult
circumstances. This was a full dress-
rehearsal and, as such, meant that the
auditorium was very dark. Although the
picture can be criticised by the fact that the
two men have been cut off at the shoulder, it
still remains a pleasing picture

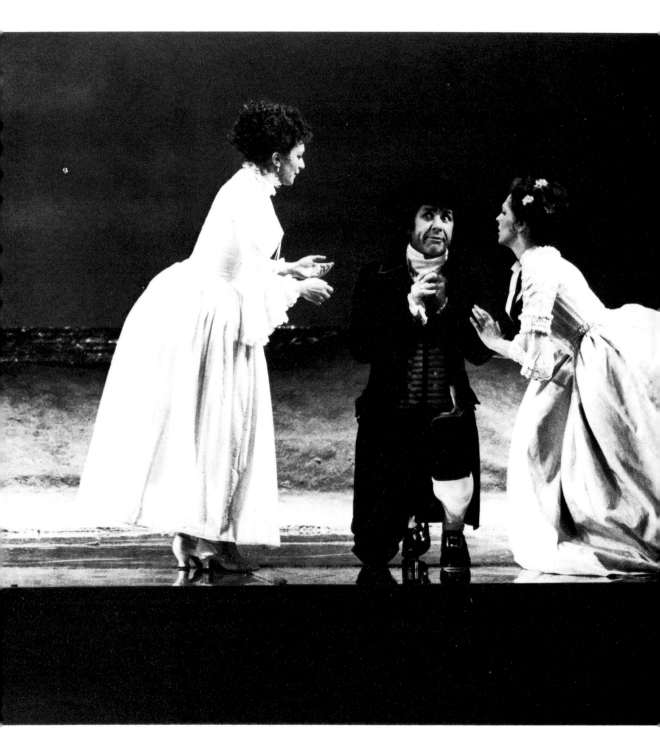

96 *Don Giovanni*, (Welsh National Opera), Mold, Wales
This final picture from Paul shows what a tremendous improvement has been achieved in a few short months. This picture really shows what the opera is saying and he has captured a particularly expressive moment. It is well framed, well exposed, and is truly indicative of the performance as a whole

again using her camera and lenses but this time shooting in colour (Ektrachrome 160 Tungsten up-rated from 160 ASA to approximately 1000 ASA). This was an afternoon occasion (so perhaps I was more alert than at Leeds!) and I was pleased to record that my overall 'framing' was more acceptable. It was gratifying to see that the use of colour made the group and full-stage pictures more interesting, without losing too much the feeling of solitude noticeable in the black and white close-ups previously taken. Also, the full impact of the special lighting effects was acceptably recorded on the colour film.

All in all, the experiences described were entertaining and instructional, and I wish it were possible for other keen amateurs to be offered the opportunities made available to me. Needless to say, I am frantically saving all my spare pennies towards a new camera system.

Observations

Paul's comments really need no further observations as he has not only described both the problems encountered, and the mistakes that he made, but he has also done a very lucid self-criticism as well! However, it is interesting to note that both he and Chris Stewart came unstuck with the same recurring problems – how to frame the picture correctly and how to cope with changing lenses and films during the dim light of a dress rehearsal. Both these techniques are learned with time and practice and, although Chris has not had further opportunity, Paul had conquered both of these problems by his third outing and seemed quite at home with both the cameras and the situation.

In retrospect, it was a most worthwhile experiment, which the two 'guinea pigs' both enjoyed and benefitted from, providing them with a unique insight to a world of professional theatre photography usually closed to the amateur.

Appendix II

SUGGESTED ORDER FOR ACQUISITION OF EQUIPMENT

1 Camera body with TTL meter, and standard lens. Although more expensive, it is recommended that the widest aperture standard lens is bought, as being potentially of most use.

2 Additional lenses. A short telephoto and a medium wide angle, with their relevant hoods (to cut down flare from theatrical back-lighting). A light meter would also be appropriate.

3 Filter holder suitable for holding Kodak Wratten gelatine filters, or a series of glass colour compensating filters.

4 Case suitable for holding existing equipment, but with space to take additional items.

5 Motor drive or automatic wind-on unit.

6 Series of 'creative' filters.

7 Medium-power flash gun.

8 More lenses, perhaps a longer telephoto or a zoom lens.

9 Second camera body to act as a 'back-up'.

If the above has all been 35mm equipment, then the next step could possibly be to invest in the larger 120mm format; the order of acquisition should be the same.

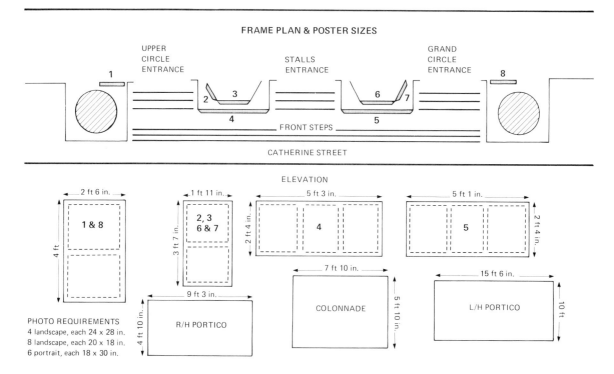

FRAME PLAN & POSTER SIZES

UPPER CIRCLE ENTRANCE STALLS ENTRANCE GRAND CIRCLE ENTRANCE

FRONT STEPS

CATHERINE STREET

ELEVATION

2 ft 6 in. 1 & 8 4 ft

1 ft 11 in. 2, 3 6 & 7 3 ft 7 in.

5 ft 3 in. 4 2 ft 4 in.

5 ft 1 in. 5 2 ft 4 in.

9 ft 3 in. R/H PORTICO 4 ft 10 in.

7 ft 10 in. COLONNADE 5 ft 10 in.

15 ft 6 in. L/H PORTICO 10 ft

PHOTO REQUIREMENTS
4 landscape, each 24 x 28 in.
8 landscape, each 20 x 18 in.
6 portrait, each 18 x 30 in.

RECORD SHEET

Production Title:

 Venue:

 Characters

 Date: **Actors/Actresses**

Technical Details

 Camera:

 motor drive – yes/no flash – yes/no

 Lens(es):

 Film(s)

 rated at ASA. Developed in
 rated at ASA. Developed in
 rated at ASA. Developed in
 rated at ASA. Developed in
 rated at ASA. Developed in

 Shutter speed(s):
 Aperture(s):

Other Comments

FILMS

	Speed		Black and White	Colour Transparency	Use in the theatre
	ASA	DIN			
Slow	25–32 50–64	14–16 17–19	Panatomic x Pan F Verichrome Pan	*Kodachrome 25 *Agfa 50 *Ektachrome 64 Ektachrome 50 Tungsten	Rarely used in the theatre as too slow to capture the action. High quality, fine grain films that would necessitate the use of flash in low lighting levels. The Tungsten 50 film is not used as it has a faster counterpart.
Medium	100–200	21–24	Plus-x Pan FP4	*Agfa 100 Ektachrome 160 Tungsten *Ektachrome 200	Monochrome medium-speed films are rarely used, as the faster films are much more suitable for the theatre. The tungsten films are usually employed as the colour stock most suited to theatrical photography.
Fast	400 +	27	Tri-x Pan HP5 XP1 Agfapan 400	*Ektachrome 400 3M 640 Tungsten	The most useful films for theatrical work. Fast and adaptable; good contrast range; can be up-rated. Ektachrome 400 needs colour correction filter to balance for tungsten lights, but useful for daylight, outdoor productions.
Ultra-fast	1000 1250	31 32	Recording Film Royal-x Pan		Special-purpose films useful in very low light conditions. Can be successfully up-rated.

*Colour film needing a Wratten 80b colour compensating filter when used in tungsten light

EQUIVALENT FOCAL LENGTHS OF LENSES, AND THEIR USES

	35mm	120mm	Use
Wide angle	6mm	30mm	Special effect lens only. No normal usage in the theatre. Often known as 'fish-eye'.
	24mm 28mm 35mm	35mm 50mm 60mm	Various degrees of wide angle. Useful for overall shots of stage. Can give dramatic impact when used very close to the subject.
Standard	50mm 55mm Macro	80mm 105mm Macro	Distortion-free lens that gives same viewpoint as human eye. Macro lenses can be used as standard lenses but are meant for close-up work.
Telephoto	85mm 105mm 135mm	120mm 150mm 200mm	Short telephotos or 'portrait' lenses. Very useful for full length pictures of artistes at photo calls and dress rehearsals.
	180mm 200mm	280mm 350mm	Telephoto lenses suitable for getting close-up head shots of artists if close enough to stage. When more distant from stage, good for full length and group shots.
	300–500mm		Not normally of use in the theatre, but could be very useful at rock concerts, where distance is a problem.

Glossary of Technical Terms

Aberration A technical term for a flaw in a lens. Aberrations can be chromatic, spherical or due to diffraction, and will affect the image quality by degrading sharpness, changing contrast and shape, or in the case of colour work, will create abnormalities of hue. The higher the quality control used by the manufacturer, so usually the higher will be the price, but this, of course, will result in a lens with fewer aberrations.

Apertures The size of hole produced by the iris diaphragm. This is one of the two ways with which to control the amount of light reaching the film emulsion (the other being shutter speed – *see* below). The iris diaphragm of the lens is very similar to the iris of the human eye, and the size of the aperture can be likened to the pupil; in low light the pupil dilates to allow more light to enter, and in bright sunshine the pupil will become very small, thus restricting the amount of light entering the eye. This is the basic working principle of the lens iris also – the aperture can therefore be altered, and the size of the aperture is measured in f stops (*see below*). The aperture will affect the depth of field (*see below*) as the larger the aperture, the less the depth of field and, as the aperture becomes smaller, so the depth of field will increase.

Bracketing When shooting in light conditions where it is difficult to assess accurately the correct exposure, a useful technique can be to bracket the exposure. This simply means taking the meter reading, making an exposure and then exposing two more frames to plus and minus one f stop (*see below*) on either side. This would, for example, give f16 and f8 when the original exposure value was f11. This technique can only be used when the lighting value is constant, as it would serve little purpose under conditions of frequent lighting changes. As a technique it is also somewhat wasteful in terms of film, as at least three exposures are required for each desired picture.

C-41 The technical abbreviation (and common title) for the processing formula for colour negative material.

Camera shake When shooting at a low shutter speed (*see below*), it is very easy to move the camera whilst depressing the shutter release, and this will result in the *whole* image on the negative being blurred. This should not be confused with subject blur (*see below*).

Catadioptric lens The correct technical term for the type of lens referred to as a 'mirror' lens. Instead of the usual arrangement of many glass elements within the lens, mirrors are used to give greater magnification and the resultant lens is shorter and more compact than the normal telephoto. A typical effect on the image from this type of lens, when there are pin-points of light or reflections in the out-of-focus area, is to create a strange light-coloured circle with a dark-coloured centre where the light has caught the lens.

Chinagraph A brand name for a type of coloured pencil (usually red, blue or white) that is suitable for marking-up

contact sheets (*see* below) or transparency sleeves.

Cibachrome A print process, marketed by Ilford, that will allow a direct positive print to be made from a transparency, thus eliminating the necessity of making an inter-negative. A similar process is marketed by Kodak and is known as R14.

Clip-test A term used to describe a process whereby the first few frames are removed from the cassette or roll of film, and developed for what is assumed to be the correct exposure value. If the clipped piece of film is found to be either under- or over-exposed then the remainder of the film can be saved by increasing or decreasing the development time accordingly, giving the correct exposure. If it is known, when shooting, that the film is liable to need a clip-test then, on 35mm, it is a good idea to expose the first frames and then wind on three frames – this means that when the film is cut (or 'clipped') no frames will be spoiled and pictures lost. With roll film, which is not re-wound like 35mm, the penultimate shot should be wound on to leave the last frame for the clip-test. This technique is suitable for both monochrome and colour.

Contact sheets Contact sheets are a way of printing one negative, or a complete roll of negatives, on one sheet of paper. The negatives are placed on the photographic paper, emulsion to emulsion, and flattened under a sheet of glass. This is then briefly exposed to light and the paper developed in the usual way. A roll of 36-exposure 35mm or 120mm film will fit into a 10 × 8in. sheet of paper. If the photographer has access to a 10 × 8in. enlarger, then enlarged contact sheets can be produced to make the assessment of the image qualtiy easier. The negatives are sandwiched between two sheets of 10 × 8in glass, placed in the negative carrier in the enlarger, and exposed in the normal way.

Cropping Ideally, all negatives and transparencies should be perfectly framed, thus allowing the entire negative area to be used, but this is not always possible. Sometimes it is the format selected which is at fault, such as with the 6 × 6cm format (it is rare for a square picture to be required) so the image must be 'cropped' to give a more attractive shape. More often, however, it is some error or oversight on the part of the photographer that necessitates cropping of the image area. With theatrical photography it is usually to eliminate some unwanted article from the picture (the back of a head, top of a double bass, or some other distraction), or to improve the image composition (such as removing too much foreground or making the subject more dominant when an incorrect lens has been used). When only a small area of the negative is selected for printing this heavy cropping, especially if used in conjunction with up-rated film, will result in a dramatic change in image quality – giving a very grainy picture with a limited range of tones.

Depth of field The term used to describe the depth of the area that will be in focus in front of and beyond the point on which the camera has been focused. The amount of depth of field is dependent upon the aperture selected, and the basic rule is that the wider one has the aperture the narrower will be the depth of field and as the aperture becomes smaller, so will a greater depth of field be apparent. The use of depth of field can help the photographer to isolate a subject from the background, making the focal point stand out. This usually the case within the theatre, as it is normal to shoot at wide apertures when working in the low lighting conditions that are often encountered.

Dress rehearsal A full run-through, in costume, of an entire theatrical production. This is put on for the benefit of the company and the production team to ensure that there are no problems prior to opening night. Most usually, only the production photographer will be allowed to take pictures but, as with opera and ballet, the dress rehearsal can also serve to give the press photographer his chance to cover the production.

Drying marks White-rimmed areas on the negative caused by uneven drying; removed by re-washing or, less drastically, by the art of retouching.

E6 The technical abbreviation (and common title) for the processing formula for colour transparency material.

Film speed Term used to indicate the film's sensitivity to light. There are two ways of expressing this – the German DIN rating and the (more usually referred to in the UK) American ASA rating. Both are clearly displayed on any roll of film purchased. The lower the ASA/DIN rating, the slower the film will react to light (hence they are termed 'slow' films), and the resulting grain will be so small as to be barely noticeable. An increase in film speed will mean that the film emulsion will react much faster to light (referred to as 'fast' film), but will give a marked increase in grain and a certain deterioration in tonal quality. A full range of films and their ASA/DIN ratings is given in Appendix II but a quick guide should list 25 ASA as slow, 400 ASA as fast and 1000 ASA as ultra-fast.

Focal lengths The focal length of the lens is the distance between the centre of the lens and the plane of sharp focus on the film whilst the focus is set at infinity. The standard lens for any format is a lens which has a length equal to the diagonal measurement across the format. The longer the focal length of a lens the larger the image and the narrower the field of vision; short lenses give a much smaller image but a much wider angle of view and are thus called 'wide angle'.

Focal plane An imaginary line that, when the lens is set at infinity, will give the plane of sharp focus.

Fogging A term used to describe what happens to film or paper when it is exposed to white light during the development process, before the image has been stabilised in fixer.

Format The actual shape and size of the negative that the camera will accept, e.g. 35mm, 6 × 6cm, 6 × 7cm, etc.

F.O.H. 'Front of house' is the area in front of the iron (safety) curtain, through the auditorium and into the foyer – the other area is 'backstage'. Used to describe the photographs which will appear outside the theatre and in the foyer.

f stop The f stop is the number that designates the size of the aperature on the iris diaphragm of the lens. The higher the f stop number, the smaller the lens aperture, and vice versa, so a wide aperture would be considered f1.4 and a small aperture f32. Using a wide aperture is commonly termed 'opening up' and using small apertures 'stopping down'. The usual range of f stop numbers is f1.4, f2, f2.8, f4, f5.6, f8, f11, f16, f22, f32 and, in some extreme cases such as with large format, f45, f64 and f90 (these latter three rarely being seen on 35mm and 120mm formats).

Godet A triangular or shaped piece of cloth that is inserted into a bodice or skirt of a costume – can also be referred to as a placket.

Grain The grain apparent on photographic film is really the random accumulation of silver halide crystals, and is caused by the action of the developer on the film emulsion during processing. All films will show grain, as it is this accumulation of crystals that makes up the image pattern, but it is more noticeable on some films than on others. Slow (25 ASA) films are often termed 'fine grain' as the grain is very small and therefore not very apparent. As the ASA speed increases, so does the size of the grain. Large grain is almost unavoidable when taking pictures in a theatrical venue, as the film used will not only be fast but also will need to be up-rated.

Green Room The area off stage, other than the wings and dressing-rooms, in which the cast will congregate prior to their entrance and following their exit from stage. Used for socialising and also the nearest area to the stage in which smoking is allowed.

Holding back (dodging) Term used to describe a darkroom printing technique whereby one portion of the image has a restricted amount of exposure so that the image does not go too dark. It is particularly useful when printing theatrical pictures, as the tonal details in shadows and highlights will be limited owing to the up-rating of the film which is almost always necessary. Whilst exposing for the general density of the negative such areas may well be lost, but holding back a light area on the negative (which would normally produce a dark area on the print) will give a much more pleasing picture. Holding back is most often effected by using a suitably shaped piece of card or with the hand – whichever method is employed care must be taken to ensure the medium is constantly moving, so that there are no obvious marks where the exposure has been (*see also* **Printing-in**).

Inspection development By using a dark green filter and low wattage bulb in the darkroom safelight, it is possible to view quickly monochrome negatives· whilst they are being developed. It is a technique used only as a last resort to salvage the negative, as it is very easy to fog the latter by exposing it for more than a few seconds.

Inter-negative A copy negative made from a transparency, from which a positive colour print can be made.

Knifing Part of the retouching process, this is a method of removing part of the image from the print by scraping gently at the paper's emulsion with a very sharp and precise scalpel blade. The technique is best used in conjunction with a non-resin-coated paper.

Parallax error Parallax error is an effect that has to be compensated for when using a camera other than a single lens reflex camera. When the mode of viewing is through anything other than the 'taking' lens, the true image will be slightly displaced and, when working at close range (less than 10ft) there will be a noticeable cut-off on the image.

Rangefinder, viewfinder and twin lens reflex cameras will all suffer from the effect of parallax and the degree of compensation which will be needed is something that can only learned by experience. Some of the more expensive cameras will mark on the viewfinder where parallax will displace the image, making it much easier for the photographer to frame his pictures correctly.

Photo call A specially-called performance of a production, in full costume, for the benefit of the press photographers. Usually lasts for thirty minutes or so. The director and production team will have organised for certain pertinent scenes (usually featuring the star performers) to be re-enacted to give the press photographers the opportunity of getting good, accurate pictures that will be representative of the production as a whole. In the US it is the production photographer who covers these photo calls.

Photo-pit An area set aside (normally in front of the stage) at rock and pop concerts, or similar, with access limited to such photographers as have been issued with special facility passes.

Printing-in (burning) Printing-in is the opposite technique to holding back, and is effected in the darkroom during the print exposure. A very dark area on the negative (that will appear white on the print) may need more exposure to reveal detail than the general exposure needed for the majority of the negative. After the normal exposure has been made, the light is restricted from all areas other than those requiring additional exposure, and a further exposure is made. The light is restricted to this area by using a suitably-prepared card with a hole in it, or by cupping the hands together, thus allowing a narrow beam of light to fall where required.

Pushing *see* **Up-rating**.

R14 *see* **Cibachrome**.

Reticulation Reticulation is caused

when a negative is exposed to extreme changes of temperature or pH balance during processing – the effect is an even but crazed grain-pattern.

Retouching A technique used to change part of the image on a print, by means of a two-stage process involving 'knifing' (*see above*) and 'spotting' (*see below*).

Set dressing A term used in the theatre for furnishing and placing items on and around the set to create an authentic atmosphere. These items are not classed as props (items handled, or referred to, by the artistes) but are merely the extras demanded for the set by the designer. They could well include pictures, ornaments, lamps, pots and pans (in a kitchen set), rugs, books in a bookcase, plants, flowers and vases, desk items such as blotter, pads, pens and pencils – all these in the case of a domestic play.

Shutter speed The shutter speed, used in conjunction with the aperture, will control the amount of light entering the lens. The shutter can be fired at a number of different speeds and the speed selected will noticeably affect the resulting picture. Slow shutter speeds (less than $\frac{1}{60}$ second) will usually mean that the camera cannot be held steady without the use of a sturdy tripod on which to mount the camera, if one is to avoid camera shake (*see above*). In order to capture action without producing a blurred image, a shutter speed of at least $\frac{1}{125}$ or faster will be required. The general rule for the minimum shutter speed that can be used with any lens (and allowing the camera to be hand-held) is that the shutter speed should not be less than the focal length of the lens, i.e. a 105mm lens would need not less than $\frac{1}{105}$, a 200mm not less than $\frac{1}{200}$, and so on, if the image is to be free of camera shake.

SLR Abbreviation commonly used to describe the single lens reflex camera. The SLR allows the photographer to see exactly what he is taking, by the use of mirrors.

Spotting Part of the retouching process, and is used for one of two reasons. Firstly, if a detail has been removed from the print by knifing (*see above*), the tones can be blended back in by diluting 'Process Black' paint until the required tone has been achieved and, using a very fine paint- or eyeliner-brush, applying it to the print surface. The second reason concerns dust or hairs on the negative when the print is made – the resulting marks can be removed by applying the paint in the same way.

Subject blur This is caused by selecting a shutter speed that is not fast enough to capture the action in front of the lens, thus resulting in an image where the background and static objects will be sharp but the moving aspects blurred.

Technical rehearsal (Tech) This is the first rehearsal at which the artistes appear on stage on the set, and is the first time that the technical staff and stage management will be able to work methodically through the show, to set the scene changes, lighting cues, sound cues, entrances, exits, etc., and iron out any technical problems that may arise during this time. These rehearsals can take up to two days to complete (approximately 30 hours) but they are imperative and indeed will help to avoid all the potential dangers that could arise but, until everyone is together on stage and *in situ*, cannot necessarily be visualised.

TLR Abbreviation for the twin lens reflex camera, having two lenses (one above the other) – one acts as a 'viewing' lens, the other as the 'taking' lens.

TTL Abbreviation for the through the lens metering systems which are built into most modern 35mm SLR cameras.

Up-rating This technique, also known as 'pushing', is a way of under-exposing the film on purpose, and compensating for this under-exposure in the processing by increasing the development time. Effectively this will increase the working speed of the film by as much as two stops.

Bibliography

FURTHER READING

Theatre
Cooper, D., *Theatre Year 1980*, In
(Parenthesis) Ltd
Cooper, D., *Theatre Year 1981*, In
(Parenthesis) Ltd
*Illustrated Encyclopaedia of World
Theatre* (ed. Esslin), Thames & Hudson
Webber, *Cats – The Book of the Musical*,
Faber & Faber Ltd

Opera
*History of the Royal Opera House Covent
Garden, 1782–1982*, R.O.H.

Ballet
Bland, A., *The Nureyev Image*, (Studio
Vista)
Crickmay, A. and Crisp, C., *Lynne
Seymour*, Studio Vista
Dance Photography of Carl van Vechten,
Schirmer
*Dancers to Remember – Photographic Art
of Gordon Anthony*, Hutchinson
Kerensky, O., *The Guinness Guide to
Ballet*, Guinness
Steen, J., *History of Ballet & Modern
Dance*, Hamlyn Publishing Group

Photography
Coote, *Monochrome Darkroom Practice*,
Focal Press
Hedgecoe, *The Photographer's Handbook*,
Ebury Press
Langford, M. J., *Basic Photography*,
Focal Press
Langford, M. J., *Advanced Photography*,
Focal Press
Pinkard, B., *Creative Techniques in
Studio Photography*, B. T. Batsford Ltd
Pinkard, B., *Photographer's Dictionary*,
B. T. Batsford Ltd

MAGAZINES & PERIODICALS
The British Journal of Photography
Creative Camera
Dance and Dancers
Dancing Times
Opera
Plays and Players
The Stage and Television Today
Melody Maker
New Musical Express
Sounds

PROFESSIONAL ORGANISATIONS
National Union of Journalists, Acorn
House, 314 Gray's Inn Road, London
WC1
British Actors Equity, 8 Harley Street,
London W1.

Equipment Suppliers

EQUIPMENT MANUFACTURERS
Hasselblad GB Ltd, York House, Empire Way, Wembley, Middlesex
Nikon UK Ltd, 20 Fulham Broadway, London SW6
Asahi Pentax, Pentax House, South Harrow, Middlesex

EQUIPMENT SUPPLIERS
Keith Johnson Photographic, Great Marlborough Street, London W1
Pelling & Cross, Baker Street, London W1
Leeds Cameras, Brunswick Centre, Brunswick Square, London WC1

EQUIPMENT HIRE
Sight & Sound, 8–12 Broadwick Street, London W1
Keith Johnson Photographic (*see above*)
Pelling & Cross (*see above*)

SPECIALIST FILM SUPPLIERS
Process Supplies, Mount Pleasant, London WC1
Keith Johnson Photographic (*see above*)
Pelling & Cross (*see above*)
Leeds Cameras (*see above*)